INFRATHIN

Infrathin

An Experiment in Micropoetics

MARJORIE PERLOFF

THE UNIVERSITY OF CHICAGO PRESS

CHICAGO AND LONDON

The University of Chicago Press, Chicago 60637
The University of Chicago Press, Ltd., London
© 2021 by The University of Chicago
Published 2021
Printed in the United States of America

29 28 27 26 25 24 23 22 21 20 1 2 3 4 5

ISBN-13: 978-0-226-71263-5 (cloth)
ISBN-13: 978-0-226-79850-9 (paper)
ISBN-13: 978-0-226-71277-2 (e-book)
DOI: https://doi.org/10.7208/chicago/9780226712772.001.0001

Library of Congress Cataloging-in-Publication Data

Names: Perloff, Marjorie, author.
Title: Infrathin : an experiment in micropoetics / Marjorie Perloff.
Description: Chicago : University of Chicago Press, 2021. | Includes
bibliographical references and index.
Identifiers: LCCN 2021007593 | ISBN 9780226712635 (cloth) |
ISBN 9780226798509 (paperback) | ISBN 9780226712772 (ebook)
Subjects: LCSH: Poetics. | Poetry.
Classification: LCC PN1042 .P38 2021 | DDC 808.1—dc23
LC record available at https://lccn.loc.gov/2021007593

♾ This paper meets the requirements of ANSI/NISO Z39.48-1992
(Permanence of Paper).

For Craig Dworkin

Contents

Figures

Preface

"Can one make works that are not works of 'art'?" Of course one can—think of the now iconic urinal called *Fountain*—but Marcel Duchamp, who posed that question and "made" that fountain, was quick to add that it does not follow that anyone can be an artist. Many of us, for instance, write poetry at some point in our lives, but our poems, written for this or that occasion, are not likely to interest anyone outside our personal circle. Here, for example, is a limerick recently included in an email from my friend Christian Bök, who had been teaching in Darwin (Australia) and was touring the Irish countryside with two old Canadian buddies, Gary Barwin and Gregory Betts:

> There once was a Christian from Darwin
> And a Wandering Jew named Barwin—
> Who, to Limerick with Betts,
> Got whiskey, comma, Tourette's:
> "Feck ye!" said all three to the barman.

As it happens, Barwin, Betts, and Bök are all poets, the last named quite a celebrated one. But this little limerick, tossed off for fun on their road trip, is more or less a throwaway, although Bök's poten-

tial biographers just might take an interest in the power of whiskey to simulate Tourette syndrome.

But what about those phrases and lines of poetry that continue to haunt us, including some of Bök's own, like "A pagan skald scans a dark saga" in *Eunoia*? Lines like "Absent thee from felicity awhile," or "To comprehend a nectar / requires sorest need," or "Till human voices wake us and we drown"? As a child in Vienna, I loved reciting the German lyric "Kennst du das Land wo die Zitronen blühn / Im dunkeln Laub die Goldorangen glühn," even though I had no idea what these lines meant or why the mysterious child Mignon expresses such longing for lemons and golden oranges in Goethe's *Wilhelm Meister*. Reading "great" poetry—I use the adjective advisedly, knowing full well that it is taboo at our cultural moment—is, I believe, one of the great (there's that word again) human pleasures. However strongly we may disagree as to the "greatness" of this or that poem or its place in a potential poetry canon, most readers who have bothered to open this book in the first place will concur that *poetry* matters. And they will also grant, I believe, that poetry is, in Ezra Pound's now familiar words, news that stays news. Which is to say that poetry can't just be read and deleted like the most recent Instagram; it demands to be *reread*.

This book is an attempt to convey to a nonspecialist audience what it is, from my perspective, that makes poetry with a capital P so captivating and indispensable. The choice of poets—most of my poets are familiar Modernists—is much less important than the example of a possible methodology. That methodology is by no means some abstract theoretical model; rather, it is a practice, based on my own sense of what a super-close reading—a reading for the visual and sonic as well as the verbal elements in a text, for the individual phoneme or letter as well as the larger semantic import—can do for us. Micropoetics, let me add, is by no means Art for Art's Sake: the context—history, geography, culture—of a given poem's conception and reception are always central.

———

Infrathin was begun some years before the coronavirus struck and is being completed in the sixth month of the Plague Year 2020. Given the current crisis, talk about Ezra Pound's page design or Susan Howe's phonemic clusters may seem frivolous; then again, our moment may well be the very "time-out" we need to return us to the charm of poetry. At the very least, the reading of poetry can be an antidote to the unbearable news cycle and Twitter feed. To paraphrase the brilliant opening statement in Karl Kraus's *Third Walpurgisnacht* (written shortly after Hitler came to power in Germany), "About Trump, I have nothing to say."

On Scansion and Notation

The scansion used throughout this book is an adaptation of the traditional one used for English metrics in standard textbooks on the subject. Primary stresses are marked by an acute accent, secondary stresses by a circumflex—as in compounds like **bláckbîrd** or **básebâll**. Unstressed syllables may be unmarked or marked conventionally as **x**. When a stress comes over a diphthong, as is so often the case, I place the accent on the second vowel, but it should be understood as being over both. Secondary stress is often the key to the meaning of a given word: compare **bláck bírd** to **bláckbîrd**. The placement of secondary stress can be somewhat arbitrary: my rule of thumb is that if the basic meter is, say, pentameter, extra stresses had best be assigned the secondary role, although one can often debate which of two neighboring syllables will receive the stress.

The lines of a rhyming stanza are marked by italic letters beginning with *a*. Thus a Shakespearean sonnet, with its three quatrains and rhyming couplet, is marked *ababcdcdefefgg*. And a ballad stanza, whose second and fourth lines rhyme, is designated as *abcb*.

A short midline pause is marked |. A stronger pause or caesura is marked by two parallel bars: ||. Words or letters to be discussed with regard to their phonemics and prosody (sonic or visual) are presented in **boldface**.

Introduction

Toward an Infrathin Reading/Writing Practice

Hegel seems to me to be always wanting to say that things which
look different are really the same. Whereas my interest is in
showing that things which look the same are really different.
LUDWIG WITTGENSTEIN[1]

A changed feature in the similar can change
the entire system by its dissimilarity.
VIKTOR SHKLOVSKY[2]

The impetus for writing this book was an invitation I received in
2017 from Ronald Schuchard, the director of the London T. S. Eliot
Summer School, to give the annual address at Little Gidding, on
the fourth of the *Four Quartets*, which bears that title. I have long
loved Eliot's earlier poetry, but the *Quartets* always struck me as
too contrived in their exposition of Christian doctrine. And yet
I had to admit that *Little Gidding* contains some of Eliot's most strik-
ing and memorable lines and phrases, like "To purify the dialect of
the tribe" or "the conscious impotence of rage" — phrases that have
taken on a life of their own and often become book or film titles.
Still, such high points could hardly account for the continuing pop-
ularity of the *Four Quartets*.

Much has been made of the "musical" structure of the *Quartets*,
which has been found to resemble the four-part structure of specific

quartets by composers from Beethoven to Bartok. But such considerations of external form, it struck me, hardly got to the heart of the matter: other Modernist poets wrote "fugues," "quartets," and so on, which never quite caught the audience's fancy as has Eliot's sequence. Is the appeal related to its distinctive imagery? I don't think so because the poem's predominantly Christian symbolism, from the rose garden of *Burnt Norton* to the refining fire of *Little Gidding*, is rather less original or memorable than, say, the conceit of the evening sky as "a patient etherized upon a table" from the early "Love Song of J. Alfred Prufrock."

It is, I would submit, at the *microlevel* that the brilliance of *Little Gidding* manifests itself. As an examination of the revisions bears out, every phoneme, every morpheme, word, phrase, rhythm, and syntactic contour has been chosen with an eye to creating a brilliant verbal, visual, and sound structure. Etymology and homology also play a central role so that everything in the poem relates to everything else in surprising and remarkable ways.

In charting the poem's *micropoetics*, I was especially aware of what Marcel Duchamp refers to as the *infrathin* (*inframince*).[3] In his famous *Notes* on the subject, Duchamp declares with characteristic irony that one cannot *define* the infrathin, one can only give examples.[4] Some of Duchamp's examples are playful. For example:

> The warmth of a seat (which has just been left) is infrathin.
> Sliding doors of the Metro—the people who pass through at the very last moment/infrathin.
> Velvet trousers—their whistling sound (in walking) by brushing of the 2 legs is an infrathin separation signaled by sound.
> When the tobacco smoke smells also of the mouth which exhales it, the 2 orders marry by infrathin.
> The infrathin separation between the *detonation* noise of a gun (very close) and the *apparition* of the bullet hole in the target.

But others raise larger issues about time, space, and especially language:

Infrathin (adjective) not a name—never make of it a noun.

In time, the same object is not the same after a one-second interval.

The difference between the contact water and molten lead make with the walls of a given container is infra-thin.

Two men are not an example of identity and on the contrary diverge with an infrathin difference that can be evaluated.

It would be better to go into the infrathin interval which separates two "identicals" than to conveniently accept the verbal generalization which makes 2 twins look like 2 drops of water.

The difference (dimensional) between two objects in a series (made from the same mold) is an infrathin one when the maximum (?) of precision is attained. [See figure 0.1][5]

Notice that in each of these examples, the case is made for *difference*, however minute, between an A and a B. Adjectives are not equivalent to nouns and shouldn't be used as such (although Duchamp himself quickly shifts from *infrathin* [adjective] to *the infrathin* [noun]). The singular is not the plural, the present tense not the past. A second-long interval can be the decisive one. And, perhaps most importantly, even two or more objects *made from the same mold* are not, in fact, identical.

This last "definition" recalls Wittgenstein's question in the *Philosophical Investigations*: "But isn't the same at least *the same*?"[6] The answer, for Wittgenstein, as for Duchamp, is always no: however minuscule the difference between one word or phrase or statement and another, the "difference," as Gertrude Stein puts it in *Tender Buttons*, "is spreading."[7] And as Stein shows us in her endlessly complex iterative prose, the slightest repetition or shift in context changes the valence and meaning of any word or word group. A rose is a rose is a rose. And by the third enunciation, it is already something else.

Duchamp's short and often enigmatic maxims here and elsewhere are always a shade tongue-in-cheek. He tells us that *infrathin* cannot be a concept—the word can only be exemplified—but of course his

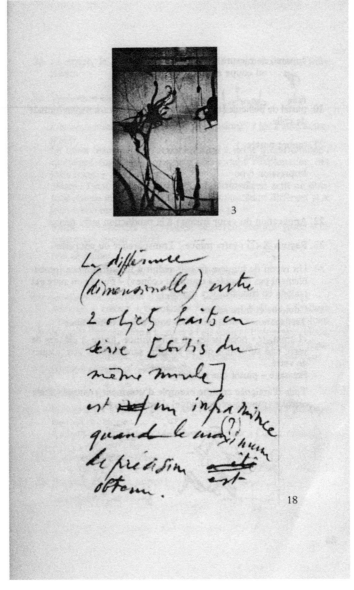

0.1 | Marcel Duchamp, *Inframince* (1934). Note 18, with photograph of Shadows of Ready-mades. From *Notes*, ed. Paul Matisse (Paris: Flammarion, 1999), 18.

witty examples do add up to a concept. Moreover, Duchamp knows only too well that he is exaggerating, but exaggeration seems necessary at a time when it would seem that *generalization*—the generalizations of the social sciences, of the media, of political discourse—has prevailed over any other discourse. And if the generalizing habit was already prominent in the 1930s, when Duchamp wrote his *infrathin* notes, think of what it is like a hundred years later.

Here are a few extracts from president-elect Joe Biden's—but it could be anyone's—victory speech on November 7, 2020:

> To make progress, we must stop treating our opponents as our enemy. We are not enemies. We are Americans.

> The plan will be built on a bedrock of science. It will be constructed out of compassion, empathy, and concern.

> We must make the promise real for everybody—no matter their race, their ethnicity, their faith, their identity, or their disability.

> And now, together—on eagle's wings—we embark on the work that God and history have called upon us to do.

This is the standard language that bombards us day and night from the media—a language of abstraction and dead metaphor. "Americans" can't be our "enemies," "science" and "history" are somehow equated with all that is good, and "disability" is used as a basic marker of identity, parallel to "race," "ethnicity," and "faith," even as "identity," in this context, is merely redundant. Add the dead metaphors "bedrock" and "eagle's wings," and you have the sort of verbal stew Duchamp would have loved to dissect. His response is what he called "a kind of *pictorial nominalism*:

> *Nominalism* [literal]= No more generic specific numeric distinction between words (tables is not the plural of table, ate has nothing in common with eat). No more physical adaptation of concrete words; no more conceptual value of abstract words. The word also loses its

musical value. It is only readable (due to being made up of conso-
nants and vowels), it is readable by eye and little by little takes on a
form of plastic significance; it is a sensorial reality a plastic truth with
the same title as a line, as a group of lines.[8]

Readable by eye. The poet, Duchamp here implies, is one who un-
derstands that "ate has nothing in common with eat," that the same
is never the same, and that hence every word, every morpheme
and phoneme, and every rhythmic form chosen makes a differ-
ence. To be a poet, in other words, is to draw on the verbal pool
we all share but to choose one's words and phrases with an eye to
unexpected relationships—verbal, visual, sonic—that create a new
construct and context—relationships that create infrathin possi-
bilities. And not only the poet: the reader in turn comes to "po-
etry" with an eye and ear for such telling difference. Indeed, poetry
might be defined as the art of the infrathin—the art in which *dif-
ference* is more important than similarity. Consider as well known
a line as "April is the cruelest month." Suppose it were "April is
the darkest month" or "the harshest month" or "the worst month
of the year"? Would the effect be the same? And if not, why not?
Does "cruelest" stand out because, unlike the other adjectives, it
connotes human agency? And do the echoes of April's **il** sound in
the word "cruelest" and the **r** in its contrasting **pr/cr** clusters make
a difference?

Consider the context. Words, as we use them, don't appear
alone: they are embedded in phrases, clauses, and, in poetry, in
lines: "April is the cruelest month, breeding / Lilacs out of the
dead land, mixing / Memory and desire, stirring / Dull roots with
spring rain." What strange line breaks, all of them following pres-
ent participles—breeding, mixing, stirring—and these participles
have surprising objects: how is it, for example, that the "dead land"
breeds "lilacs"? Then again, "breeding," in Duchampian terms (one
thinks of his famous glasswork *Dust Breeding* of 1920), is not the
same as "bred." The emphasis on the ongoing—an emphasis coun-
tered by the stoppage produced the curious line breaks—is what
gives the opening of *The Waste Land* its particular *frisson.*

The Question of Formalisms

To understand how micropoetics can operate, I want to lay to rest two possible misconceptions regarding the infrathin project. The first is that the close differential reading Duchamp advocates is like the "close reading" of the New Criticism, which dominated the American literary scene, and especially the academy, from the late 1930s to at least the mid-1960s. In fact, there is little relationship between the two. A text like Cleanth Brooks's *The Well Wrought Urn* (1947), which served as a kind of bible for the movement, was based on the principle that, as Brooks's opening chapter explains it, the language of poetry is the language of paradox. In John Donne's "The Canonization," Brooks's Exhibit A, "the basic metaphor"—and metaphor is at the very heart of poetry—"which underlies the poem . . . involves a sort of paradox":

> For the poet daringly treats profane love as if it were divine love. The canonization is not that of a pair of holy anchorites who have renounced the world and the flesh. The hermitage of each is the other's body; but they do renounce the world, and so their title to sainthood is cunningly argued. The poem then is a parody of Christian sainthood; but it is an intensely serious parody . . .[9]

Note the underlying assumption here that poetry is designed to convey a special meaning. That meaning, as Brooks makes clear throughout, is not scientific meaning—it is not a question of facts or information—but a meaning only poetry can convey. Structure, in other words, is always *semantic structure*. Thus even *The Waste Land*, with all its complexities, so Brooks explains in his earlier *Modern Poetry and the Tradition* (1939), is "built on a major contrast—a device that is a favorite of Eliot's. . . . The contrast is between two kinds of life and two kinds of death. Life devoid of meaning is death; sacrifice, even the sacrificial death, may be life-giving, an awakening to life. The poem occupies itself to a great extent with this paradox, and with a number of variations upon it." And again,

"The basic method used in *The Waste Land* may be described as the application of the principle of complexity. The poet works in terms of surface parallelisms which in reality make ironic contrasts, and in terms of surface contrasts which in reality constitute parallelisms. . . . The two aspects taken together give the effect of chaotic experience ordered into a new whole."[10]

Brooks gives a masterly exposition of the way each section in *The Waste Land*—say, "A Game of Chess" (part II)—reiterates the central Christian paradox, but although chapter 11 of *The Well-Wrought Urn* is called "The Heresy of Paraphrase" and insists that the language of a particular poem cannot be altered without destroying its complexity, and that, hence, prose paraphrase is not possible, the fact remains that what matters to Brooks—and this was true of such fellow New Critics as Robert Penn Warren, Allen Tate, and R. P. Blackmur—is an *extricable* and larger meaning—a meaning conveyed, in successful cases, by means of metaphor, irony, and paradox—the tropes of indirection. Rhythm, sound structure, visual patterning, etymology—these are all but ignored.

There are certain exceptions: in *The Verbal Icon*, whose subtitle is *Studies in the Meaning of Poetry*, W. K. Wimsatt has some brilliant chapters on rhyme and rhetorical features in the poetry of Alexander Pope, and on the historical evolution of symbolic imagery from late eighteenth-century poets like William Bowles to Wordsworth.[11] But even here, sound structure and rhetorical device are always secondary, a given antithesis or chiasmus being designed to convey the particular verbal ambiguity that belongs to poetry. Indeed, metaphor was judged to be so essential to poetry that such Modernists as William Carlos Williams, whose lyric is given to literal language, metonymy, and visual design, were dismissed by the New Critics as wholly negligible. As for Ezra Pound, whose poetry could hardly be said to order "chaotic experience" into "a new whole," the *Cantos* were dismissed, for example by Blackmur, as no more than a "ragbag" of miscellaneous items.

The radical difference we associate with the *infrathin* was thus precisely what the New Criticism tried to suppress: its close read-

ings were pointedly not so close as to open up the text to particular contradictions or to explore the role context plays in the reception of a given text. Accordingly, only certain poets could count: Donne rather than Milton, Keats rather than Shelley; among American Modernists, Robert Frost and later Robert Lowell, but never Robert Creeley.

A closer analogue to the practice of micropoetics may be found in the groundbreaking work of the Russian Formalists, who remain, a century after they wrote their key texts, perhaps the most important theorists of poetics in the Modern period. This is not the place to give a lengthy account of what is a complex set of theoretical models; I want merely to point to the key elements that have directed my own thinking on the subject.

For starters, it is important to remember that Roman Jakobson, probably the most famous of the Russian Formalists, began his career as a poet, in alliance with the Futurists Velimir Khlebnikov and Aleksei Kruchenykh, both of whom made a strong case for the primacy of form over content in poetry. "Genuine novelty in literature," wrote Kruchenykh, "does not depend upon content. . . . If there is a new form, there must also exist a new content."[12] From these poets' doctrine of the emancipation of the word and especially from Khlebnikov's close study of morphology and poetic neologism, Jakobson developed his now well-known doctrine of *literaturnost'* (*literariness*) rather than the broader category *literature* as the object of the poet's study. If the central question was to be "What makes a verbal message a work of art?" it followed that questions of sound and visual form were just as important as questions of meaning. And so we get the axiom, "In poetry, any conspicuous similarity in sound is evaluated in respect to similarity and/or dissimilarity in meaning."[13]

But, one may well ask, isn't Jakobson's insistence on the separation of the *aesthetic* from all other textual functions the very antithesis of Duchamp's nagging question "Can one make works that are not works of 'art'?"[14] Yes and no. In his first interview with Pierre Cabanne (1966), Duchamp remarks:

I shy away from the word "creation." In the ordinary, social meaning of the word—well, it's very nice but, fundamentally, I don't believe in the creative function of the artist. He's a man like any other. It's his job to do certain things, but the businessman does certain things also, you understand? On the other hand, the word "art" interests me very much. If it comes from Sanskrit, as I've heard, it signifies "making."[15]

The notion of *making—poiesis—*presented no problems to Duchamp: it is the second term, *art*, that he found unsatisfactory. For centuries, he understood, *art* had referred primarily to one particular visual art—*painting*; indeed, the two words have often been used interchangeably, as in such book titles as *The Art of Henri Matisse*. And even the radical new art of *Cubism* referred to a style of painting, give or take the occasional sculpture made by Picasso or Braque.

But suppose, Duchamp posited, one substitutes for the common synecdoche "the painter's hand"—the individual talent to deploy line and color (or, in the case of poetry, to deploy words to convey unique personal emotion)—the appropriation and reconfiguration of items already in existence? In the case of Duchamp's own readymades, beginning with the urinal signed "R. Mutt" and called *Fountain*, an ordinary plumbing-store object, later photographed by Alfred Stieglitz against a backdrop that earned it the sly name *Madonna of the Bathroom* (see figure 1.2), choice and framing—often by infrathin means—meant everything. And gradually, Duchamp sensed, such "conceptual" works would come to be recognized as "works of 'art,'" comparable to their seemingly antithetical counterparts.

Duchamp also coined the related term *delay*. "The Bride" was "a delay in glass" (*Salt Seller*, 26), as were the "Nine Malic Moulds." "It was the poetic aspect of the words that I liked," Duchamp tells Cabanne, "I wanted to give 'delay' a poetic sense that I couldn't even explain. It was to avoid saying, 'a glass painting,' 'a glass drawing.... The word 'delay' pleased me at that point, like a phrase one discovers. It was really poetic, in the most Mallarméan sense of the word, so to speak" (*Dialogues*, 40).

Duchamp gives no further explanation, but I think what he had in mind is the *delay*, not as the art object itself, but as the perception of the viewer/reader who confronts it, the *delay* that occurs when that viewer tries to take in what is being seen. As such, a delay would be a temporal infrathin, as in the "velvet trousers" or gunshot examples above. In Jakobsonian terms, the delay would occur when we try to understand how the perceived similarity of sound in a given poem relates to a comparable similarity in meaning. It is the interval we experience as we recognize that even the same is not the same.

Russian Formalist studies, we should note, never came around to studying new hybrid art forms of the twentieth century like the readymade, the installation, the "found" or appropriated poem, and so on. But within literary confines, their understanding of *language* operations was profound. "The word," wrote Jurij Tynjanov in 1924, "does not exist outside of a sentence. An isolated word is not found in a nonphrasal environment. Rather it is found in a *different* environment from the word in a sentence. If we pronounce an isolated 'dictionary' word, we do not obtain the 'basic word,' a pure, lexical word, but simply a word in new circumstances." Tynjanov gives the example of the Russian word *zemlja*:

1. *Zemlja* and Mars; heaven and *zemlja* (*tellus*).
2. Bury an object in the *zemlja*; black *zemlja* (*humus*).
3. It fell to the *zemlja* (*Boden*).
4. Native *zemlja* (*Land*).

However various the meanings here (earth, soil, ground, land), the "unity of the lexical category"—what Wittgenstein was to call *family resemblances*—allows a native speaker to construe the meaning in each instance without much difficulty.[16] But, as Tynjanov understood, it is the poet who knows how to make the most of the subtle, sometimes contradictory, meanings *zemlja* can have and who can relate that word to its cognates.

In a brilliant essay, itself a kind of prose poem, called "Z and Its Environs" (1915), Khlebnikov considered the curious number of *z*-words relating to the nature of reflection:

Names for universal reflectors: *zeml'ia* [earth], *zvezdy* [stars], *ziry*, another word for stars, *zen'*, another word for Earth. The ancient exclamation "zirin" may possibly have meant "to the stars." The Earth and the stars all shine by reflected light. The word *zen'*, which means both Earth and eye, and the word *ziry*, which means both star and eye, demonstrate that both Earth and stars are understood to be universal reflectors. . . .

In wintertime the earth reflects rays, and so that season of the year is called *zima* [winter]. In summer it swallows them up, But where do they go, these rays of summer? They too become reflected, in complicated ways, and these types of summer reflections, rays reflected by the universal mirror, also begin with *z*.

And now Khlebnikov goes on to list metonymic *z* nouns designating summer heat and vegetation, culminating in the insight that:

Zem [earth] is the eternal reflector upon which people live. If *zen'* means eye, then *zem* is the majestic *zen'* of the nighttime sky: compare *ten'* [shadow] and *tem'* [darkness]. The other reflecting points of the black night sky are *ziry* and *zvezdy* [stars].[17]

Here is the play of differences—first the variations on *z* words and then *zem* versus *tem'*—that furnish Khlebnikov with his poetic arsenal in all its infrathin manifestation.

Further important studies of context—this time in more ordinary situations—were made by the Prague Linguistic Circle. Jan Mukařovský reminds us that a simple sentence like "It's getting dark," made as a statement by A to B at a specific time and place, means very differently when the same sentence "is conceived as a poetic quotation." "The focal point of our attention," Mukařovský notes, "will immediately become its relation to the surrounding contexture, even if it is only an assumed one."[18] The same would be true for the examples of *infrathin* Duchamp gives in his *Notes*: for instance, the changing texture of the walls of a given container.

The Russian Formalists were at their best in their earlier, relatively informal texts: Jakobson's "On a Generation That Squandered

Its Poets," for example, written in 1931 in response to Mayakovsky's suicide, is surely one of the most profound texts ever written on how poetic strength can become dissipated and ultimately end in self-destruction. And Viktor Shklovsky's famous discussion of *ostranenie* ("making strange") and *faktura* (density) have become classics.[19] Later Formalist works like Jakobson's exhaustive analysis of the two versions of Yeats's "The Sorrow of Love" (see "Linguistics and Poetics") are perhaps less suggestive because they are exhaustively empiricist, the study counting such things as every instance of the article "the" and so on. Literary criticism, I would posit, will never be an exact science, and Jakobson was at his best when he did not try to give an exhaustive account of every part of speech or syllable count in a given poem.

But the notion of literary art as a "labyrinth of linkages" (Shklovsky) was developed by later poet-critics, for example, the Brazilian poet Haroldo de Campos. Elaborating on Jakobson's insistence that "any phonological coincidence is felt to mean semantic kinship," Haroldo gives the following French example:

> Whereas for the referential use of language it makes no difference whether the word *astre* (star) can be found within the adjective *désastreux* ("disastrous") or the noun *désastre* ("disaster") . . . for the poet this kind of "discovery" is of prime relevance.[20]

The (unstated) reference is to Baudelaire's "Le Voyage":

> Nous avons vu des astres
> Et des flots, nous avons vu des sables aussi;
> Et malgré bien des chocs et d'imprévus désastres
> Nous nous sommes souvent ennuyés, comme ici . . .

In my literal translation:

> We have seen stars
> And seas, we have seen sands too;
> And despite many shocks and unforeseen disasters
> We have often been bored, as we are here . . .

Here the rhyming *astres* (stars) and *désastres* (disasters) are pre-
sented as alternatives. Neither the exotic and beautiful vistas nor
the myriad dangers encountered on the poet's journey can allay
the terrible ennui of modern life. But the noun *désastre* is formed
by combining the negative prefix *des* or *dis* with *astron* (Greek for
"star"); the reference, in other words, is to the negative role of the
stars—to that which is *ill-starred*. So in fact, *astres* and *désastres*,
nouns unrelated in ordinary discourse, do go together. In poetry,
as Haroldo puts it, this time citing the sinologist Ernest Fenollosa,
who was Pound's mentor, "relations are more important than the
things related" (298).

Relatedness: Haroldo may well be thinking of his own long poem
Galáxias or of Pound's *Cantos*, where the juxtaposition and orches-
tration of individual motifs is perhaps at the furthest possible re-
move from any kind of prose paraphrase or discussion as to what
the poem is "about." But the process is of course also at work in
more traditional lyric poems like Baudelaire's "Le Voyage," cited
above. One reason Baudelaire is so difficult to translate, is that the
rhymes—like *astres/désastres*—and rhetorical figures contain so
much indirect and paragrammatic meaning. Here is the famous
opening stanza of "Le Voyage":

> Pour l'enfant, amoureux de cartes et d'estampes
> L'univers est égal à son vaste appétit.
> Ah! Que le monde est grand à la clarté des lampes!
> Aux yeux du souvenir que le monde est petit!

Literally: "For the child who loves maps and stamps, / The universe
is equal to his vast appetite. / Ah! how large the world is by the light
of the lamp! / In the eyes of memory, how the world is small."

"Le Voyage" is written in four-line stanzas comprised of alex-
andrines (the traditional twelve-syllable line, dominant in French
poetry till the beginning of the twentieth century), rhyming *abab*.
But English, not being an inflected language, makes rhyming much
more difficult, and few of Baudelaire's translators have attempted

to retain the rhyme scheme. Here are three translations, all of them by poets:

1. Roy Campbell
 For children crazed with maps and prints and stamps —
 The universe can sate their appetite.
 How vast the world is by the light of lamps,
 But in the eyes of memory how slight!
2. Richard Howard:
 The child enthralled by lithographs and maps
 can satisfy his hunger for the world.
 how limitless it is beneath the lamp,
 and how it shrinks in the eyes of memory!
3. Keith Waldrop:
 For the child who likes maps and stamps, the universe is a match
 for his vast appetite. Ah! how large the world is in lamplight! In
 memory's eye how the world is small.[21]

Roy Campbell is the only one of the three to adopt Baudelaire's rhyme scheme, but his rhymes lack Baudelaire's semantic charge, of which more in a moment, and his shift from singular to plural in line 1 ("children"), as well as the addition of the gratuitous noun "prints," are problematic. Then, too, Campbell does not reproduce the brilliant chiasmus in lines 3–4:

Ah! **que le monde est grande** *à la clarté des lampes*!
Aux yeux du souvenir **que le monde est petit!**

The chiasmus is similarly lost in Richard Howard's rather lackluster translation, which avoids rhyme and substitutes "lithographs" for stamps in line 1 — a change that makes no sense since this child is obviously a stamp collector. And the fourth line, "and how it shrinks in the eyes of memory" dissolves Baudelaire's tight sound structure into a prosaic comment. Keith Waldrop's is the most literal of the three, and he does keep the chiasmus of the original, but as a prose

strophe (or "verset," as Waldrop calls it), the translation cannot reproduce the drama and tautness of the original.

Indeed, no translation can reproduce the effect of Baudelaire's rhymes. Take *appétit/petit* in lines 2/4. The word *appétit* comes from the past participle, *appetitus*, of the Latin verb *appetere*—"(ad) petere," to desire, to long for. "Appetite" is a hunger *for* something: it is a strong emotion. In rhyming "appétit" with "petit"—small—the poem anticipates what will gradually be shown to be the case: that in the course of one's life human appetite will be rewarded by only the smallest of satisfactions. A similar effect is met in stanza 2, where "les désirs amérs" (bitter desires) rhymes with "des mers" (seas), the implication being that the longed-for exotic waters of distant oceans turn out to be the site of mere bitterness.

It is such verbal play, often discernible only on a second or third reading, that gives Baudelaire's poems their special *frisson* as well as their great memorability. And we might note that he is also a master of indeterminacy: "à la clarté des lampes" refers to the light of the lamp beneath which the child is looking at his stamps and maps. But *clarté* also means "clarity": in childhood, things seem so clear; the grown-up must learn otherwise. The English "lamplight" (Waldrop) cannot convey this subtlety of meaning. For the Anglophone reader, there is no entirely satisfying solution; but the recognition that in translation infrathin shades of meaning may well be lost can stimulate the translator to produce parallel constructions that may well be satisfying.

"A Mania for Change"

"In time the same object is not the same after a one-second interval." The infrathin, Duchamp insisted, is always temporal as well as spatial. And the artist himself was extremely sensitive to historical change as it affected his own work. In the interviews with Cabanne, he recalls, in great detail, how eager he was, in the early 1910s, to separate himself from the Cubists, who were becoming the rage of the avant-garde. "I tried constantly," Duchamp tells Cabanne, "to find something which would not recall what had happened be-

fore. I have had an obsession about not using the same things . . . it was a constant battle to make an exact and complete break" (*Dialogues*, 38).

Why this "mania for change"?[22] Duchamp's detractors have suggested that he realized his early paintings could not compete with those of Picasso or Braque, and that hence he had to find something else to gain recognition. But a more charitable interpretation would be that Duchamp understood that even the painting of Picasso, however formally inventive, was still *painting* in the great "retinal" tradition initiated by Courbet in the nineteenth century. Even his own *Nude Descending a Staircase* was, Duchamp came to feel, too "Cubist" (34):

> Since Courbet, it's been believed that painting is addressed to the retina! That was everyone's error. The retinal shudder! Before, painting had other functions: it could be religious, philosophical, moral. . . . It unfortunately hasn't changed much; our whole century is completely retinal, except for the Surrealists, who tried to go outside it somewhat. And still, they didn't go so far. (43)

The turning point for Duchamp was the Munich year of 1912, when he came in contact with an entirely different set of artists, working under the influence of Kandinsky and the latter's *On the Spiritual in Art*; Duchamp also spent hours in the Alte Pinakothek studying the Cranachs, and became interested in Renaissance perspective, which Apollinaire and the Cubists had so vociferously rejected.[23] Aloofness became Duchamp's signature stance: in the early 1920s, when the Dadaists tried to claim him as a kindred spirit, he carefully kept his distance. Thus, when Tristan Tzara asked him to send something to the 1921 Dada Salon in Paris, Duchamp responded that he had nothing on hand, and that anyway the verb "to exhibit" (*exposer*) sounded too much like the verb "to marry" (*épouser*).[24] "From afar," he wrote to Ettie Stettheimer, "these things, these Movements are enhanced with a charm which they don't have in close proximity."

Exposer/épouser: here is an early instance of the punning, wordplay, and "infrathin" Duchamp would produce for the rest of his life:

in 1920 he had already made the readymade French window called *Fresh Widow*. But to understand these works, it helps to see them, as Duchamp himself did, in their historical context. A meaningful close reading cannot exist in the abstract, as it often did in the work of the New Critics and Russian Formalists. In my own essays, in any case, I regular place the formalist problem at hand in a historical frame or context. Indeed, each of the following chapters may be said to have a twin purpose: (1) to show that an "infrathin" reading of particular Modernist works—many of them very well known— can remind us what it is that makes poetry poetry, and (2) to engage in revisionist history regarding the poetry in question, placing it in new contexts and suggesting unexpected alignments.

In chapter 1, for example—a study of the close verbal relationship between Duchamp and Gertrude Stein—I have wanted to dispel the old cliché that Stein's writing was strongly influenced by Picasso. To grapple with some of Stein's elliptical writings of the 1920s and 1930s, including her "portrait" of Duchamp, in the context of Duchamp's own comments about her work and his translation of one of her *Stanzas in Meditation*, is to come to see that theirs was a link much more significant for her writing than was the great friendship with Picasso, who never actually *read* her work. Such seemingly nonsensical poems as "Sacred Emily" turn out to be not so opaque after all. And vice versa: to study the Duchamp-Stein relationship is to come to the conclusion that Duchamp's Jewish female alter ego Rrose Sélavy was based in large part on Gertrude Stein herself— and for good reason.

In chapter 2, I make the case for Eliot's poetic language in *Little Gidding* as a brilliant verbal-visual-sonic complex that is an important forerunner, not only of American midcentury poets like Lowell and Roethke, as is generally recognized, but also of Concrete poetry, specifically that of Ian Hamilton Finlay. This connection will no doubt strike many Eliot readers—readers who may never have heard of Concrete poetry—as absurd. But if we forget the standard generalizations in most literary histories and try to come to Eliot (and the other poets studied here) with fresh eyes, we will be surprised how radical Eliot's verbal, syntactic, and rhythmic inventions

actually were. And surely in the centenary year of *The Waste Land*, it is high time to rethink the poet's seemingly familiar oeuvre.

Ezra Pound (chapter 3) is another case in point. There is much superb Pound scholarship—and I am indebted to many Pound scholars—but despite all the talk of Pound's "breaking" the pentameter and Making It New with respect to verse form and what Hugh Kenner called his "subject rhymes," I have never seen a close study of what Pound's actual rhythmic groupings and layout in the *Cantos* sound and look like—on how he decides on spatial configuration, placement of words and ideograms, specific repetitions, and the larger design of a given page or set of pages. What follows what and why, and where are the ideograms (which are omitted from Pound's oral performances of *The Cantos*) placed? I found it a challenge to answer these questions because the poem is a true labyrinth. But what I did discover, in considering, first, an early short poem like "The Return" and, then, passages from the *Pisan Cantos*, is that no rhythmic or visual detail goes unplanned. Again, as in the case of Eliot but more so, Pound, who is traditionally read as the precursor of the American Objectivists and Black Mountain poets, paves the way for the great work of the Concrete poets, especially, in Pound's case, the Brazilians of the later twentieth century. Indeed, Brazilian Concrete poetry would hardly have come into being without Pound's example.

Wallace Stevens (chapter 4) is a poet who has been given countless philosophical readings, whether by pragmatists or phenomenologists or deconstructionists. But the fabric of the language—and especially the sound structures—have received little attention. The most perceptive ones I found were by the poet Susan Howe, herself decisively influenced by Stevens. Howe has written brilliantly on Stevens's infrathin wordplay, even as her own poetry, which I discuss in tandem with Stevens's, is in fact quite different from his and in some ways closer to Pound's or Eliot's. Both Stevens and Howe, in any case, make much of sound and particular kinds of juxtaposition and fragmentation, and to read Stevens from Howe's perspective was, for me, an eye-opening exercise.

My essay on John Ashbery (chapter 5) originated in a certain dis-

satisfaction with the many discussions of the "tribe of John"—the many poets, mostly New York poets, who claimed to be writing under the sign of Ashbery, especially when he was teaching at Brooklyn College in the 1970s. To analyze Ashbery's micropoetics closely is to see that perhaps it is time to look elsewhere for the more genuine heirs—for example, at the unlikely "language" poetry of Charles Bernstein and Rae Armantrout. In future criticism, I would posit, the place of Ashbery in the canon will thus be understood rather differently from what it was during his lifetime. The anxiety of influence is operative, but not quite as the inventor of that term, Harold Bloom, imagined it.

The Beckett case (chapters 6 and 7) is perhaps the most deceptive of all. Beckett is surely one of the great poets of the later twentieth century, but he is never taught in poetry courses, which still divide literature into the familiar genre categories, fiction, drama, and lyric poetry. Beckett's early poems were indeed lyric; they were also, to my mind, not very satisfying. He had to find a different modus vivendi, and it was only after World War II, when he began to write French, that he learned how to "drill one hole after another" into the word surface he was inventing. *Texts for Nothing*, which I discuss here, is a great case in point. At the same time, it was in his Paris years that Beckett came to appreciate the precursor-poet he had scorned in his youth—W. B. Yeats. Chapter 7 takes up the gradual transformation of Beckett the critic of Yeatsian rhetoric into Beckett the advocate of Yeats's poems, a good many of which he had come to learn by heart, relishing especially their brilliant sound structure. So I come full circle from Beckett back to the early Modernist era when Yeats wrote such remarkable poems as "The Wild Swans at Coole." Indeed, Yeats could be considered a precursor of later sound poets, although he would not have understood—or approved of—the term.

From Yeats to Stevens to Ashbery, the poets I am featuring here are not only canonical; in most cases (especially Eliot and Pound), whole libraries have been written on their lives and work. But it is precisely because they are so familiar that I think their poetry can benefit from a reconsideration from what is my own micropoetic,

"infrathin" perspective. Think, for example, of the many studies of Gertrude Stein as a representative American, or as an expatriate, a feminist, a lesbian, a Jew. In recent years, her problematic politics, including her translations, during the Nazi occupation in World War II, of speeches by the traitorous Maréchal Pétain have come under close scrutiny. But what about the actual literary texts Stein produced in her Paris decades—her poems and plays, portraits and essays? How do they work? And what did someone like Duchamp, so critical of his fellow Cubists and Dadaists, see in them? Reading Stein as if for the first time, reading her, moreover, against such others as Pound or Beckett, allows us to see the larger configuration of Modernists and their contemporary heirs with new eyes.[25]

Language, not Lyric

It should be clear to the reader by now that when I talk of *poetry* and the *poetic*, I am generally using the terms to refer to *poetic language*, not the genre *lyric poetry*. To talk of Renaissance lyric or Romantic lyric makes good sense, but for at least the past century, some of the most significant poems, like *The Waste Land* or Pound's *Cantos*, cannot be classified under the rubric of *the* lyric. At the same time, the narrative poem has become all but obsolete, replaced by the dominant literary form of prose fiction. And dramatic poetry has been quite simply replaced by the umbrella term *drama*.

The word *lyric* is derived from the Greek musical instrument the lyre: originally, the lyric was a poem accompanied by the lyre, and this etymology gives us our own designation for song lyrics. But the musical definition never really took hold; Plato and Aristotle differentiated lyric from narrative and drama—the three constituting the dominant poetic modes—according to voice: the poet may speak either in his own voice—*lyric*, or he may assume the voices of others—drama—or he may mix the two, as in classical epic and of course, later, in fiction. But as early as the Renaissance, with its proliferation of lyric genres, from songs and sonnets to odes and elegies and epigrams, the link of lyric to some form of subjectivity had become firmly established. From Wordsworth's "Poetry is

the spontaneous overflow of powerful feelings" and "It is emotion recollected in tranquility," to Eliot's counterstatement "Poetry is not the expression of emotion, but an escape from emotion," personal feeling has been considered central to the first-person mode. Recent models like Jonathan Culler's in his influential *Theory of the Lyric* (2015), tend to take their point of departure from Hegel's *Lectures on the Aesthetic* (1818–28), although Culler, like so many other theorists before him, qualifies and amends Hegelian doctrine at many points.[26] Here is Culler:

> Although the essence of lyric for Hegel is subjectivity attaining consciousness of itself through self-expression, he stresses that the lyric process is one of purification and universalization. . . . The lyric is not a *cri de coeur*. It becomes "the language of the *poetic* inner life, and therefore however intimately the insights and feelings which the poet describes as his own belong to him as a single individual, they must nevertheless possess a universal validity." (94–95)

And, as Culler further explains:

> While declaring that the poet must recognize himself as himself in the particularization that his lyric offers, Hegel notes that despite the details a poet presents, "we have no inclination at all to get to know his particular fancies, his amours, his domestic affairs. . . . we want to have in front of us something universally human so that we can feel in poetic sympathy with it." (95)

In our own relativist and populist century, however, the notion of "universal validity" seems increasingly elusive, the poets themselves hardly claiming to speak for everyone or about universal emotions. On the contrary, the discourse has moved in the opposite direction, taking into account the role of ethnicity, national identity, race, class, sex, and gender as determinants of a given poet's vision. Given the proliferation of these categories, the emphasis falls precisely on the particular, the unique, the detail that defies simple

reproduction or reception. "Particular fancies," "amours," "domestic affairs": these are very much with us, whether in memoirs, personal essays, or poems.

The New Critics understood that a poem's "I" need not be the poet himself or herself, and they paid special attention to the dramatic monologue. Culler shifts focus from the dramatized "I" to the "you." He is particularly interested in the role *apostrophe* plays in lyric: "triangulated address—address to the reader by means of address to something or someone else—is a crucial aspect of the ritualistic dimension of lyric" (186). Classic examples would be Shelley's "Ode to the West Wind" or Keats's "Ode to a Nightingale." But Culler is interested in more complex cases, for example, the use of the "'blurred you,' which gestures toward the reader but is also plausibly taken as either the poet himself or someone else" (194). A "classic example," he suggests, is Goethe's second "Wandrers Nachtlied" ("Wanderer's Nightsong"), one of the most famous German poems, which reads as follows:

Über allen Gipfeln	Above all the peaks
Ist Ruh,	It is calm,
In allen Wipfeln	In all the treetops
Spürest du	You feel
Kaum einen Hauch:	Barely a breath;
Die Vögelein schweigen im Walde	The birdies in the woods are silent.
Warte nur, balde	Just wait, soon
Ruhest du auch.	You will rest too.[27]

Culler comments: "Here the two 'du's are at least ambiguous. The first can be an impersonal 'one' but the second, because of the command, 'just wait,' is read either as self-address—the speaker too will rest soon—or, as the poem is generally interpreted because of the universality of death, as a broader address in which readers are implicated as well" (195).

It is true that the first "du" is more generic than the second: the first is the "you" of ordinary conversation, as if I were to say, "On

clear mornings, you can see the ocean from here," whereas in the second the poet turns inward. But this shift seems normal enough, and I see no reason to infer that "Warte nur, balde / Ruhest du auch" refers to the universal rest which is death. On the contrary, I think the poem is merely suggesting, that given the idyllic natural conditions, the wanderer can now rest.

Perhaps Culler wants to bring in the death note so as to follow the Hegelian prescription of universality. But the irony is that in focusing on the "blurred you," he ignores, to my mind, the very things that make the little "Wanderers Nachtlied" such a unique and brilliant poem. I am thinking of the poem's sound structure — its rhythm, sound repetition, and verbal play. And here it helps to know something about the poem's occasion, which has been well documented.

Goethe's "Wandrers Nachtlied" was written on the night of 6 September 1780 in the mountains at Ilmenau above Weimar, where the young Goethe had accompanied his master, the imperious Duke Karl August, whom Goethe was serving in his Weimar years. The poem was first recorded in pencil, evidently in a moment of inspiration, on the wall of the mountain hut on the Gickelhahn where the poet spent the night. The same evening, Goethe wrote one of his nightly letters to his great love, Charlotte von Stein, this time reminding her of the time she had accompanied him to a nearby cave, where he had carved her initials in the rock. Declaring his passion for her, the letter concludes:

> The sky is quite clear and I am going out to enjoy the sunset. The view is extensive but plain.
>
> The sun has set. It is the landscape of which I made a drawing for you when it was covered with rising mist. Now it is as clear and quiet as a large and beautiful Soul, at its calmest and most satisfied.
>
> If there weren't, here and there, some mists rising from the mines, the whole scene would be motionless.[28]

It is this delicate moment after sunset that the nightsong presents: note how careful the poet is to discern that the residue of mist

makes the evening landscape not quite "motionless"—an infrathin difference.

Goethe's minimalist lyric has only twenty-four words, divided into eight lines rhyming *ababcddc*. There is no division between the two quatrains: on the contrary, line 4, "Spürest du," is enjambed, the object of the verb not known till the next line, "Kaum einen Hauch." But most remarkably, for a rhyming ballad, no two lines of this "song" have the same rhythmic contour. The poem begins with a line of three trochees—"**Ü**ber **al**len **Gip**feln"—which is suspended, its meaning being completed by the single iamb of line 2—"Ist **Ruh**"—the long vocalic **u** prolonging the stress on rest. The third line, "In allen Wipfeln," would be parallel to the first, were it not foreshortened (five syllables rather than six), and it is again suspended so that we read on to the next line, "Sp**ü**rest d**u**," with its echo of the opening **ü** and **du**'s rhyming partner **Ruh**. Yet another suspension in line 4 (what is it "you" feel?) forces the reader to draw a short breath before pronouncing the choriamb "**Kaum** einen **Hauch**," with its assonance of **au**. It is at this point, that the song shift gears, line 6 being a self-contained statement of nine syllables, predominantly dactylic-trochaic:

Die **Vö**gelein **Schweig**en im **Wald**e.

Oddly, the silence portrayed is rendered by the repetition of **g**'s and **w**'s and the emphatic, less than lovely sound of **Schweigen**. But now comes a surprise turn: the trochaic "**Warte** nur" reprises the sounds of "**Walde**," even as "**balde**" rhymes with that noun. It is as if harmony were almost complete, and indeed the four-syllable conclusion has been, so to speak, anticipated all along—

Ruhest **du auch**

where "**Ruh**est" picks up the earlier **Ruh** and **du** and **auch** rhymes with **Hauch**. Indeed, the sound structure is so tightly woven that if the last line were reversed to read "**Ruh**est **auch du**," it would make perfect sense, the rhyme scheme in that case being *ababcdd(b)*. For

Goethe, the interrelation between man and the natural world is so strong that the rapid-fire movement from beginning to end of the song, a movement made in more or less one long breath, can stand for either conclusion. I have long known "Wanderer's Nightsong" by heart and yet often hesitate in the last line to see which of the two sequences is the right one.

The notion of *rest* (*Ruh*) seems to be taken quite literally in Goethe's poem, which does not seem to contain any sort of death wish, as does, say, Keats's "Ode to a Nightingale," where the poet declares having long been "half in love with easeful death." Indeed, the poem's brilliance stems not from any larger meaning but from its careful articulation of sameness and difference, the "neat" rhyming "song" stanza offset by small but significant differences in line after line. "Eat" is not the same as "ate": "Ruhest" is not the same as "Ruh." Every word, indeed every syllable and phoneme here, has been chosen to create what has often been called a perfect poem.

But isn't the same at least the same? The attention to difference, to the infrathin, is especially important, I think, in the Age of Digital Reproduction. Substitute a single letter or punctuation mark in a password, and your document won't open, no matter how hard you try. Every letter stroke, every space, matters. And when you dictate, say, an email, as I regularly do, lounging in bed in the early morning, the error can prove embarrassing, as when once I dictated the name Ashbery and it came out "asshole," or when "Faulkner" appeared as "fuck you."

For all the talk of artificial intelligence, Siri's "imagination," it would seem, leaves much to be desired. "She" cannot, in any case, understand that Duchamp's *Three Standard Stoppages* create unequal line lengths, that the pochoir replica of *Nude Descending a Staircase* is a very different work from the original, or that in Stein's short story *Miss Furr and Miss Skeene*, the word "gay" keeps shifting its meaning. The French *En Attendant Godot* is very different from

the English *Waiting for Godot*. And even in Yeats's "Wild Swans at Coole," "still" (adjective) is no longer "still" as we proceed through the poem. When it comes to reading poetry—at least its most striking exemplars—the fascination, not only of what's difficult (the Yeats title) but also of what's different, may well be the heart of the matter.

I

"A Rose Is a Rose Is a Rrose Sélavy"

Stein, Duchamp, and the "Illegible" Portrait

In 1935, as Gertrude Stein recalls it, Picasso was suffering from what we might call painter's block.[1] Finding himself at an impasse in his personal life, for two years he stopped painting altogether, taking up writing instead. "He commenced to write poems," Stein remarks, "but this writing was never his writing. After all the egoism of a painter is not at all the egoism of a writer, there is nothing to say about it, it is not. No" (*Picasso*, 67). And in *Everybody's Autobiography* (1937), Stein recalls telling the great painter, who was perhaps her closest friend:

> Your poetry . . . is more offensive than just bad poetry I do not know why it is but it just is, somebody who can really do something very well when he does something else which he cannot do and in which he cannot live it is particularly repellent, now you I said to him, you never read a book in your life that was not written by a friend and then not then and you never had any feelings about any words, words annoy you more than they do anything else so how can you write you know better. . . . all right go on doing it but don't go on trying to make me tell you it is poetry.[2]

Stein's almost visceral reaction here was prompted, not just, as is often assumed, by Picasso's invasion of her territory or by her surpris-

ingly traditional insistence on the separation of the arts. The deeper reason—and we tend to forget this when we discuss the relationship of the two—is that Picasso had never so much as pretended to *read* Stein's writing. For him, Gertrude was a wonderful patron and *copain*—he loved coming to her salon and gossiping with her on a daily basis—but her writing, especially given that it was in English, a language he couldn't, after all, read, was hardly within his discourse radius. Not surprisingly, when he did take on "poetry" in the mid-1930s, his models were the then prominent French surrealists, beginning with his good friend André Breton. Here, for example, is the opening of a typical Picasso prose poem from 1935, as translated from the Spanish by Jerome Rothenberg:

> I mean a dish a cup a nest a knife a tree a frying pan a nasty spill while strolling on the sharp edge of a cornice breaking up into a thousand pieces screaming like a madwoman and lying down to sleep stark naked legs spread wide over the odor from a knife that just beheaded the wine froth and nothing bleeds from it except for lips like butterflies and asks you for no handouts for a visit to the bulls with a cicada like a feather in the wind[3]

The passage is characteristically Surrealist in its mysterious juxtaposition of seemingly unrelated images—"a tree a frying pan," a "cornice . . . screaming like a madwoman"—its emphasis on violence—"stark naked legs spread wide over the odor from a knife"—and its collocation of fanciful metaphor and simple syntax. A passionate advocate of Picasso's early Cubism, which she adapted for literary purposes in such works as *Tender Buttons* (1912), Stein could hardly have approved of the painter's Surrealist poetic mode, with its elaborate metaphors, so antithetical to her own constructions built on the repetition, with variation, of abstract nouns and indeterminate pronouns, articles, and prepositions.[4] "The surrealists," Stein remarks dismissively in her discussion of Picasso's painting of the early 1930s, "still see things as everyone sees them, they complicate them in a different way but the vision is that of everyone else, in short the complication is the

complication of the twentieth century but the vision is that of the nineteenth century" (*Picasso*, 65).

This critique of surrealism, whether just or unjust, is echoed by another of Stein's contemporaries. In describing his *Box of 1913–14* (the *Green Box*) to Pierre Cabanne, Marcel Duchamp explains that the assemblage of miscellaneous notes placed inside the box was designed as an art object "not to be 'looked at' in the aesthetic sense of the word," but as a conduit for the removal of what we might call the retinal contract that had dominated painting from Courbet to the present:

> Before, painting had other functions: it could be religious, philosophical, moral. If I had the chance to take an antiretinal attitude, it unfortunately hasn't changed much; our whole century is completely retinal, except for the Surrealists, who tried to go outside it somewhat. And still, they didn't go so far! In spite of the fact that [André] Breton says he believes in judging from a Surrealist point of view, deep down he's still really interested in painting in the retinal sense. It's absolutely ridiculous. It must change.[5]

Duchamp's critique of the *retinal* has its counterpart in Stein's writing, but the two artists have rarely been linked. For all the critical studies devoted to the relationship of Stein and the Cubists or to Stein's self-declared debt to Cézanne, what has been curiously ignored is the reverse situation: the influence, if any, of Stein's verbal composition on the visual artwork of the French contemporaries she lived among. And here Duchamp, whose move to New York in 1915 necessitated the acquisition of English, even as Stein's expatriation to Paris a decade earlier meant that her "art discourse" (especially with the Spanish painters Picasso and Gris) was to be conducted in French, is the pivotal figure.

The two first met, according to the *Autobiography of Alice B. Toklas*, in Paris in 1913:

> It was not long after this [the winter of 1913] that Mabel Dodge went to America and it was the winter of the armory show which was the

first time the general public had a chance to see any of these pictures. It was there that Marcel Duchamp's Nude Descending the Staircase was shown.

It was about this time that Picabia and Gertrude Stein met. I remember going to dinner at the Picabias' and a pleasant dinner it was, Gabrielle Picabia full of life and gaiety, Picabia dark and lively, and Marcel Duchamp looking like a young Norman crusader.

I was always perfectly able to understand the enthusiasm that Marcel Duchamp aroused in New York when he went there in the early years of the war. His brother had just died from the effect of his wounds, his other brother was still at the front and he himself was inapt for military service. He was very depressed and he went to America. Everyone loved him. So much so that it was a joke in Paris when any American arrived in Paris the first thing he said was, and how is Marcel.[6]

"The young Duchamp," she wrote a few days later to Mabel Dodge, "looks like a young Englishman and talks very urgently about the fourth dimension."[7] We know that Stein at this time was keenly interested in questions relating to mathematics and so this was a compliment.[8]

Indeed, Stein's account in *Alice B. Toklas* is unusually flattering and without her usual malice—quite unlike, say, her references to Matisse or Pound or Hemingway. The "young Norman crusader": Duchamp was the son of a notary in the little Normandy town of Blainville, a fact Stein refers to with amusement in *Everybody's Autobiography*, where she remarks how many artists—Cocteau, Bernard Faÿ, Dali—were the sons of notaries (26). Duchamp was handsome and charming. And in 1917, Stein was made aware of the brouhaha over *Fountain* (by a letter from her friend Carl Van Vechten):

This porcelain tribute was bought cold in some plumber shop (where it awaited the call to join some bath room trinity) and sent in. . . . When it was rejected [by the Salon of Independents], Marcel Duchamp at once resigned from the board. Stieglitz is exhibiting

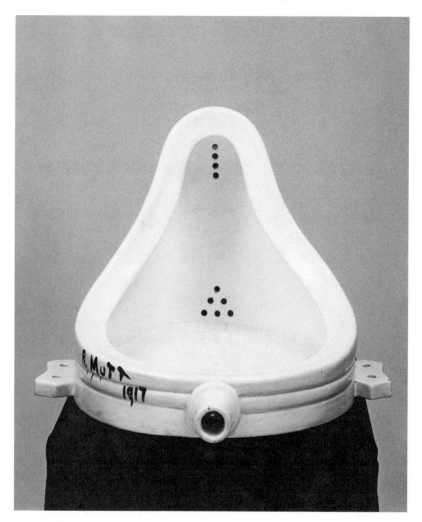

1.1 | Marcel Duchamp, *Fountain* (1917/1964). © Association Marcel Duchamp/ADAGP, Paris/Artists Rights Society, New York 2020. Third version, replicated under the direction of the artist in 1964 by the Galerie Schwarz, Milan. Glazed ceramic, 63 × 48 × 35 cm. Photograph: © CNAC/MNAM/Dist. RMN-Grand Palais/Art Resource, New York. Photography: Philippe Migeat/Christian Bahier.

the object at "291." And has made some wonderful photographs of it. The photographs make it look like anything from a Madonna to a Buddha. [See figures 1.1, 1.2][9]

Did *Fountain* and related Readymades influence Stein's writing? Yes and no. Her compositions resemble Duchamp's "objects" in their

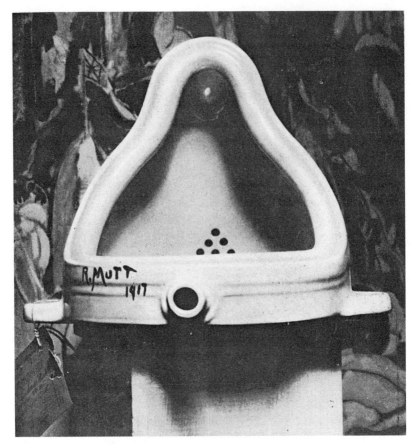

1.2 | Alfred Stieglitz, *Fountain by R. Mutt*, in *The Blind Man (No. 2) (May 1917)*. Published by Beatrice Wood in collaboration with Marcel Duchamp and Henri-Pierre Roché, edited by Marcel Duchamp and Man Ray. Periodical paper covers, 11 × 8 in. The Louise and Walter Arensberg Collection, 1950 (1950-134-1053). Photograph: The Philadelphia Museum of Art/Art Resource, New York.

wholesale rejection of the mimetic contract—a rejection that, to my mind, goes well beyond Cubist distortion and dislocation of what are, after all, still recognizable objects and bodies.[10] In this sense, Duchamp's dismissal of the "retinal" is also hers. Such prose poems as "A Substance in a Cushion" and "A Box" in *Tender Buttons*, for example, can be related to Duchamp's *Green Box* and the later *boîtes en valise* in their emphasis on what cannot be seen or inferred from the outside. More important, as different as their artistic productions were—Stein, after all, did not use "readymade" or found

text—they drew on each other's work in striking ways—ways that have largely been ignored.

The key text here is *Geography and Plays*, published in 1922. After the war, when Duchamp, having returned to Paris, called on Stein with their mutual friend Henri-Pierre Roché (the writer who had introduced Gertrude and her brother, Leo, to Picasso and was the subject of a 1909 portrait),[11] the discussion was evidently about Stein's desire to publish a collection of the shorter experimental texts—poems, prose pieces, portraits, and plays—she had been writing since 1908, for example, her masterpiece "Miss Furr and Miss Skeene."[12] Walter Arensberg and Henry McBride were enlisted, and Sherwood Anderson, newly arrived in Paris in 1921, offered to write a preface. After a number of rejections, Edmund F. Brown's Four Seas Company of Boston agreed to publish *Geography and Plays*, surely one of Stein's most seminal collections.[13]

Geography and Plays contains the well-known early portraits of Harry Phelan Webb, Constance Fletcher, Georges Braque, Carl Van Vechten ("One"), and Mrs. Whitehead; rhyming musical pieces like "Susie Asado" "Pink Melon Joy," and "Accents in Alsace"; and the plays "Ladies Voices" and "What Happened." Roughly at the center of the volume, Stein placed "Sacred Emily" (1913), a ten-page poem Duchamp is quite likely to have known, which contains the first instance of what is probably Stein's most famous line: "Rose is a rose is a rose is a rose" (187). In later appearances of her tribute to the rose as merely itself (e.g., "Do we suppose that all she knows is that a rose is a rose is a rose," in *Opera and Plays*), the noun "rose" is preceded by the indefinite article: in "Poetry and Grammar," for example, where Stein defines poetry as "concerned with using with abusing, with losing with wanting, with denying with avoiding with adoring with replacing the noun," she illustrates "noun—the name of anything"—with the comment:

When I said.
A rose is a rose is a rose is a rose.
And then later made that into a ring I made poetry

"In that line," Stein was to declare later, "the rose is red for the first time in English poetry for a hundred years."[14]

But in the opening section of "Sacred Emily" (178), "rose" is not yet "made into a ring":

> Compose compose beds.
> Wives of great men rest tranquil.
> Come go stay philip philip.
> Egg be takers.
> Parts of place nuts.
> Suppose twenty for cent.
> It is rose in hen
> Come one day

These lines, so seemingly opaque—readers and even Stein scholars have thrown up their hands and declared such passages "meaningless"[15]—begin to resonate as soon as we read them aloud. The word "compose," in line 1, made prominent by its repetition, refers both to beds to be made and to composition itself; further, it contains the word "pose," here suggesting, perhaps, the poet posing for the painter. Most important, it rhymes with "rose" in line 7 of this curiously dissonant little nursery-rhyme stanza. The oral repetition of "compose," for that matter, evokes the word "compost": fittingly, the beds are thus also flower beds containing those roses.

The imperatives "Come go stay" in line 3 create a sense of confusion—which is it to be?—even as the repetition of philip philip" sounds like a bird call or the English greeting "pip pip." Then, too, the syntax of "Wives of great men rest tranquil" suggests the French "tranquille," which rhymes nicely with the "phil" of "philip. "Egg be takers" brings to mind "egg beaters," but the "be takers" also refers literally to those that collect the eggs laid. "Parts of place nuts": the harsh *ts* sound is appropriate to the line's sexual innuendo: "nuts" is slang for testicles and "to nut" is to ejaculate. Then too, "Parts of place nuts" seems to be a misheard reference to "placements" or "place names," just as "twenty for cent" sounds like "twenty percent," but, then again, since "per" means "for," "twenty

for cent" is reasonably accurate for the price of eggs in Stein's day. All this talk of eggs and placing one's nuts, in any case, culminates in the presentation of the "rose in hen" in line 7. Stein's is hardly the proverbial "lovely rose" of poetry, but a rose in hen—a phrase relying on French syntax as in "poisson en papillote" or "boeuf en gelée." "Rose in hen" suggests that the flower belongs inside the hen—inside, that is to say, my little game hen or chicken. The resulting sexual image is reinforced by the double entendre created by the reading of *rose* as past tense verb: it (whatever "it" is here) rose, the words leading directly into the next line "Come one day" (with its echo of "come what may"). Rising, coming, placing nuts: "Sacred Emily," with its composition of beds, is a playful, erotic, and oblique love poem.

But who is "Sacred Emily"? Americans reading the title will think at once of Emily Dickinson, but Stein's Emily—Dickinson was still quite unknown in her day—is likely to be a very different one, namely Émile Zola, a sacred cow indeed in turn-of-the-century literary France. The second line, "Wives of great men rest tranquil," evidently refers to the well-known story of the great author's death, while asleep in his bed, from carbon monoxide poisoning from a blocked chimney, even as his wife, "composed" in the bed beside him, miraculously survived. Again, the sculptor of Zola's tomb (see figure 1.3) was Philippe Solari—the "philip philip" invoked in line 3.

I do not mean to suggest that "Sacred Emily" is "about" Émile Zola. Stein does not operate in this way; rather, "So great so great Emily. / Sew grate sew grate Emily" becomes the occasion for the celebration of Stein's own domestic happiness with Alice: "I love honor and obey I do love honor and obey I do." The famous sentence "Rose is a rose is a rose is a rose," which appears much later in the poem, is embedded in the following passage:

Rose is a rose is a rose is a rose.
Loveliness extreme.
Extra gaiters.
Loveliness extreme.
Sweetest ice-cream.

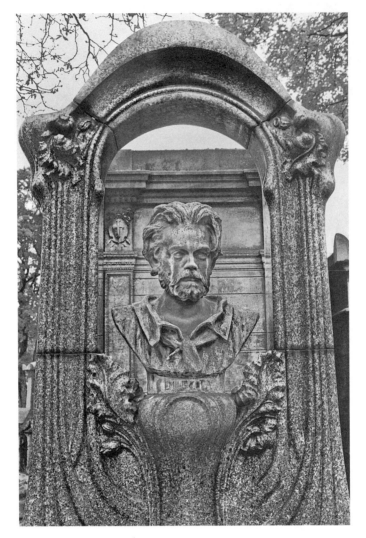

1.3 | Philippe Solari, Tomb of Émile Zola (1904), Cimetière Montmartre, Paris. Photograph by David Henry.

Page ages page ages page ages.
Wiped Wiped wire wire.
Sweeter than peaches and pears and cream.
Wiped wire wiped wire. (187)

"Loveliness extreme," with its allusion to Edmund Waller's famous "Go Lovely Rose," jostles in Dadaesque fashion with those "Extra

gaiters"—excavators? extricators?—of the beloved's "Sweetest ice-cream" (compare that other poem of 1913, "Preciosilla," which culminates in the line "Toasted Susie is my icecream"). The lines that follow introduce the elaborate repetition that, in these years, became one of Stein's signatures: "Page ages page ages page ages," where the loss of initial *p* makes all the difference and also sounds like "passages." Stein's incremental repetition takes us to the strange refrain "Wiped Wiped wire wire." Wiped and then wire? Wiped a wire? Wiped (a soft substance) versus wire (a hard one)? The scene is in any case domestic, household tasks forming the backdrop to the loving and sing-song cliché, "Sweeter than peaches and pears and cream." The address, as we know from neighboring poems, is evidently to Alice, but Gertrude does not wish to be cloying and so she returns to the harsh-sounding refrain of "Wiped wiped wire wire."

Cyrena Pondrom remarks that "Sacred Emily" "proceeds as an interplay of three extensive sets of reference—the sexual, the domestic, and the aesthetic (*G & P*, xlv). We might add the documentary, as in the line, mentioned above, "Wives of great men rest tranquil"—a reference to Zola's wife that allows Stein to celebrate her own. A rose is a rose is a rose: a rose is eros. By line 18 of its opening page, the erotic theme is distinctly audible in:

> Murmur pet murmur pet murmur.
> Push sea push sea push sea push sea push sea push sea push sea
> push sea
> Sweet and good and kind to all. (178)

And eros is the dominant motif of the entire book, coming to a kind of crescendo in "Accents in Alsace," which culminates in the passage:

> Sweeter than water or cream or ice. Sweeter than bells of roses. Sweeter than winter or summer or spring. Sweeter than pretty posies. Sweeter than anything is my queen and loving is her nature.
>
> Loving and good and delighted and best is her little King and Sire whose devotion is entire who has but one desire to express the love which is hers to inspire.

In the photograph the Rhine hardly showed

In what way do chimes remind you of singing. In what way do birds sing. In what way are forests black or white.

We saw them blue.

With for get me nots.

In the midst of our happiness we were very pleased. (415)

The image of the Rhine, that reminder of the Great War, now "hardly showed"; indeed the lovers see the forests in the black-and-white photograph as "blue" (as in a blue movie) for those equivocal "for get me nots." It is an occasion for tautological pleasure: "In the midst of our happiness we were very pleased."

"Accents in Alsace" (1919) follows a portrait that was the last piece written for inclusion in *Geography and Plays*: namely, "Next. Life and Letters of Marcel Duchamp" (405–6). Its "nextness" is not literal—"Life and Letters" is a paean not to love but to friendship—but *next* can, I think, be related to the fact that in the year of its composition, 1920, Duchamp, back in New York, had given birth to his female alter ego Rrose Sélavy, who, from then on, signed many of his personal letters and paintings and played a major role in his art-making. Asked by Calvin Tomkins why he felt the need to invent a new identity, Duchamp responded, "It was not to change my identity, but to have two identities." His first thought, he said, had been to choose a Jewish name to offset his own Catholic background. "But then the idea jumped at me, why not a female name? Much better than to change religion would be to change sex. . . . Rose was the corniest name for a girl at that time, in French, anyway. And Sélavy was a pun on *c'est la vie*."[16] Talking to Pierre Cabanne, Duchamp explains that doubling the *R* gave him a further pun on "arrose," "arroser" meaning to water, to sprinkle, and hence also to make fertile, enrich. "Sélavy," one should also note, contains the name "Levy"—as common a Jewish name as is Stein.

The iconic image of Duchamp's "Rrose" is Man Ray's famous photograph of 1920–21, signed "lovingly Rrose Sélavy alias Marcel Duchamp" (figure 1.4). In this soft-focus photograph, Rose wears a cloche hat with a brim that comes down to her eyebrows. Du-

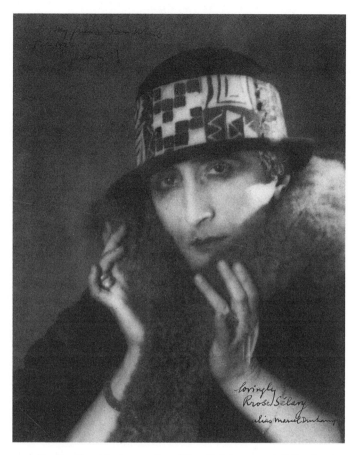

1.4 | Man Ray, *Marcel Duchamp as Rrose Sélavy*, Paris (ca. 1920–21). © Man Ray 2015 Trust/Artists Rights Society, New York/ADAGP, Paris 2021. © Association Marcel Duchamp/ ADAGP, Paris/Artists Rights Society, New York 2020. Gelatin silver print 8½ × 6¹³/₁₆ in. Signed in black ink, at lower right: lovingly / Rrose Sélavy / alias Marcel Duchamp. The Samuel S. White III and Vera White Collection, 1957. Photograph: The Philadelphia Museum of Art/ Art Resource, New York.

champ's shaved face and discreet smile, generously framed by a fur collar (a punning displacement of facial hair), invokes the illusion of a feminine presence.[17] But this Rose hardly looks like a woman: Duchamp's own masculine features are unmistakable. The ambiguity is surely intentional: the image is riddling, at once Marcel and Rose, masculine and feminine. Two further Man Ray photographs of Rrose Sélavy, this time in an even more elaborate headdress, sweeping velvet cape, and bead necklace, recalling Renaissance portraits of painters (see figure 1.5) are even more ambiguous.

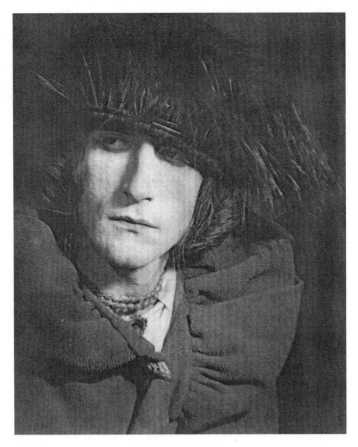

1.5 | Man Ray, *Rrose Sélavy*, New York (1921). © Man Ray 2015 Trust/Artists Rights Society, New York/ADAGP, Paris 2021. © Association Marcel Duchamp/ADAGP, Paris/Artists Rights Society, New York 2020. Gelatin silver print. Marcel Duchamp Archive, gift of Jacqueline, Paul, and Peter Matisse in memory of their mother, Alexina Duchamp. Photograph: The Philadelphia Museum of Art.

Rose's first appearance in a Duchamp artwork was in the assisted readymade *Fresh Widow* (figure 1.6), in which a miniature French window, painted an ugly blue-green like that of beach furniture, contains eight glass panes covered with sheets of black leather. The French window stands on a wooden base bearing large capital letters FRESH WIDOW COPYRIGHT ROSE SELAVY 1920. It is a brilliant aural pun, made simply by erasing the letter *N* in both words. A "fresh widow" is a recent one (here perhaps a war widow) but also "fresh" in the sense of bold, not easy to repress or squelch. What is this widow thinking? We don't know because the leather

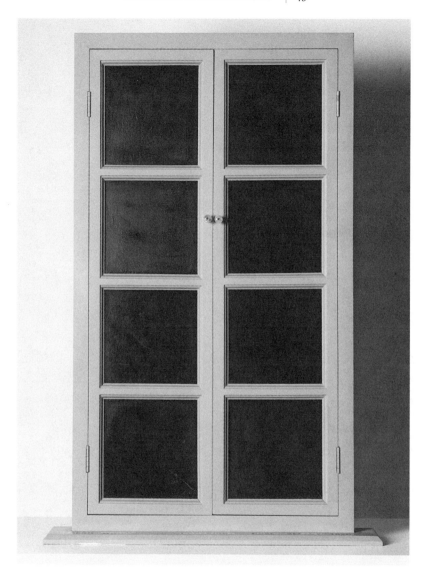

1.6 | Marcel Duchamp, *Fresh Widow* (1920/1964). © Association Marcel Duchamp/ADAGP, Paris/Artists Rights Society, New York 2020. Painted wood, leather, 79.2 × 53.2 × 10.3 cm. Photograph: © CNAC/MNAM/ Dist. RMN-Grand Palais/Art Resource, New York. Photography: Philippe Migeat.

panes are impenetrable: we can't see what's behind them. The window is also closed, but the little knobs suggest it could be opened.

Rrose next appears in *Belle Haleine, Eau de Voilette* of 1921 (figure 1.7). The title reduces the "Belle Hélène" of Offenbach's popular Paris opera to *Belle Haleine* (beautiful breath), even as the *eau*

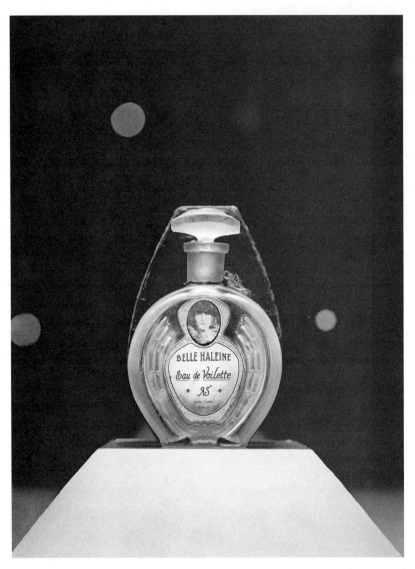

1.7 | Marcel Duchamp, *Belle Haleine, Eau de Voilette* (1921). © Association Marcel Duchamp/ADAGP, Paris/ Artists Rights Society, New York 2020. Assisted Readymade perfume bottle, with label by Duchamp and Man Ray. Bottle: 6 in., in oval box 6⁷⁄₁₆ × 4⁷⁄₁₆ in. Photograph: bpk Bildagentur/Nationalgalerie, Staatliche Museen, Berlin/Art Resource, New York.

1.8 | Marcel Duchamp, *Why Not Sneeze Rrose Sélavy?* (1921). © Association Marcel Duchamp/ADAGP, Paris/Artists Rights Society, New York 2020. Painted metal birdcage, marble cubes, porcelain dish, thermometer, and cuttlebone, 4⅞ × 8¾ × 6⅜ in. The Louise and Walter Arensberg Collection, 1950. Photograph: The Philadelphia Museum of Art/Art Resource, New York.

de voilette of the subtitle, which sounds like *eau de violette* (violet water, tincture of violet), is literally *veiled water*, a euphemism for urine, the water that must be veiled. Above the label on the little vial, we find a small oval photograph of Rose, signed "Man Ray and Rrose Sélavy"—the guardians, so to speak, of *belle haleine*.

The same year, Duchamp put together a small wire birdcage (recall "wiped wiped wire wire"), painted it white, and put inside it some 152 sugar cubes (actually marble and very heavy), an ordinary fever thermo-meter, a cuttlebone, and a little porcelain dish. The construction was named *Why Not Sneeze Rrose Sélavy?* (figure 1.8). The thermometer used to measure a girl's "heat," the phallic cuttlebone and female dish, the sugar that is really cold marble: these objects placed in the empty cage create a complex and witty spectacle of unfulfilled desire. For unlike all those erotic eighteenth-century paintings of young girls who let the bird out of the cage and watch it

fly about, this cage contains no bird and a good "sneeze" is needed to change things, to *arroser la vie. Eros c'est la vie.*

Rrose Sélavy is thus the subject of what we might call Duchamp's portrait readymades. Indeed, when Marcel returns to France for an extended stay in July 1921, he starts signing his letters to friends Rrose Sélavy, sometimes with variants like "Rose Mar-Cel" or "Rrose Marcel," "Marcel Rrose," "Marcelavy" (in a letter to Man Ray), "Selatz" or "Mar-Sélavy" (in notes to Picabia).[18] After 1925 or so, the Rrose Sélavy signature disappears, replaced by Duchamp's nicknames "Duche" and "Totor," but most frequently simply "Marcel." The punning and wordplay on gender, elaborate as it is in the early 1920s, gradually decreases in volume, although Duchamp's short book of puns, *Rrose Sélavy*, was not published until 1939. Stein's own most playfully erotic verse ("Happy happy happy all the. / Happy happy happy all the.") comes in the same period.

In *Alice B. Toklas*, Gertrude Stein recalls her first visit, soon after the war, to Man Ray's tiny studio on the Rue Delambre, where "he showed us pictures of Marcel Duchamp" (197). Man Ray was photographing Duchamp as early as 1916–17 (see figure 1.9), and Rrose Sélavy had not yet been born, but it is hard to believe that Stein would not have been aware of Rrose's presence by the time she composed her portrait of Marcel in *Geography and Plays*. Conversely, although there is no proof that Duchamp based his pseudonym Sélavy on Stein or his ambiguous Rrose on her ubiquitous roses, it is, to say the least, an astonishing coincidence that Duchamp, who never seems to have expressed a particular interest in Jewish culture, would want to adopt a Jewish surname that, like Stein's, began with an S, even as he chose as his first name the banal "Rose" that Stein had made so prominent.

The two artists, in any case, seem to have understood one another's work perfectly. Consider—to return to *Geography and Plays*—Stein's portrait "Next. Life and Letters of Marcel Duchamp":

A family likeness pleases when there is a cessation of resemblances. This is to say that points of remarkable resemblance are those which

1.9 | Man Ray, *Portrait of Marcel Duchamp* (1920–21). © Man Ray 2015 Trust/Artists Rights Society, New York/ADAGP, Paris 2021. Gelatin silver print, 9¾ × 7⅝ in. Gift of the Estate of Katherine S. Dreier (1953.6.181). Photograph: Yale University Gallery of Art.

make Henry leading. Henry leading actually smothers Emil. Emil is pointed. He does not overdo examples. He even hesitates.

But am I sensible. Am I not rather efficient in sympathy or common feeling.

I was looking to see if I could make Marcel out of it but I can't.

Not a doctor to me not a debtor to me not a d to me but a c to me a credit to me. To interlace a story with glass and with rope with color and roam.

How many people roam.

Dark people roam.

Can dark people come from the north. Are they dark then. Do they begin to be dark when they have come from there.

Any question leads away from me. Grave a boy grave.

What I do recollect is this. I collect black and white. From the standpoint of white all color is color. From the standpoint of black. Black is white. White is black. Black is black. White is black. White and black is black and white. What I recollect when I am there is that words are not birds. How easily I feel thin. Birds do not. So I replace birds with tin-foil. Silver is thin.

Life and letters of Marcel Duchamp.

Quickly return the unabridged restraint and mention letters.

My dear Fourth.

Confess to me in a quick saying. The vote is taken.

The lucky strike works well and difficultly. It rounds, it sounds round. I cannot conceal attrition. Let me think. I repeat the fullness of bread. In a way not bread. Delight me. I delight a lamb in birth. (*G & P*, 405–6)

This is one of Stein's particularly opaque portraits, and readers seem to have studiously ignored it. Indeed, Stein herself says in the third paragraph, "I was looking to see if I could make Marcel out of it but I can't," thus presumably admitting the impossibility of "portraying" her subject. Or is the portraitist merely teasing her readers, challenging us to see how she does it? The title "Next," for starters, can be understood either spatially or temporally. A can be *next* to B in a picture, or A can be next in line at the grocery store; in either case, *next* is a relational term. One cannot be next in a vacuum. Does this mean Stein is relating "Next" to the previous piece in *Geography and Plays*, "Tourty or Tourtebattre: A Story of the Great War"? Or that this composition is "next" on Stein's list? The question is left open: certainly the subtitle is parodic, for the "Life and Letters" format, so common in middlebrow portraits of the Eminent Victorians, could hardly be less appropriate for the iconoclastic Duchamp, who was anything but a Man of Letters—indeed not known

as a "writer" at all, although he did in fact engage in complex games with *letters* in every sort of punning combination. As for "Life," Stein's portrait is hardly biographical—or is it?

"A family likeness pleases when there is a cessation of resemblances." It is only when two family members *seem* to have nothing in common, Stein suggests, that the underlying family likeness emerges—and pleases. The Henry and Emil to whom Marcel is compared are almost surely Henry James, whom Stein regarded as her literary model, and, again, Émile Zola, France's great naturalistic writer. Henry "smothers" Emil, because Zola is "pointed": he has important points to make and engages in none of the subtleties ("examples") we find in James's prose. But, Stein asks herself, "am I sensible"? The common phrase "deficient in human sympathy" is inverted: this author is perhaps too efficient in "human sympathy and common feeling" to be "sensible," and so, she tells herself, "I was looking to see if I could make Marcel out of it but I can't."

This remark, it turns out, is made tongue-in-cheek because in fact Duchamp fits the paradigm of "cessation of resemblances" perfectly. Take his *In Advance of the Broken Arm*—that ordinary snow shovel hanging on a wire from the ceiling (figure 1.10). This readymade doesn't *resemble* Duchamp's bicycle wheel or bottle dryer, much less his *Large Glass*. But its family—the readymades and objects now living with it in the Arensberg Collection in Philadelphia or in any given Duchamp catalogue—all belong to the Duchamp "family" of industrial objects, given erotic overtones like *Fountain* or the *Coffee Grinder*. One cannot mistake them for anyone else's work!

Still, Duchamp's place in the poet's life remains to be assessed. "Not a doctor to me not a debtor to me not a d to me but a c to me a credit to me." Duchamp is neither her mentor nor her disciple—indeed not a "d" at all—but a "c" for "credit"—the *c* phoneme perhaps of "Sélavy," for whose existence Stein *can* take credit. And in the next sentence, she pays homage to the *Large Glass* (figure 1.11): "To interlace a story with glass and with rope with color and roam." "How many people," the portraitist asks, "roam"—that is, do something really original, roam from the conventional way of

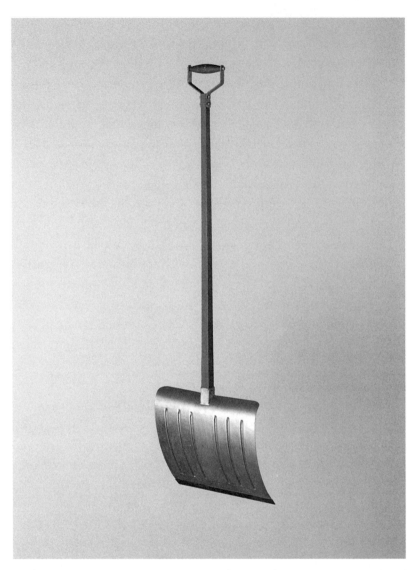

1.10 | Marcel Duchamp, *In Advance of the Broken Arm* (August 1964). © Association Marcel Duchamp/
ADAGP, Paris/Artists Rights Society, New York 2020. Fourth version, after lost original of November 1915.
Wood and galvanized-iron snow shovel, 52 in. high. Gift of The Jerry and Emily Spiegel Family Foundation.
Photograph: © The Museum of Modern Art/Licensed by SCALA/Art Resource, New York.

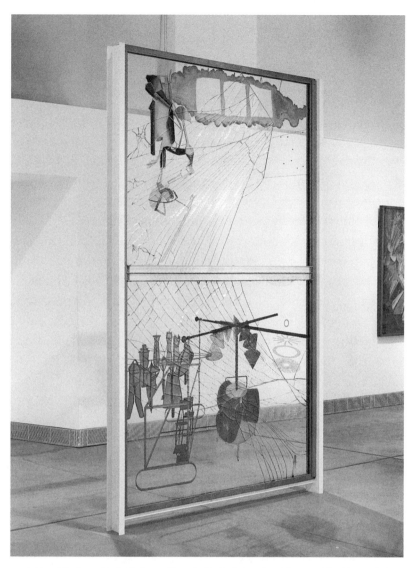

1.11 | Marcel Duchamp, *The Bride Stripped Bare by Her Bachelors, Even (The Large Glass)* (1915–23). © Association Marcel Duchamp/ADAGP, Paris/Artists Rights Society, New York 2020. Oil, varnish, lead foil, lead wire, and dust on two glass panels (cracked), each mountain between two glass panels, with five glass strips, aluminum foil and a wood-and-steel frame, 109¼ × 69¼ in. Bequest of Katherine S. Dreier, 1952. Photograph: The Philadelphia Museum of Art/Art Resource, New York.

doing things? "Dark people roam." Duchamp's great friend Francis Picabia is always described by Stein as "dark"—a reference, no doubt, to his being half Cuban. Dark people, Stein suggests, are known for their roaming—their creativity—but "can dark people come from the north," as does that "Norman crusader" Duchamp? Can this son of a Normandy notary be a significant roamer like his more exotic sidekick Picabia? The answer is yes. Duchamp, who was always traveling back and forth—between France and the US, the US and Argentina—cuts an exotic figure. By "roaming" during wartime (World War I), moreover, Marcel avoided the "grave a boy grave" of his brother Raymond, who was killed in action in 1918.

"Any question leads away from me." Stein cannot "collect" Marcel's art, which seems, at this moment in time, quite uncollectable, but she can "recollect" his chess-playing: the black and white board to be mastered. "Black is white. White is black. Black is black. White is black. White and black is black and white." Chess is also the paradigm for Marcel's art in which, like her own, "words are not birds"; they don't fly away. And a few lines further down, "The lucky strike works well and difficultly. It rounds, it sounds round." The sentence evokes not only the cigarette brand (already in use in 1917, and Duchamp was a chain smoker) but also the "difficulty" of rounding out sound.

Duchamp had by this time invented not only the wordplay of *Rrose Sélavy*, but also the elaborate verbal play of his readymade titles, which begins as early as 1915 with *l'Egouttoir I* (in English, *Bottle Dryer*)—literally, a device that takes the taste out of something (figure 1.12). The phallic bottle rack holds no bottles, having removed their "taste": it is this kind of wordplay that must have appealed to Stein, culminating as it does in the goateed and whiskered Mona Lisa, called *L.H.O.O.Q* (*Elle a chaud au cul,* figure 1.13) and those self-designations *Rrose Sélavy* and *Le Marchand du sel* (*The Salt Seller*). It is Duchamp's facility with letters, not his life ("return the unabridged restraint") that matters. Addressing Duchamp as "My dear Fourth"—no doubt because *D* for Duchamp is the fourth letter of the alphabet, but also perhaps a reference to Duchamp's interest in the fourth dimension—she delights in "the fullness of

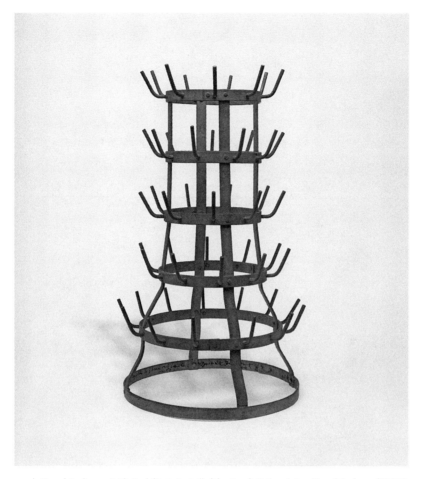

1.12 | Marcel Duchamp, *Bottle Rack (Porte-Bouteilles)* (1958–59). © Association Marcel Duchamp/ADAGP, Paris/Artists Rights Society, New York 2020. After lost original of 1915. Galvanized iron, 23¼ × 14¼ in. Through prior gifts of Mary and Leigh Block, Mr. and Mrs. Maurice E. Culberg, and Mr. and Mrs. James W. Alsdorf; Charles H. and Mary F. S. Worcester Collection Fund; through prior gift of Mary and Earle Ludgin Collection; Sheila Anne Morgenstern in memory of Dorothy O. Morgenstern and William V. Morgenstern; through prior bequests of Joseph Winterbotham and Mima de Manziarly Porter; Ada Turnbull Hertle and Modern Discretionary funds (2017.422). Photograph: The Art Institute of Chicago/Art Resource, New York.

bread," the rising or creativity also seen as "a lamb in birth." Duchamp's art, we conclude from the portrait, relates to Stein's own, to her own "life and letters."

The seemingly abstract "Next," an "infrathin" reading reveals, thus does give us a surprisingly detailed portrait of Marcel, an artist whose attack on "retinal art" was also Stein's dissolution of retinal—that is, descriptive—poetry, a poetry of visual images. In

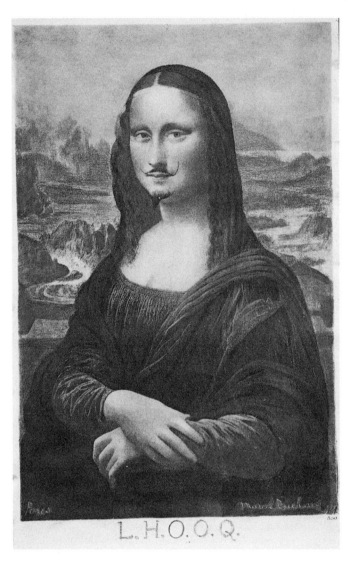

1.13 | Marcel Duchamp, *Mona Lisa (L.H.O.O.Q)*, Paris (1919). © Association Marcel Duchamp/ADAGP, Paris/Artists Rights Society, New York 2020. Rectified Readymade (reproduction of Leonardo da Vinci's *Mona Lisa*, altered with pencil), 7¾ × 4⅛ in. From Box in a Valise (Boîte-en-Valise) by Marcel Duchamp (or Rrose Sélavy). The Louise and Walter Arensberg Collection, 1950. Photograph: The Philadelphia Museum of Art/Art Resource, New York.

both cases, language is to be seen as well as heard, and one letter, or rather, phoneme, can make all the difference, as when "deficient" becomes "efficient" (Stein) or "french window" becomes *Fresh Widow*. Again, both Stein and Duchamp have a predilection for erotic double entendre, as in the "egg be takers" and "parts of place nuts" of "Sacred Emily" and in the *l'Egouttoir, Eau de voilette*, and androgynous *Fountain* of Duchamp, not to mention his alter ego Rrose Sélavy.

Stein's poetics is, in any case, much closer to Duchamp's than to Picasso's vigorous, masculinist, and still essentially *painterly* aesthetic. Consider Duchamp's playful treatment of book art and page layout. In 1922, Henry McBride, who had been close to both Stein and Duchamp for years, commissioned Marcel, who was once again living in New York, to design a book for his art essays. The resulting pamphlet (figure 1.14), was composed of eighteen cardboard sheets, held together by three rings. Its title, *Some French Moderns Says Mc-Bride*, is spelled out in twenty-seven separate file tabs attached to the right edge of the pages; when viewed from the verso, these same tabs spell out the name of the book's publisher: SOCIETÉ ANONYME INCORPORATED. The copyright holder is designated as *Rrose Sélavy*. Rrose provides her autograph, and underneath her name, we read, "for Joseph Solomon forty years later by Marcel Duchamp." Rrose-Marcel's design also affects the typography: the first essay is set in standard type, but page by page, the print gradually increases in size, until only a few words fit on the page, and then drops back suddenly on the last page to standard type. McBride's essays can hardly be read: rather, the "unreadable" text forms a backdrop for the seven photographs by Charles Sheeler that grace its orange pages.

"It's a wonderful book," Alfred Stieglitz wrote to McBride, who passed the sentiment on to Duchamp.[19] In Paris, the young Dada poet Pierre de Massot heard about the McBride project and in turn produced a book written in English called *The Wonderful Book: Réflections on Rrose Sélavy* (1924). This intriguing little pamphlet has been reproduced page for page as part of the "Dossier Pierre de Massot" assembled by Paul B. Franklin for the second issue (1999) of the seminal journal *Etant Donné*, edited by Franklin for the As-

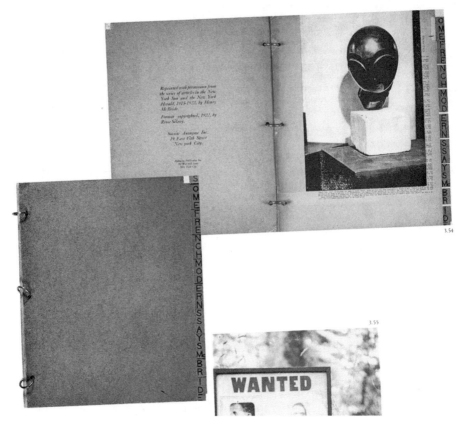

1.14 | *Some French Moderns Says McBride* (1922). Book composed of eighteen cardboard sheets and seven photographs by Charles Sheeler, held together by three rings. From Francis Naumann, *Marcel Duchamp: The Art of Making Art in the Age of Mechanical Reproduction* (New York: Harry N. Abrams, 1999), 90.

sociation pour l'Etude de Marcel Duchamp.[20] In the frontispiece, the first part of the title is dropped and *Reflections on Rrose Sélavy* is followed by an epigraph, which is none other than that revealing sentence in Stein's portrait "Next. Life and Letters of Marcel Duchamp," *"I was looking to see if I could make Marcel out of it but I can't"* ("Dossier," 101).

Why would Massot choose these words as his epigraph, thus making an explicit link between Gertrude Stein and Rrose Sélavy? The book itself turns out to be a "livre blanc": it consists of twelve blank pages, each headed by a single word designating one month of the year in sequence. But the "Introduction" by "A Woman of No

Importance"—the reference is to Oscar Wilde's 1893 play about a humble woman who learns that her son's aristocratic employer is her former lover and hence her son's father—provides a clue:

> P[ierre] de M[assot] determined . . . to write a wonderful book on MARCEL DUCHAMP. But at each attempt he was overwhelmed by the difficulty of such a task. For, I ought to explain that M has always declared he considers Duchamp the greatest genius he knows.
>
> To speak about the youth, the evolution, and especially the life of Marcel Duchamp without blundering! Might not one well hesitate? Anybody would hesitate. The thing is impossible.
>
> We know that the author of "Nu descendant l'escalier" lives on chess and love. The author of this book loves to recall a Sunday afternoon when he slept in Duchamp's room under the gaze of the King, the queen and the pawns. Black and white move on the chequerboard of life.
>
> After years of hesitation, P. de M. brought me this book. I preface it without the slightest hesitation. It is perfectly idiotic—or idiotically perfect! But since it is my duty to be sincere, I must admit, for the benefit of the reader, that this lazy, naughty little boy said to me the other evening: "Un livre agréable doit toujours être illisible."

In her portrait, Stein presents Marcel as seemingly *illisible*, unreadable: "I was looking to see if I could make Marcel out of it but I can't." She cannot, in other words, produce a coherent identity from what she knows about the artist's work: "glass and with rope with color and roam," his chess-playing, his "dark" Northern heritage. Then, too—although Stein doesn't say it—what to make of Rrose Sélavy, that "woman of no importance" who *is* Marcel? Pierre de Massot, who again refers to Duchamp's preoccupation with chess—"black and white move on the chequerboard of life"—here reinforces Stein's response to Duchamp, her perplexity mingled with "delight" born of the conviction that "The lucky strike works well and difficultly. It rounds, it sounds round" (*G & P*, 406). And Massot now spells out that aesthetic as the pleasure of unreadability—the *illisible*. Wilde's dramatic treatment of the mystery of identity,

becomes, for Stein, the recognition that human identity cannot be satisfactorily captured in words. The idea of an art that is *illisble* looks ahead, not only to the blank calendar pages of Masson's own *Wonderful Book* but to such later responses to Duchamp as John Cage's *Not Wanting to Say Anything about Marcel*. And the *illisible*, is, of course, central to our own aesthetic today, from Augusto de Campos's riff on Melville's *Moby Dick*, called *The Whale's Night Song* (1994), to Susan Howe's 2020 *Concordance*.[21]

On the back cover of *The Wonderful Book*, Massot placed a series of Rrose Sélavy's choice puns, from "Étrangler l'étranger" "Ruiner, Uriner," to "Orchidée fixe"—his pun on the *idée fixe*. These puns, Massot evidently thought, could be related to Steinian wordplay, and indeed, in his incisive preface for *Dix Portraits*, Stein's important 1930 volume, which contained her second Picasso portrait (1923),[22] Massot gives this perceptive summary of her language art:

> Everything here is weighed, released in doses, calculated, measured, deduced, just as in a mosaic; each term encloses the next, strictly, co-penetrating it, like the planes and volumes of a still life; each element is broken down with such acuity that its representation is equivalent to a new element; we are present at an abstract recreation, from the inside out, of the exterior world so that I can only call it a miracle. [My translation][23]

One of the portraits Massot probably had in mind was "Guillaume Apollinaire" (1913), which begins with the line "Give known or pin ware," a homophonic translation of the poet's name of which the author of "Orchidée fixe" and "Des bas en soie . . . la chose aussi," would surely have approved.[24]

Throughout the 1920s, when Duchamp shuttled back and forth between Paris and New York, he and Stein kept in touch, especially through their mutual friend Picabia. In December 1932, when the latter had an exhibition of his drawings at the Galerie Léonce Rosenberg in Paris, Stein was asked to contribute a preface to the catalogue. Her "Préface" turned out to be Stanza 71 of Part V of her long and difficult poetic sequence *Stanzas in Meditation*, and it was

translated by none other than Duchamp.[25] It was, we should note, the first selection from *Stanzas* to be published anywhere. Indeed, except for a few extracts, *Stanzas* was not published during Stein's lifetime.

"These austere stanzas," wrote John Ashbery, reviewing the post-humous Yale edition (1956), "are made up almost entirely of color-less connecting words such as 'where,' 'which,' 'these,' 'of,' 'not,' 'have,' 'about,' and so on, though now and then Miss Stein throws in an orange, a lilac, or an Albert to remind us that it really is the world, our world, that she has been talking about." He calls *Stanzas* "a hymn to possibility."[26] No doubt, *Stanzas* is Stein's most abstract, her least "retinal" work.

Stein's meditation begins with a fractured narrative, like a pas-sage from a childrens' book:

> There was once upon a time a place where they went from time to
> time.
> I think better of this than of that.
> They met just as they should.
> This is my could I be excited.
> And well he wished that she wished.
> All of which I know is this.
> Once often as I say yes all of it a day.
> This is not a day to be away.
> Oh dear no.

Duchamp translates this as follows:

> Il y avait une fois un endroit où ils allaient de temps en temps
> Je pense mieux de ceci que de cela
> > Ils se sont recontrés exactement comme ils devaient
>
> Lui et moi puis-je être excité
> Et alors il a désiré qu'elle desire
> Tout ce que j'en sais c'est ceci
> Une fois souvent tout cela un jour quand je dis oui

Ce n'est pas une journée à être loin
Oh! mais non[27]

The translation is, if anything, even more prominently rhyming than the original, with "fois" rhyming with "endroit" and "cela," "ceci" rhyming with "oui," and so on. Duchamp follows the original fairly closely but does make some subtle changes. For one thing, he eliminates the periods which, in Stein's poem, terminate each line, emphasizing the separateness of each phrase. Then, too, in line 4, "This is my could I be excited" gets an extra set of male/female pronouns so as to emphasize the union: "Lui et moi puis-je être excité." And in line 5, the choice of "desiré" (rather than, say, "voulu" or "souhaité") for "wished," and then the shift from the second "wished" to the present tense—"qu'elle desire"—enhances the erotic element in the stanza: it's as if Rrose Sélavy could almost make an appearance.

With the introduction to Picabia in line 17, however, comes the admonition to "forget men and women" ("oubliez hommes et femmes"), and the meditation culminates in the following passage:

The thing I wish to say is this.
It might have been.
There are two things that are different.
One and one.
And two and two.
Three and three are not in winning.
Three and three if not in winning.
I see this.
I would have liked to be the only one.
One is one.
If I am would I have liked to be the only one.
Yes just this.
If I am one I would have liked to be the only one
Which I am.
But we know that I know.
That if this has come
To be one

Of this too
This one
Not only now but how
This I know now.

<div align="right">(Stanzas, 242)</div>

In Duchamp's version:

La chose que je désire dire est ceci
Qu'aurait pu être
Il y a deux choses qui sont différentes
Un et un
Et deux et deux
Trois et trois ne sont pas en gagnant
Trois et trois si pas en gagnant
Je vois ceci
J'aurais voulu être la seule
Un et un
Si je suis aurais-je aimé être la seule
Oui rien que ceci ou exactement
Si je suis un j'aurais aimé être la seule
Que je suis
Mais nous savons que je sais
Que si ceci est venu ou celui-ci
Pour entre un
De ceci aussi
Celui-ci
Pas seulement maintenant mais comment
Ceci je sais maintenant

The French cannot quite reproduce Stein's clipped monosyllabic lines with their rhyme and paragram: "not only now but how / This I know now." But Duchamp captures the tone with "maintenant," "comment," and "Ceci je sais." The one subtle change he makes comes in the ninth line above: the revealing remark, "I would have liked to be the only one," which in English has no gender designa-

tion, becomes "J'aurais voulu être la seule." And further, in trans-
lating line 13, "If I am one I would have liked to be the only one,"
Duchamp creates an odd split, making "one" masculine ("un") but
the "only one" ("la seule") feminine: "Si je suis un j'aurais aimé être
la seule."

In her own writing, Stein never gave herself away so fully; her
pronouns usually have a studied indeterminacy.[28] But Duchamp
playfully implies that Stein is all too aware that to be "the only one"
is to be a male one—indeed, a man like Picabia—or, for that matter,
Picasso. And she adds proudly, "Which I am" ("que je suis"). She *is*
the one. It is what Stein has always wanted. "Yes just this." Here Du-
champ embellishes the line slightly, making it "Oui rien que ceci ou
exactement." Why, the extra emphasis? Perhaps because Duchamp
sympathizes with Stein's need to be *exactly* that Only One. It was a
need not felt by Rrose Sélavy, for Rrose could always shift back to
become Marcel: from his perspective, "une" could become "un" at
any time. Stein, on the other hand, was who she was: she could not
adopt another identity as readily as did Marcel; indeed, the ironic
distance so central to Duchamp's oeuvre was not her métier. Se-
rious (if also very funny) and single-minded, she understood that
"Three and three are not in winning." Three, whether in the love
triangle at the back of *Stanzas in Meditation*[29] or in her relationship
to Picabia and Picasso, was a crowd. Unlike Duchamp—and here
she may have been more like Picasso—Stein had no desire to be a
translator of someone else's work. No, she was "the only one," "This
one." "Not only now but how," she concludes, "This I know now."

Marcel, Marcelavy, le Marchand du Sel, Rrose Sélavy the Fresh
Widow, the Rose of Eros, had no such ego. Certainly, Duchamp too
wanted to be "one," to have autonomy as creator, but for the sake
of his close friend Picabia, who was getting a bad press in these
years, he was quite willing to do a quick translation of a verbal
composition whose indeterminacy and wordplay he could obvi-
ously relish. He found such tasks—as he always put it—"amusing"
(*amusant*). Especially a composition by an author as *sympathique*
as Gertrude Stein. "This I know now"; "Ceci je sais maintenant": in
their dismantling of the painterly form and the dissolution of retinal

identity, the Stein of "a rose is a rose is a rose" and Marcel-Rrose were nothing if not natural allies. Indeed, from the vantage point of the twenty-first century, it is Duchamp rather than Picasso or the Cubists, Duchamp rather, for that matter, than Apollinaire or Max Jacob, who stands "Next" to Stein.

When it appeared in the Picabia catalogue and in the fourth issue of *Orbes* (1932–33), Stein's Stanza 71 was introduced by an epigraph from Picabia: "La vie n'aime pas les verres grossissants c'est pour cela qu'elle ma tendu la main" ("Life doesn't like magnifying glasses that's why she gave me her hand"). This may well be a sly allusion to the poet Georges Hugnet's encomium to Stein in the Spring 1929 issue of *Orbes* called "Rose Is a Rose on Stein":

En Espagne, un jour, vêtue de violet et la main baguée, Gertrude Stein fut tout etonnée que dans la rue on lui baise la main.[30]

In Spain, one day, dressed in purple and rings on her fingers, Gertrude Stein was astonished that on the street, someone kissed her hand.

Then, too, *verres* puns on *vers* (verses): Stein's, it is implied, are not the bloated (*grossissants*) verses of traditional poetry, but they are indeed "magnifying" in the sense that Duchamp referred to his own *Grand Verre* as "a delay in glass as you would say a poem in prose."[31] The homage is Picabia's. But it is cited by Duchamp. "One and one. / And two and two." *Next.*

2

Eliot's Auditory Imagination

A Rehearsal for Concrete Poetry

That of which we cannot speak, we must construct.

IAN HAMILTON FINLAY[1]

Of the four poems that comprise T. S. Eliot's *Four Quartets, Little Gidding* evidently gave Eliot the most trouble (five typed drafts sent to John Hayward plus thirteen typescripts of parts or the whole poem), but it was also the poet's personal favorite. The astonishingly rich commentary, by Christopher Ricks and Jim McCue, in their recent edition of *The Poems of T. S. Eliot*, charts the difficulties and revisions at each stage of the writing process, which took place in the wartime London of 1941–42.[2]

In the decades since the publication of *Four Quartets*, much has been written on Eliot's choice of the *quartet* form for his final long poem. In what way are the four five-part poems like musical quartets? "The idea of the whole sequence emerged gradually," Eliot remarked in a letter of 1949. "I should say during the composition of *East Coker*. Certainly by the time that poem was finished I envisaged the whole work as having four parts, which gradually began to assume, perhaps only for convenience sake, a relation to the four seasons and the four elements" (*PTSE*, 1:882). And in "The Music of Poetry" (1942), Eliot notes:

The use of recurrent themes is as natural to poetry as to music. There are possibilities for verse which bear some analogy to the development of a theme by different groups of instruments: there are possibilities of transitions in a poem comparable to the different movements of a symphony or a quartet, there are possibilities of contrapuntal arrangements of subject matter. (*PTSE*, 1:894)

But he was cautious about the analogy: in a letter of 1946, Eliot insisted, "There is no suggestion that my *Four Quartets* are intended for four voices or indeed for any voice except the author's, as most lyrical poetry is. As soon as the author has a different voice in mind than his own the poem becomes to that extent dramatic. I meant simply chamber music with distinct themes and movements" (*PTSE*, 1:894). So, although Eliot later told interviewers that he "had particularly in mind the late quartets of Beethoven," and that he wanted to get into his poetry the sense of "reconciliation and relief after immense suffering" that he admired in these quartets, "there wasn't," as he told his brother Henry, "that much of a parallel" (see *PTSE*, 1:898).

Others—notably Hugh Kenner and David Moody—have suggested that the string quartets most in Eliot's mind were Bartok's nos. 2–6. Moody refers to Bartok no. 4 and cites the composer as observing, "The slow movement forms the kernel of the work. The other movements are stratified around it . . . the first and fifth movements providing the external layer, and the second and fourth, the internal layer" (*PTSE*, 1:895). Kenner, in *The Invisible Poet*, provides us with the following outline:

The first movement [of each Quartet] . . . introduces a diversity of themes; the second . . . presents first "poetically" and then with less traditional circumscription the same area of experience; the third . . . gathers up the central vision of the poem while meditating dispersedly on themes of death; the fourth is a brief lyric; the fifth a didactic and lyric culmination, concerning itself partly with language.

Numerous other formalities, resemble in function those conventions of musical structure that distinguish a quartet from an improvisation. The poems concern themselves in turn with early summer, late summer, autumn, and winter; with air, earth, water, and fire, the four elements of Heraclitus's flux. Their brief fourth movements celebrate successively the Unmoved Mover, the Redeeming Son, the Virgin, and the Holy Ghost, and each poem is named after some obscure place where the poet's personal history or that of his family makes contact with a more general past.[3]

Grover Smith goes so far as to label the five movements as allegro, andante, minuet, scherzo, and rondo.[4]

It was Helen Gardner who first called our attention to the verse form of the *Quartets*. As in the first part of *The Waste Land*, "the norm to which the verse constantly returns," she notes, "is the alliterative four-stress line, with strong medial pause, with which *Burnt Norton* opens":

Tíme présent | and tíme pást
Are bóth perhaps présent | in tíme fúture

There are, Gardner notes, variations on this pattern, ranging from three- to six-stress lines (I have found as many as eight) in the individual movements; the verse thus has extraordinary fluidity although it is also highly formalized, the four strong stresses prominently placed on key syllables. The colloquialisms and racy speech fragments of *The Waste Land* are now quite gone. Like Kenner, Gardner emphasizes the musical analogue of the verse: the first movement "contains statement and counter-statement, or two contrasted and related themes, like the first and second subjects of a movement in strict sonata form." In *Little Gidding*, which she calls "the most brilliantly musical of the four poems," "the third paragraph [of Part I] is a development of the first two, weaving together phrases taken up from both in a kind of counterpointing."[5]

Such commentary, illuminating as it is, leaves much to be

said about the poem's sound patterning. For the analysis of the five-part form of each Quartet—what we might call the poem's macrostructure—cannot account for what it is that makes the language of the *Quartets* so intensely memorable. Even the discursive movements, after all, have provided phrases that have become part of our literary vocabulary: consider, in *Little Gidding*, such striking phrases as "the parched eviscerate soil," "a familiar compound ghost," "the spirit unappeased and peregrine,"[6] "to purify the dialect of the tribe," "the conscious impotence of rage," "To summon the spectre of a Rose," and so on. For novelists and essayists, The *Four Quartets* has become a gold mine, yielding book and chapter titles.

To account for the continuing resonance of such individual phrasing in the *Four Quartets*, we must, I propose, look more fully than we have at the poem's microstructure. It is not enough to talk about the relationship of discursive to lyric sections or even to analyze the shift from alliterative line to iambic tercets, as in the "ghost" passage (Movement 2) of *Little Gidding*, with its allusion to Dantean *terza rima*. Rather, we might consider the poem's material form, the sonic and visual structure of word, syllable, morpheme, phoneme, and letter, within the individual line or section as well as the etymological wordplay at which Eliot excels. For it is not, after all, the Pentecostal theme as such or the Dantesque descent into the underworld and meeting with the composite "dead master" that makes *Little Gidding* what it is, but rather, in the poet's words:

> The common word exact without vulgarity,
> The formal word precise but not pedantic,
> The complete consort dancing together. . . .

Indeed, in Eliot's case, the choice of genre—elegy, ode, pastoral, dramatic monologue, and now quartet—or of verse form—sonnet, villanelle, canzone, *terza rima*, quatrain, free verse—is never as important or as telling as is the poet's eye and ear for the Duchampian *infrathin*—in Eliot's case, the smallest, almost subliminal differences that give a particular poetic passage its very particular

texture. "Tables," Duchamp insists, "is not the plural of table."[7] Indeed, "The infrathin separation is working at its maximum," Thierry de Duve reminds us, "when it distinguishes the same from the same."[8]

Eliot himself suggests as much. In *The Use of Poetry and the Use of Criticism* (1933), Matthew Arnold is criticized for being insufficiently sensitive to what Eliot calls the "auditory imagination," namely, "the feeling for syllable and rhythm, penetrating far below the conscious levels of thought and feeling, invigorating every word; sinking to the most primitive and forgotten, returning to the origin and bringing something back. . . . [It] fuses the old and obliterated and the trite, the current, and the new and surprising, the most ancient and the most civilized mentality."[9] "The music of a word," Eliot remarks in "The Music of Poetry" (which dates, incidentally, from 1942, the same year as *Little Gidding*), "is, so to speak, at a point of intersection: it arises from its relation first to the words immediately preceding and following it, and indefinitely to the rest of its context."[10] And that relation, as he has been at pains to say in *The Use of Poetry*, need not be fully conscious. "My theory of writing verse," he tells Stephen Spender in a letter of 1931, "is that one gets a rhythm, and a movement first, and fills it in with some approximation to sense later" (*PTSE*, 1:895).

The priority of an overarching rhythm had been there for Eliot from the beginning. Consider the famous opening of "The Love Song of J. Alfred Prufrock" (1911):

Let us go then, you and I
When the evening is spread out against the sky
Like a patient etherized upon a table;
Let us go through certain half-deserted streets,
The muttering retreats
Of restless nights in one-night cheap hotels
And sawdust restaurants with oyster shells . . .[11]

The opening line enacts Eliot's meaning both sonically and visually:[12]

Lét ûs gó thên || yóu ând Í

The falling rhythm and the stress, whether primary or secondary, on each of the seven monosyllables creates a note of torpor—the sense that, despite the talk of going somewhere, there is an inability to move—an inability further accented by the pairing of line 1, via end rhyme, with the second line, this time eleven syllables long and carrying at least six strong stresses—

Whên the évenîng is spréad oút agaínst the skŷ

the line dragging along in a catatonic torpor (note that internal rhyme of "then," "when," "against") that extends into line 3, which is even longer (twelve syllables) and markedly ungainly, what with the awkward shift from falling to rising rhythm in its third foot and its sputtering voiced and voiceless stops—*k, p, t, d, p, t*:

Líke a pátient étherízed upón a táble

These delicate adjustments are not ones that Eliot could have derived from his French master Jules Laforgue, if for no other reason than that French prosody, dependent as it is on quantity rather than stress, cannot produce such pronounced shifts in intensity and pitch.

In his introduction to the *Selected Poems of Ezra Pound* (1928), Eliot made an important comment on verse form that illuminates his own technique here and in the *Quartets*:

> People often wonder why poets do not remain content with the vocabulary and the verse forms inherited from older poets who have done well with them, and why poets insist on devising new forms which seem at first uglier or more disorderly. . . . Something is constantly happening to any living language; the changes in the world about us and in the lives we live are reflected in our speech; so that a verse form which once was natural, which once was a development of the way men talked in ordinary intercourse, can become artificial. I think that this superannuation has happened to blank verse;

that the way we talk nowadays does not fit naturally into that frame.
(*PTSE*, 1:361–62)

In "Prufrock," blank verse—indeed any iambic pentameter—
becomes no more than a shadow, a backdrop against which the
"new" *vers libre* asserts itself. But of course Eliot's verse is never
really "free": at every turn its structure is charged with meaning.
Thus In line 5, "The muttering retreats" (six syllables) literally pro-
vides an echo, as in a dark passageway, of the preceding eleven-
syllable line culminating in "half-deserted streets," an echo, inciden-
tally, visual as well as aural, the fifth line providing a short response
to its rhyming partner. And now the poem shifts ground and moves
into a parodic rhyming iambic pentameter couplet, whose domi-
nant consonants are *s* (used twelve times) and *t* (eight times), used
in the most various combinations:

> Of **réstless** níghts in óne-**nîght** chéap hotéls
> And sáwdûst **rés**tauránts with óyster **shélls**

The couplet is immediately striking, its sing-song metrical base off-
set by the repetition of those stinging *st* and *ts* phonemes, the prom-
inent repetition of "night" (with the noun changing its meaning as it
morphs into adjective) and "rest-," and the rhyming of "hotels" with
"shells." But the conjunction *restless/restaurant* is not only sonic:
the word *restaurant* (it also picks up all the phonemes of *retreats* in
the previous line) comes from the French verb *restorer*—to restore
to a former state. A restaurant was originally so named because it
was a place where food would act as restorative. Here, however, the
opposite is the case, the phrase "sawdust restaurants" reinforcing
the tone of "restless nights"—the very opposite of restoration. No
other word, then, will do: if we replaced "restless" with "uneasy"
"one-night cheap hotels" with "seedy flophouses," and "restaurant"
with "bistro" or "café," the overall meaning of the lines would be
intact but their impact would be entirely lost.

And not only aural effect but semantic density. Eliot's avant-
garde invention—an invention that went much further than the

precepts of Imagism or Futurism—was that the new poetry of the twentieth century, now composed on the typewriter to be both seen and heard, must pay attention to each and every letter, syllable, and word in a given poem. In Prufrock's impotent world, the aphrodisiac oyster is reduced to *shells* covering the "sawdust" floor, and "sawdust" sets the stage for the "soot that falls from chimneys" and the "yellow smoke that slides along the street" in the second verse paragraph. Everything in this poem relates to everything else, even as the identity of the monologue's speaker is so fluid and evasive that it spills over into the external world, denying all demarcation between self and other.

"Prufrock" is famous for the concreteness of its imagery. The more austere style of *Four Quartets* would seem to give less prominence to wordplay, pun, paragram, and intricate sound structure than the early work, but I believe the opposite is the case. In what follows, I want to look closely at the landscape passage—the composition of place (lines 1–20)—that opens Part I of *Little Gidding*.

The Voice of the Hidden Waterfall

I begin with Eliot's first notes for his fourth Quartet (ca. early 1941), as jotted down on his scribbling pad:

Winter scene. May.

Lyric. air earth water end ℘ ℘
daemonic fire. The Inferno

> *They vanish, the individuals, and*
> *our feeling for them sinks into the*
> *flame which refines. They emerge*
> *in another pattern ℘ recreated ℘*
> *reconciled*
> *redeemed, having their meaning to-*
> *gether not apart, in a union*
> *which is of beams from the central*

fire. And the others with them
contemporaneous.

Invocation to the Holy Spirit[13]

Little Gidding is Eliot's Pentecostal poem, its initial movement de-
tailing the dazzling fire reflected as the sun touches the ice of a win-
ter afternoon—an emblem of the Holy Spirit as it descended upon
the Apostles in the brief epiphany of a midwinter spring. Pentecost
represents, for Eliot, the passage of the separate individual into "a
union," a moment of "meaning to- / gether not apart." Consequently
Part I of *Little Gidding*, introduces a sudden and momentary inti-
mation of *communion,* the coming together so difficult to achieve
which will not occur until Part V of the Quartet.

Here is the twenty-line opening verse paragraph:[14]

Mîdwínter spríng | is its ówn séason
Sémpitérnal | though sódden towards súndôwn
Sûspénded in tíme, | between póle and trópic.
When the shórt dáy is bríghtest, | with fróst and fíre
The brîef sún flámes the íce | on pónd and dítches 5
In wíndless cóld | that is the héart's héat,
Reflécting ín | a wátery mírror
A gláre that is blíndness | in the éarly âfternóon.
And glów môre inténse | than bláze of bránch or brázier,
Stírs the dúmb spírit: || nô wínd, | but Pêntecóstal fíre 10
In the dárk tíme of the yéar. || Betwêen mélting and fréezing
The sôul's sáp quívers. || Thêre is nô éarth sméll
Or sméll of líving thíng. || Thís is the spríng tîme
But nót in tíme's cóvenant. || Nów the hédgerôw
Is blánched for an hóur | with tránsitôry blóssom 15
Of snów, || a blóom môre súdden
Than thát of súmmer, || nêither búdding nor fáding,
Nót in the schéme of géneration.
Whére is the súmmer, | the únimáginâble
Zéro súmmer? 20

The memorability of this passage is not a function of its radical treatment of syntax or imagery. The syntax is largely straightforward. Gone are the fractured noun phrases of *The Waste Land* or incomplete clauses of *Ash Wednesday*: the first declarative sentence is followed by adjectival modifiers (lines 1–3); a second declarative sentence is introduced by a temporal clause (line 4) and modified first by a prepositional phrase (lines 5–6) and then a participial one (7–8). And now further declarative sentences follow, the verse paragraph culminating in the direct question of lines 19–20—"Where is the summer, the unimaginable / Zero summer?"—a question which, however urgent, is syntactically still straightforward.

In the same vein, Eliot's imagery in Part I of *Little Gidding* comes unabashedly out of the English poetic tradition. Among possible sources cited by Ricks and McCue are Eliot's own *Murder in the Cathedral* ("Spring has come in winter. . . . Ice along the ditches / Mirror the sunlight"), John Donne's "Valediction Forbidding Mourning" ("And cheat the winter into spring"), and Shelley's "Triumph of Life" ("a cold glare, intenser than the noon, / But icy cold, obscured with blinding light"). Donne is also the presiding presence in line 11, which echoes his sermon at St. Paul's (13 October 1622: "Christmas . . . that dark time of the year"), and line 12, where "the soul's sap quivers" recalls Donne's "The world's whole sap is sunke" from "A Nocturnall upon St. Lucies Day" (see *PTSE*, 1:998). Ricks and McCue note that lines 13–14, "This is the spring time . . . ," recall Robert Herrick's "give the honour to this day, / that sees *December* turn'd to *May . . . the Spring-Time of the year*." The "transitory blossom . . . neither budding nor fading" of lines 15–17 may allude to Arthur Clough's "budding, unfolding, and falling, decaying and flowering ever . . . the transient blossom of Knowledge" (*PTSE*, 1:999). And so on. The governing trope—the "Midwinter spring" paradox, in any case—is firmly rooted in poetic tradition. Like our own conceptual poets today, Eliot appropriates images and metaphors, rearranging and adapting them to his own purpose.

The distinction and authority of the Quartet's opening are not then, dependent on syntactic indeterminacy, as in Pound's *Cantos*, or on the invention of striking images and concrete particulars, as

in the case, say, of Eliot's contemporary Marianne Moore or, for
that matter, in Eliot's own earlier poetry. Rather, it is the figure of
sound that takes center stage. Helen Gardner has noted the subtle
variations in the alliterative four-stress line throughout the *Quartets*,[15] but it is worth remarking further that a key passage like the
one in lines 9–10, which introduces the "Pentecostal fire" by name,
introduces secondary stressing and caesurae so that almost every
syllable is sounded:

> And **glow more** intense | than **blaze** of **branch** or **braz**ier,
> **Stirs** the **dumb spirit**: || **no wind**, but **pentecost**al **fire**

Here the clusters of sounded monosyllables culminate in flames,
and line 12, with its strong caesura and stress on six of its ten syl-
lables, forces the reader to dwell on every word:

> The **soul's sap quiv**ers. || **There** is **no earth smell**

As the passage continues, caesurae become more frequent, and the
sixteenth foreshortened line, with only seven syllables, enacts what
it describes:

> Of snów, | a bloóm môre súdden

Following this, the rhythm becomes increasingly choppy, a more
colloquial urgency created by the choriambs "**Not** in the **scheme**"
and, in the poet's pressing question, "**Where** is the **sum**mer."

But the passage's insistent rhythm is further heightened by sec-
ondary sound features—the network of phonic repetitions and
paragrams. To see what makes Eliot's verse here so distinctive, we
might begin with one of the earliest drafts, typescript M1, as repro-
duced by Gardner in *The Composition of Four Quartets* and included
by Ricks and McCue in volume 2 of *Poems*:

> Midwinter *summer* is its own season
> Sempiternal though sodden *at the day's end*

Suspended in time, between *cold and heat,*
When the short day is *lightest, ice and fire*
Windless cold that is the *soul's* heat,
The *short* sun flames the ice, on ponds and ditches
Not melting but making a watery *film*
Of light that is blindness in the early afternoon,
And *fire* more intense than that of branch, or brazier,
Warms the animated spirit: no wind, but pentecostal fire
In the dark time of the year. Between melting and freezing
The soul's sap quivers.[16]

There are no revisions for lines 11–14, and then in M5, we find the following:

Glitters for an hour with transitory blossom
Of snow, a bloom more sudden 15
Than that of summer, neither budding nor fading,
Not in the scheme of generation.
Where is the summer, the unimaginable
Summer beyond sense, the inapprehensible
Zero summer? 20

Eliot took great pains in revising these drafts. Lines 5 and 6 were soon to be reversed, but that transposition is only one of many changes. "Midwinter summer," for starters, is the more usual representation of the natural phenomenon in question—a freakishly hot day in the middle of winter—but Eliot evidently opted for spring, not only because spring is the season of Resurrection, but also because his revised line—"Midwinter spring is its own season"—with its five short **i**'s, gives him a near-anagram on the title of his poem, *Little Gidding.* The name contains 3 **i**'s, two **l**'s, two **t**'s, two **g**'s, two **d**'s, and an **n**. Line 1 spins variations on this pattern, "Midwinter spring is its own season" containing five of the same phonemes—short **i**, **d**, **g**, **t**, and **n**. And further: **spring** rhymes with **ing** in "Gidding," and **season** echoes **own**. Everything coalesces and comes together for a brief revelatory moment.

ELIOT'S AUDITORY IMAGINATION | 77

"At the day's end" (line 2) is still present in the first draft sent to John Hayward on 7 July 1941 — a draft close to the final version. The prepositional phrase is bland and wordy — Ezra Pound would probably have crossed it out — and Eliot soon revises it. Sem**pit**ernal, the archaicizing version of "always eternal," not only introduces the harsh voiceless stop (**p**) that leads to "sus**p**ended" right beneath it in the next line, but also carries on the short **i** sound of "Midwinter spring." It contains, moreover, the paragram **pit**, anticipating "the cold friction of expiring sense" and "the conscious impotence of rage" to be evoked in Part II of *Little Gidding*. The "down" of **sundown** reinforces this note. The two words "sodden" and "sundown," moreover, are linked both by stress pattern and consonance: **Sodden/sundown**: the words sound almost the same even though they are different parts of speech and have no semantic or etymological relationship. Then too "towar**ds**" gives us a visual, if not a sounded echo of the **d** and **s** of its neighbors, effecting a kind of overdetermination, as in the nonsense verse of Edward Lear, of whom Eliot was so fond.[17]

We see then that although "at the day's end" and "towards sundown" *mean* pretty much the same thing, the revision of line 2 adds an important dimension. In a similar vein, in line 3, the familiar pair of oppositional nouns "cold and heat" is replaced by "**po**le and tr**op**ic," in which the extremes of temperature, rendered more graphically than in "cold and heat," are transferred to the sound-visual level by the mirroring of **op/po**. Again, **tropic** contains the short **i**, pointing us back to line 1 of "Little Gidding."

In line 4, "lightest" is replaced by the more emphatic "brightest," and "ice and fire," again too familiar an antithetical couple — I think right away of Robert Frost's "Fire and Ice" — becomes the alliterative "frost and fire." The sun that "flames the ice, on pond and ditches" is originally "short"; in the revision, "short" is replaced by **brief**, which echoes **brightest** and the **f** of "frost and fire." And in a notable revision, line 6, "Windless cold that is the soul's heat," becomes

In wíndless **cól**d that is the **heárt's heát**

This line is especially important. The sensation of heat, Eliot decides, properly belongs, not to the disembodied soul, but to the sentient **heart**. The two heavily stressed nouns **heart** and **heat** are, after all, identical except for the single letter **r**—a post-vocal **r** that changes the preceding diphthong but is barely heard in its own right. Who ever doubted, it is implied, that the heart is, so to speak, the hot seat? "In windless cold" gives us two more short **i**'s, reminding us that it is "Midwinter spring," but also, with the switch to the **o** of **pole** and **tropic** that it is bitter **cold** at Little Gidding. The adjectives, moreover, mirror one another, the **dl** of **windless** becoming the **ld** of **cold**.

And, sure enough, the next two lines reinforce the notion of mirroring: "Reflecting in a watery mirror / A glare that is blindness in the early afternoon." In the first draft, line 7 reads, "Not melting, but making a watery film." This may well be a more accurate description of the surface of the pond, but Eliot, intentionally, I think, endowed his Pentecostal landscape with an almost surreal quality so as to convey the force with which the blinding light strikes the eye. The adjective **windless** moreover, also picks up the **i**, **l**, and **d** phonemes of *Little Gidding*. As for "Reflecting in a watery mirror," here again are four short **i**'s and a reprise of the **fl** of the "**fl**am[ing]" sun. In line 8, the "**glar**c" (a revision of the original "light") that is "blindness" is said to occur "in the early afternoon." **Early** is almost an anagram on **glare**, uniting the two hemistychs, and the **gl** here as well as in the next line, **glow**, takes us back to the key letters in the title "Little Gidding."

Line 10 begins dramatically with the strongly stressed monosyllabic word **Stirs**. In the context, "stirs" is synonymous with "moves" or "arouses," but etymologically the verb "stirs" means "disturbs" (from the German *stören*); the verb "warms" in the original draft has no such connotation. Eliot chose "stirs," I believe, because the religious experience he is describing *is* disturbing, arousing the "spirit" that is, at this point, not yet "animated," as in the first draft, but "dumb." And the alliterative link between **stirs** and **spirit**, the latter word sharing all but one of its consonants, /**p**/, with the former, creates an indelible link. The brevity of the epiphany is emphasized:

"Between melting and freezing / The soul's sap quivers." "Soul's sap" has a slightly Yeatsian ring—"Soul clap its hands and sing and louder sing," in "Sailing to Byzantium"—but **quivers** is striking for its delicacy, its reference to barely perceptible movement between freezing and fire. Given the "heart's heat," portrayed six lines earlier, the soul does not shake or tremble: it merely **quivers**, with the short **i** as well as the **er** of "Midwinter spring." The verb stands out, both because of the line's rhythmic curve—"**The sôul's sáp quívers**," with its three strong stresses and alliteration of s's—but also because it introduces something new in the form of the poem's first **qu** as well as **v**. Surely **quiver** is a key word in this poem, signaling as it does the most momentary—the most *infrathin*—of moments when a sudden visitation of the Holy Spirit is felt.

The "auditory imagination," let's recall, is defined by Eliot as "the feeling for syllable and rhythm, penetrating far below the conscious levels of thought and feeling, invigorating every word." One cannot prove that Eliot consciously chose to produce the dense verbal-sonic-visual structure I have been describing, but the drafts suggest that in fact he did revise words and phrases in the interest of sonic and visual density as well as semantic subtlety. The passage's basic meaning, after all, is not appreciably affected. At the end of the opening paragraph, for example, we come to the famous lines:

> Whére is the **súmm**er, | the **únim**áginâble
> Zéro **súmm**er?

In all typescripts except the last, the summer was defined as "beyond sense, the inapprehensible" (see *PTSE*, 1:1000). Not only is "Zero summer," on the model of "zero hour," the term designating the feared but necessary moment or "season" of truth, a late addition, but "unimaginable" is much more striking than "inapprehensible," its **u** and **m** echoing summer and thus suggesting, with further "infrathin" wordplay, that the unimaginable **zero sum** game can in fact be imagined.[18] Indeed, as the "transitory blossom" of spring snow—"a bloom more sudden / Than that of summer"—fades, the lightly accented i's of "Midwinter spring" give way to the letter **u**, so

prominent in the last five lines: **summer** used three times, is allied to **sudden, budding**, and **unimaginable**. In all these instances, **u** is phonemically a schwa ($/ə/$) and hence only lightly sounded, but visually the chiming of **u**'s creates a darker image. The "heart's heat," it would seem, has frozen into "Zero." More important: note how imperceptibly the verse paragraph has moved from "Midwinter *spring*" in the first line to "Zero *summer*" in its last, suggesting the inexorable passage of time within the very moment when time seems frozen. When the stanza breaks, the low-key literalism of the next passage — "if you came this way, / Taking the route you would be likely to take" — reminds the reader that something profound has just taken place, but that, at least for the moment, the visionary gleam — "Not," the poet has warned us, "in the scheme of generation" — has fled.

Indeed, the loss of vision is to be enacted, later in the Quartet, by the turn to abstract language, as in the ghost's "disclos[ure] of "the gifts reserved for age" in Part II — the mock–*terza rima* passage that, according to Gardner, "gave Eliot more trouble than any other."[19] But abstraction is just as subject to verbivocovisual control as is the nature imagery of Part I. Lines 137–38, for example, which, in the penultimate draft, read:

> And last, the doubt of self in retrospection
> > Of all that you have been and done . . .

become

> And last, the rending pain of re-enactment
> > Of all that you have done, and been . . .

"Self-doubting," Eliot wrote John Hayward, is "rather weak." At first he wasn't satisfied with the word "re-enactment" either, finding the composite noun "unpleasing," in its proximity to the word "enchantment" six lines earlier:

> First, the cold friction of expiring sense
> Without enchantment, offering no promise . . .

"I cannot," Eliot remarks, "find any alternative for either 'enchant-ment' or 're-enactment' which does not either lose or alter meaning. 'Re-enacting' is weak as a substantive; and I want to preserve the as-sociation of 'enact'—to take the part of oneself on a stage for oneself as the audience." As for "Of all that you have been and done," Eliot scolds himself, exclaiming, "What, whatever was I think of, to have been and done that? Read 'Of all that you have done, and been....'"[20]

Action—doing—is the embodiment of what one *is*: the phrase had to be reversed. And then the conventional "doubt of self in ret-rospection" becomes "the rending pain of re-enactment," where the prominent consonance of **rending/re-enactment** makes starkly vivid the painful humiliation of acting out, for oneself as the audience, what one has suffered. The gerund "Re-enacting," Eliot suggests, is too weak for what has to be not a temporary pro-cess but a condition, and so the *-ment* suffix is necessary even if **re-enactment** is a slightly awkward echo of **enchantment**. Every word must count—not as concrete image, as the early Pound would have had it—but with respect to semantic precision as well as mem-orability. Creating iambic pentameter is not in itself the problem— the original passage did that as well—but the figure of sound must work on the micro-level of each line. Thus "The rending pain of re-enactment," the "last" of the "gifts reserved for age," is itself a re-enactment of "**First, the cold friction of expiring sense,**" a line whose lettristic play—**first/frict/piring**—has already drawn the reader into the poet-ghost's account of palpable pain.

The Look of Flowers That Are Looked At

Eliot has never, so far as I know, been considered a precursor of Concrete poetry. Unlike Pound, whose representative *Canto* page is designed as collage, where spatial layout is central to the mean-ing and includes such visual symbols as Chinese written charac-ters, Latin and Greek citations, phonetic spelling, and commercial abbreviations such as dollar signs ($), a representative Eliot page looks normal enough, what with its justified left margins and use of capital letters at the beginning of each line.

The Eliot exception is, of course, *The Waste Land*, where typography and layout do play a large part, as in the "HURRY UP PLEASE ITS TIME" passage that concludes the "The Game of Chess" or in the climax or "The Fire Sermon," with its references to Augustine and the Buddha [*PTSE*, 1:66]:

To Carthage then I came
Burning burning burning burning
O Lord Thou pluckest me out
O Lord Thou Pluckest

Burning

But the visual-sonic design of *The Waste Land* owes much to Pound's revisions: an example is line 60, originally "Terrible city, I have sometimes seen and seen," which Pound crosses out; it is then replaced by the famously concise line "Unreal City."[21] *Four Quartets* avoids such fragmentation in favor of more traditional lyrical and discursive forms. And however widely later poets, from W. H. Auden and Louis MacNeice, to Delmore Schwartz and Robert Lowell, to Geoffrey Hill and John Ashbery, have drawn on Eliotic themes and phrasing, *Little Gidding* is generally viewed as a culmination—an ending rather than a beginning—and hence a monument to Modernism rather than a poem that looks ahead to post–World War II poetics.

Perhaps, however, the "sense of an ending" associated with the *Quartets* is the result of looking for the Eliot legacy in the wrong place. The true heirs of that legacy, even if they were not fully conscious of it themselves, were the new visually and sonically oriented poets of the postwar, including such American Objectivists as Louis Zukofsky and Lorine Niedecker, as well as Concretists, from the Scottish Ian Hamilton Finlay and the English Tom Raworth to such concretist-conceptual poets as Susan Howe and Craig Dworkin.[22] These are poets for whom the expressive first-person lyric—always the dominant poetic form—has given way to an emphasis on the poetic *how*, experimenting with sound figures, visual constellations,

paragrams, and etymologies so as to emphasize the infrathin of poetry rather than its larger themes and topoi. "I can't agree," Finlay wrote to the Austrian Concrete/Sound poet Ernst Jandl in 1994, "that just any poem defines itself as art. On the contrary, almost any Scottish poem of the present is offered to one as a comment on life, an aid, an extension, etc. . . . Hence we get inane critical remarks like: 'X has something to say' (which actual means, X's poems are crammed with jargon, about politics, hunger, Scotland, his love-life, or whatever). The notion that 'something to say' is actually a *modulation of the material* scarcely enters anyone's head." "The Concrete poets," to the contrary, and related experimental poets, Finlay adds, "regarded language itself as rhetorical."[23]

"In windless cold that is the heart's heat": suppose we take a line like this one from *Little Gidding* and take out the connective clause "that is." Such an experiment leaves us with two units—

in windless cold **the heart's heat**

—both of them highly figured, the first placing the initial "in" inside "windless" and connecting that word to "cold" via the l's of "-less cold"; the second, taking a single letter out of "heart" to produce "heat," both nouns further containing all three letters of the article "the." And further: suppose we now create visual arrangements, as in

```
    w
     i
      n
 c  o  l  d
    e  s  s
```

or

```
 t  h  e  a  r  t  s
    h  e  a  t
    h
```

CHAPTER TWO | 84

ring of waves
row of nets
string of lights
row of fish
ring of nets
row of roofs
string of fish
ring of light

2.1 | Ian Hamilton Finlay, *ring of waves* (1968). © The Estate of Ian Hamilton Finlay. From *The Blue and Brown Poems* (New York: Jargon Press, 1968). Mat: 51 × 49.5 cm., sheet 39.5 × 38 cm. Photograph: The Getty Research Institute, Los Angeles (2016.PR.36).

and it would be a short step to the Concrete poetry of Ian Hamilton Finlay himself. Consider a representative Finlay Concrete poem called *ring of waves* (figure 2.1), originally made for the 1968 series *The Blue and Brown Poems* (no doubt an oblique homage to Wittgenstein's *Blue Book* and *Brown Book*, where the "language game" is first defined), which were first published as a folio calendar by Jonathan Williams for the Jargon Press.[24] To read this little "nature" poem, seemingly so childishly reductive, in the context of the opening lines of *Little Gidding* is revealing. Eliot's vocabulary is much more complex—and also more abstract—than Finlay's, and his nature imagery is, unlike Finlay's, clearly symbolic. But just as Eliot's

"Midwinter spring is its own season" allows its short i's and st's and d's to encapsulate the look and sound of "Little Gidding," and just as "tropic" mirrors "pole" and the f of "frost and fire" points to the brief nature of the sun's flaming, so Finlay's unassuming stanza, made up of eight successive noun phrases, uses sound and visual representation to create an epiphany that recalls Eliot's "Midwinter spring."

The poem's ten monosyllabic nouns (one of them, **ring**, used three times, and four others—**row**, **nets**, **string**, and **fish**—used twice) are each modified by the prepositional phrase **of** the nouns are printed in green, the preposition in blue. The "ring of waves" is followed by a "row of nets," "a string of lights," and so on. When "ring" is preceded by the phoneme **st** to make "string" (line 3), "light" accommodates grammatically by becoming "ligh**ts**," the **st** mirrored by **ts**. But mirroring is only the beginning: what seems, in this seascape, so neatly coherent, undergoes an odd clinamen. First, one would expect the instances of "of" to form a vertical column, but **string**, having six letters, throws the pattern off. The "ring of waves" becomes the "ring of nets" and then a "ring of light," even as the "string of lights" becomes a "string of fish." But the parallelism breaks down: in line 6, where we might have expected to meet "waves" a second time—**row of waves**--we are presented, oddly, with the new noun "roofs"—**row of roofs**. Why **roofs** (note that the noun also stands out because it contains another **of** inside it) in what is otherwise a seascape? The substitution of "roofs" (no "ring" or "string" of these) suggests that despite the parallelism of Finlay's lines, the angle of vision is shifting: the moving boat, never mentioned by name, from which the items catalogued are seen, has evidently moved further out to sea, the waves now behind it. And so the harbor emerges as a **row of roofs** in the distance, with a **ring of lights** above and beyond it. The change that has occurred in the course of Finlay's little poem is both spatial and temporal. Not only is the "ring of lights" further away; the nets have been filled with "string of fish." Thus the journey out to sea has been completed: the original **ring of waves**, crossed on the outbound trip, indeed even the **row of roofs** back on the shore, merge and disappear, leaving

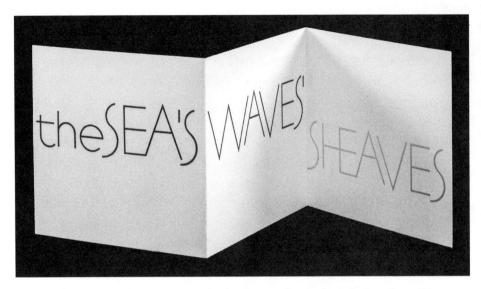

2.2 | Ian Hamilton Finlay, *The Sea's Waves* (1970). © The Estate of Ian Hamilton Finlay. From *Sheaves* (Edinburgh: Wild Hawthorn Press, 1970). Single sheet folded twice to make three panels (flat 15.2 × 34.6 cm.). Photograph: The Getty Research Institute, Los Angeles (890164).

the sailor with a vision of a **ring of light**. The harbor lights merge with the stars in what is an unforeseen epiphany. And oddly, the blue, which might have been expected to be the color of waves and water, here belongs to the colorless preposition **of**, whereas the sea and its creatures and properties are green.

Like Eliot's, Finlay's is an aesthetic of calculated *difference,* of the infrathin. Just as Eliot aligns the "windless cold" of "Midwinter spring" with the "heart's heat," with its eye rhyme, so Finlay's harbor images, lulling the reader as does the motion of waves, gives way to the more transcendent "ring of light." Not a string of **lights** as in line 3, but a singular **light**—in other words, a halo. Finlay's may thus be more of a spiritual landscape than it appears to be. Correspondences, at any rate, are crucial: look at a related poem, *The Sea's Waves* (figure 2.2), where, as in Eliot's "heart's heat," "THE SEA'S WAVES," become anagrammatically, "THE WAVES' SHEAVES." In a related stone plaque attached to a tree at Finlay's famous garden Little Sparta,[25] it morphs into "THE SEA'S NAVES" as well:

THE SEA'S WAVES

THE WAVES' SHEAVES

THE SEA'S NAVES

Here land and sea exchange places in a complex *lettriste* metaphor.

"History," we read in Part V of *Little Gidding*, "is a pattern / Of timeless moments." It was Eliot's great gift—a gift perhaps most clearly formulated in the last of his *Four Quartets*, to use the very smallest particles of language—letters, syllables, paragrams, etymological puzzles—to point the way toward a new poetry—a poetry that, already in his day, could counter the endless clichés and platitudes broadcast by the media in the age of mechanical reproducibility and later in the digital age. In 2019, the poet Craig Dworkin produced a beautiful prose poem called *The Pine-Woods Notebook*, a sequence of 306 strophes, ranging from one to four lines each, with the addendum, as in *The Waste Land*, of a few pages of footnotes.[26] Although the poem is subtitled "after Francis Ponge's *Le Carnet du Bois de pins*" (1947), Dworkin's is not, like Ponge's, a poetry of *things* (*le chosisme*); it is, rather, like Finlay's, a poetry of *words*, specifically a definition poem, presented as a list of short aphoristic definitions.

Here is the opening line (13):

The pitch of the pines on the ridgeline thickens, bewitching.

This seems, on the face of it, a fairly normal descriptive opening for a poet's meditation in a pine forest. But the intricacy of internal rhyme (*pitch/bewitch*; *pine/line*), the alliteration of hard stops (**p**, **k**) and fricatives (**tch**), the assonance of short **i**'s, as well as the tight metrical form (from iamb and anapest to trochee), call attention to musical and visual *form* rather than to what is being represented. Then, too, the meaning is equivocal: how can the "pitch" (we first think of pitch as angle) "thicken"? Are the trees sloping downward? And with "bewitch" used intransitively here, who or what is being bewitched? "Pitch," of course, also refers to the pines' blackness—

"pitch black" comes from the term for the viscous substance produced by plants (in this case, the pine bark) or formed from petroleum—which, from below the "ridgeline," is seen to "thicken."

We are, in any case, in a world of words rather than the things designated by the words in question. In strophe after strophe, *pine*, whether noun, adjective, or verb (**to pine**), is invoked, repeatedly reminding us that etymologically, **pine**, the Latin *poena*, originally referred to punishment and then came to mean the suffering inflicted as punishment. Alexander Pope, according to the *Oxford English Dictionary*, still used **pine** and **pain** interchangeably. And, for that matter, in US Southern as well as Australian pronunciation, **pain** continues to be heard as **pine**.

The play on words, in any case, continues throughout Dworkin's densely allusive meditation, culminating in the strophes:

> **The insatiable frustrates its statement's conclusion.**
> **The pitch of the pines aligns, defining: to repine: to sigh—from desire to resign.**
>
> (*Pine-Woods*, 38)

Desire, this oblique love poem suggests, is insatiable: one must resign oneself to that "defining" insight. The final line contains five rhyming words, providing a kind of echo structure, but what is also clear is that no definition can adequately convey the poet's response to the pine/pitch world he has been exploring. "To sigh—from desire to resign": it is the perennial lover's mission. And it is also the poet's mission to re-sign his text. As Dworkin himself explains his procedure:

> First, [the poem] has an exhaustive, comprehensive impulse: to find the connection between ALL the definitions of "pine" and ALL the definitions of "pitch." And so on, for other key terms.
>
> Second, it's not "expressive" in a certain, conventional way. . . . most of the words . . . had to be there because of their own logics, not my initial whim, or desire or what I "wanted to say." So there are multiple reasons for any word, usually at least three: rhyme, etymol-

ogy, homography . . . but also the conventional definition of a given term. . . . My mode throughout was the resonance of sympathetic vibration: a poetics that would echo its theme of sound. . . . It's not as if I had something to say and then found the right words, or as if I wanted to communicate some idea and then found the "poetic" way to say it . . . but rather that I was finding words and then—under their own chance constraints—seeing what THEY said. I was trying to record what the sets of sounds were constructing on their own.[27]

The resonance of sympathetic vibration: isn't this precisely what Eliot has arrived at in the final draft of Part I of *Little Gidding*? It is such resonance that characterizes Eliot's verbal creation of a sonic and visual force field, in which the "reflect[ions] in a watery mirror" that anticipate the "Zero Summer" continue to charm us with a "glow more intense than blaze of branch, or brazier." The larger form of the poem may be that of a traditional Beethoven or Bartok quartet, but its individual grace notes look ahead to the sonically and visually charged experimental poetry of our own moment.

3

Reading the Verses Backward

The Invention of Pound's Canto Page

In an early scene in James Joyce's *The Portrait of the Artist as a Young Man*, young Stephen Dedalus, a homesick schoolboy at Clongowes Wood College, is leafing through his geography textbook:

He turned to the flyleaf of the geography and read what he had written there: himself, his name, and where he was.

> *Stephen Dedalus*
> *Class of Elements*
> *Clongowes Wood College*
> *Sallins*
> *County Kildare*
> *Ireland*
> *Europe*
> *The World*
> *The Universe*

That was in his writing and Fleming one night for a cod had written on the opposite page:

> *Stephen Dedalus is my name,*
> *Ireland is my nation.*

Clongowes is my dwellingplace
And heaven my expectation.

He read the verses backward but then they were not poetry.[1]

Of course not! Because, as Stephen, like all schoolchildren of his day—indeed, like all readers before the twentieth century—was taught, poetry is written in metrical verse: in this case, the common ballad stanza using trochaic/dactylic meter and rhyming *abcb*. And so of course one cannot reverse lines, much less words, and have a proper "poem."

Today, a hundred years after the publication of *Portrait*, the situation of poetry has radically changed. Some people would claim that Stephen's own entry might be considered a poem, its lineation putting great stress on the individual words culminating in "universe." Then again there are those who would derive pleasure from turning Fleming's little jingle around, giving us, say:

expectation
my heaven
and dwelling place . . .

Rhyme is no longer a requisite for poetry and neither is any kind of fixed meter or even recurrent rhythm. More important: the look of poetry *on the page* (or the screen) has changed completely, thanks to the typewriter in the early twentieth century and the computer a few decades later.

In the Anglophone world, the poet most responsible for the prosodic revolution of twentieth-century poetry was surely Joyce's literary friend and staunch advocate, Ezra Pound. In the same year Joyce published *The Portrait of the Artist*, Pound included in his collection *Lustra* a poem called "The Coming of War: Actaeon":[2]

An image of Lethe,
and the fields

Full of faint light
> but golden,
Gray cliffs,
> and beneath them
A sea
Harsher than granite,
> unstill, never ceasing.
High forms
> with the movement of gods,
Perilous aspect;
> And one said:
"This is Actaeon."
> Actaeon of golden greaves!
> Over fair meadows
> Over the cool face of that field,
> Unstill, ever moving
> Hosts of an ancient people,
> The silent cortège.

The young Pound, who had just recently published his masterpiece *Cathay*,[3] does not yet grant us permission to "read the verses backward": In one sense, "The Coming of War: Actaeon" moves quite conventionally from a beginning to an endpoint. But the linear forward thrust is the only thing conventional about this poem. For one thing, Greek mythology, a staple of English poetry throughout the nineteenth century, is here used in a highly idiosyncratic way: the ominous vision of this Actaeon, either leading or being pursued by what seems to be a huge armed force, has little to do with the Actaeon we know from Ovid—the hapless young man who invokes the wrath of the goddess Artemis (Diana) for spying on her at her bath, and whom the vengeful goddess turns into a stag, to be pursued and dismembered by his own hounds. What connects this famous myth to Pound's Actaeon is the notion of violence—an impending violence leading to sudden and unforeseen destruction. Pound's "image of Lethe" (the river of forgetfulness) is his own in-

vention, linking Greek myth—the poem's landscape recalls the My-
cenae of Agamemnon, another of Artemis's victims—to the horrors
of World War I.

What makes "The Coming of War: Actaeon" such a remarkable
poem is less its anatomy of violence than its use of rhythm, sound
repetition, and visual layout to create a mood of irrevocable doom.
Indeed, the poem's articulation is in perfect accord with Pound's
stated poetics. In the famous manifesto "A Retrospect" (1912), he
had put forward three principles:

1. Direct treatment of the "thing" whether subjective or objective.
2. To use absolutely no word that does not contribute to the presen-
 tation.
3. As regarding rhythm: to compose in the sequence of the musical
 phrase, not in sequence of a metronome.[4]

The immediate impetus for this demand was the state of the art in
both Britain and the United States in the first decade of the twenti-
eth century, so much of it characterized by its fuzzy, vague diction,
conventional phrasing, circumlocution, clichéd metaphor, lofty
sentiment, and sing-song iambic meter. T. S. Eliot was to put it as
follows, when he recalled his beginnings three decades later:

> Whatever may have been the literary scene in America between the
> beginning of the century and the year 1914, it remains in my mind
> a complete blank. . . . I do not think it is too sweeping to say, that
> there was no poet, in either country, who could have been of use to
> a beginner in 1908. The only recourse was to poetry of another age
> and to poetry of another language.[5]

In this context, the prescriptions, further along in "A Retrospect,"
to "Use no superfluous word, no adjective which does not reveal
something," and "Don't use such an expression as 'dim lands of
peace.' It dulls the image" (LE, 4–5), were a breath of fresh air,
comparable in their force to Wordsworth's attack on Poetic Dic-
tion a century earlier. A key sentence in "A Retrospect" is "Do not

retell in mediocre verse what has already been done in good prose"
(*LE*, 5), a prescription whose corollary was the demand, already
noted, to "compose in the sequence of the musical phrase, not in
the sequence of metronome." Thirty years later, in Canto 81, Pound
would famously put it as follows: "(To break the pentameter, that
was the first heave)."[6]

All too often, that "break" has been taken to mean the shift from
meter to free verse, but Pound's verse is hardly "free" in the usual
sense of unstructured or voice-based. The English poet-critic Don-
ald Davie was one of the first to note that Pound's transformation
of English prosody had less to do with the rejection of iambic pen-
tameter as such than with his emphasis on the line itself rather
than on the stanza or strophe in which that line was embedded: "It
was only when the line was considered as the unit of composition,
as it was by Pound in *Cathay*, that there emerged the possibility of
'breaking' the line, of disrupting it from within by throwing weight
upon smaller units within the line."[7]

How does such line disruption work here? The poem's "free
verse," to begin with, is in fact highly formalized. The end-stopped
lines, with their slow, insistent falling rhythm, appropriate for a
Lethean image, are peppered with echoes of the Greek and Roman
quantitative meters Pound had absorbed in his student days—the
choriamb (/ x x /), the cretic (/ x /), the antispast (x / / x), and
especially the five-syllable Adonic foot (/ x x / x), which we meet
in the poem's very first line, after an elided and barely pronounced
"An":

(x) / x x / x
An image of Lethe

The Adonic foot can also be scanned as a dactyl (/ x x) followed by
a trochee (/ x) or spondee (/ /), but the former designation is bet-
ter because it indicates that the rhythm is perceived as constituting
a single figure.[8]

We need not name all the Classical feet involved since Pound
uses none of them systematically. Then too, bear in mind that in the

English language, stress overrides all considerations of length or pitch, and so terminology doesn't accurately transfer from Greek metrics to our own. But it is Pound's attention to length within the framework of a stress language that is worth noting. In "The Coming of War: Actaeon," the figure I referred to as the Adonic foot (/ x x / x) in "ímage of Léthe" is repeated in "Hársher than gránite" and "périlous áspect," and it occurs throughout the poem with slight variations, as in "Óver faîr meádows," where the third syllable has a secondary stress, or in "Hósts of an áncient peóple," which adds a second trochee to the five-syllable base, making for a seven-syllable unit: / x x / x / x. Falling rhythm and stressed long vowels are used throughout: line 3, for example, "Fúll of faínt líght," has three heavy stresses (on three long vowels) in four syllables, as well as alliterative f's and consonance in "faint / light." The line "únstíll, || néver ceásing"—a spondee followed by two trochees—is further lengthened by its midline caesura. Nine lines later that particular rhythmic curve is repeated in "Únstíll, || éver móving." And the repetition of "Áctaêón," with its three heavy stresses, and the anaphora of "Over" intensify the poem's ominous note. Then, too, Pound never merely repeats: "Óver faîr meádows" (five syllables, two primary stresses) is followed by an eight-syllable line with two choriambs (/ x x /), giving us four strong stresses and prominent alliteration, especially for the eye: "**Óver** the **cóol** | **fáce of** that **fiéld.**" And in what is one of the nicest details of sound structuring, the very last word of the poem, "cortège," with its open *e* and soft **g**, echoes the word "image" in line 1. **The silent cortège**: the foreshortened line, with its hissing **s** and **t**'s, is the ultimate *image* that confronts us, like fear in a handful of dust.

Pound's sound figure would thus be distinctive even if the poem's layout were conventional—a twenty-line block of print (or print block with stanzaic division after, say, line 14) with a justified left margin. But the poem's spatial design plays a central role in its configuration. "The Coming of War" and its neighboring poems in *Personae* represent a watershed in early twentieth-century poetry in that they were composed directly on the typewriter, taking advantage of its properties.[9] When we compare the poems of W. B.

Yeats (twenty years Pound's senior and his early mentor), always first written in longhand and then typed out, often by someone other than the poet, to the lyric of Pound, the difference is startling. Yeats, not surprisingly, had no use for blank verse, much less free verse:

> If I wrote of personal love or sorrow in free verse, or in any rhythm that left it unchanged, amid all its accidence, I would be full of self-contempt because of my egotism and indiscretion, and foresee the boredom of my reader. I must choose a traditional stanza, even what I alter must seem traditional.[10]

Pound was one of the first poets—Eliot was another—to understand that the typewriter offered possibilities that made the "traditional stanza," a print block surrounded by white space, seem constrictive. Indeed, the typewriter allowed for innovations that would come into their own, some seventy years later, with the advent of the digital. Typeface, font, layout, color, the insertion of visual image: our own understanding of these devices, so ubiquitous a part of word processing, is prefigured in Poundian page design.

In "The Coming of War: Actaeon," as in such related poems as "Near Perigord," visual prosody is used to mime the poet's (and reader's) process of discovery: we see things, one at a time, just as the poem's narrator comes across them.[11] The technique is film-like: first there are fields (the line is set to the right, the intervening space providing a pause while our eye adjusts to the image), next we learn that these fields are "Full of faint light." The next line, again set to the right, qualifies that perception with the observation "but golden." The observer now notes the "Gray cliffs," but what is it that is "beneath them"? We don't know until we come to line 7: "A sea." And what kind of sea? "A sea / Harsher than granite." After another pause, we learn that this sea is "unstill, never ceasing," the line moving slowly and emphatically because of its heavy stressing, caesura, and falling rhythm:

Únstíll || néver ceásing

Spacing and lineation continue to define what it is the poet sees and hears.

Who is the Actaeon now named for the first time? The next line will tell us only so much: "Actaeon of . . ." "Greaves" are the insignia of war, but the adjective "golden" has also been used to describe the "fields" of line 2, with their promise of beauty, so the noun phrase "golden greaves" (reinforced by its homonym *grieves*) is ambiguous. And now the observer steps back to give us a kind of distance shot of the scene: "**Óver fáir méadows, / Óver the cóol fáce of that fiéld** . . ." Note that by the time we reach the variant of line 9:

Únstíll || éver móving

Actaeon is no longer visible: he has been absorbed—but how?— into the crowd, the "Hosts of an ancient people, / The silent cortège." In terms of the Greek myth, he has been removed from the scene. The image is, in any case, distanced, and no longer in doubt: hence the placement of the last five lines in a columnar sequence. The hesitation and tentative observations represented by broken lineation in the poem's first half are no more: the sound of the "unstill" sea, for that matter, gives way to the ominous flow of the "silent cortège." The nameless and faceless "Hosts of an ancient people," it would seem, are on their way. There is no turning back.

"Poetry," Pound declared in the *ABC of Reading*, is "the most concentrated form of verbal expression"; it is "language charged with meaning to the utmost possible degree" and hence "News that STAYS news."[12] These formulations have become so well known that they are almost clichés, but it is worth remembering, in our politicized moment when expressive and didactic theories of poetry are once again dominant, that if poetry were not a special form of discourse, it would hardly be worth reading and writing: we have plenty of other forms of discourse that grapple with ideas, with argumentation. It is not a question of art for art's sake, but poetry is unique in being the art form that conveys its meanings, which are often highly complex, by means of intense language, soundscape, and visual design. "Dichten = condensare" (*ABC*, 36).

"The Coming of War: Actaeon" is a model of such condensation. There are no excessive adjectives, no detailed descriptions of fields, cliffs, or sea. Conversely, not a word is wasted or replaceable. The cliffs, for example, are "gray," not as a matter of painterly description, but because they reflect "A sea / Harsher than *granite*." Mirroring, semantic or visual, is central throughout but also points up differences. "Ever moving" would seem to be identical to "never ceasing," but, infrathinly, the latter, with its negative qualifier and hissing sibilants is more emphatic. Again, the line "Hósts of an áncient peóple" points back vocally to "Hígh fórms / with the móvement of gods," but the rhythm changes slightly.

Finally—and this is a key feature of Poundian poetics—note the use of the proper name *Actaeon*. I remarked above that Pound's Actaeon hardly seems to be the figure familiar from Ovid and dear to poets and painters—for example, to the Titian of *Diana and Actaeon*. As presented in Pound's poem, the character might almost be Agamemnon, setting out across the Argive plain to confront the Trojans. But like Duchamp, whom he admired and resembled in surprising ways, Pound was at heart a nominalist: he took each word, number, or material object to bear a distinct name—a name not to be confused with any other and pointing to no abstraction or universal concept outside itself.[13] Nominalism turns its back on metaphor and takes things literally. What Pound called "constatation of fact"[14] was later to be associated with Confucianism, specifically the doctrine in the *Analects* cited by Pound at the opening of *Guide to Kulchur*:

> Tseu-Lou asked: *If the Prince of Mei appointed you head of the Government, to what wd. you first set your mind?*
> Kung: *To call people and things by their names, that is by the correct denominations, to see that the terminology was exact. . . .*[15]

To call things and people by their names: in Pound's scheme of things, the Confucian "rectification of names" (*chêng ming*) should be understood less as an ordering system—Pound was not given to producing neat systems or hierarchies—than as a kind of Duns

Scotian *haecceitas*, the uniqueness or *thisness* that makes a given thing *that thing*.[16] To put it another way, the proper name is what Duchamp called an *infrathin*: it belongs to no class but its own. Pound's *Actaeon*, we have seen, is a unique figure. Phonemically, he is defined here as *one who acts*, and whose heavily stressed stately name—*Act-ae-on*—gives his actions special force. In the poem, the name chimes with the words "And one said," immediately preceding the figure's introduction.

> And one said
> Act ae on

And further, he is "Actaeon of golden greaves", whose epithet echoes the reference to the "golden" fields through which we see him move. The proper name—the only one in this poem except for the Lethe of the opening—resonates with power and mystery.

From Lyric to the Canto Mode

It is in Pound's *Cantos* that the visual poetics that was to prove so decisive for the poets of the later twentieth century becomes prominent. In the *Cantos*, a typical page will combine words and short phrases, drawn from a variety of languages and presented in a variety of fonts and sizes, arranged spatially and interspersed with numbers (often dates), quotations ranging from Dante and Cavalcanti to John Adams and Stalin, snatches of dialect, homophonic translation, phonetic spelling, abbreviations like "sd" and "cd," local slang, dollar signs and business shorthand, diagrams, distinctive proper names (both persons and places), often capitalized or italicized, and, beginning with Cantos 52–73 (1944), Chinese ideograms. The orchestration of these many devices gives the Canto page its very special look.[17]

Much has been made of what Pound himself called "the ideogrammic method,"[18] but from the first, reaction to that method has been largely hostile. I am thinking not just of conservative reviewers or New Critics like R. P. Blackmur, who dismissed the *Cantos* as

a "rag-bag,"[19] but of such notable poets as the great Mexican Modernist Octavio Paz. "Pound," Paz declared in his essay collection *The Bow and the Lyre* (1967), "accumulates quotations with the heroic air of one who robs graves." He "offers us so many and such diverse traditions because he himself has none." Indeed, the *Cantos* lack "a central tradition."[20] This critique, prompted in part by a debate with the Brazilian poet-critic Haroldo de Campos, who venerated Pound, becomes even more pointed in a related essay called "Poesía latinoamericana?" in which Paz observes:

> The method of the *Cantos* is founded on a false analogy—what Pound called presentation is really little more than juxtaposition. . . . *What do Chinese ideograms signify inside a text written in English?* There are only two possibilities: the citations demand translation which isn't ideographic, or the ideograms are magic traces, signs that have lost their power to signify. . . .
>
> [Pound's] theory is barbaric and arrogant. The barbarism and arrogance of the conquistador: Rome is no Babel.[21]

Pound a robber of graves? An arrogant conquistador? The charge could be leveled against any contemporary conceptual poet. It is true that the *Cantos* exhibit a high reliance on found text, citation, and Chinese ideograms—taken from a language Pound never mastered despite his close study of the Chinese written character. But Paz is wrong to assume the ideograms either demand translation or are mere "magic traces." They do indeed signify, though not as what Paz calls, with reference to Mallarmé, "centers of irradiation.'"[22] As in the case of Duchamp's readymades, making art (or in this case, poetry) for the Pound of the *Cantos*, depended on *choice* coupled with *context* or *framing*. In the words of the anonymous editorial written by Duchamp (under his alias Richard Mutt), published in *The Blind Man* (May 1917) in response to the rejection, by the Salon of the Independents, of a urinal submitted as *Fountain*, "Whether Mr. Mutt with his own hands made the fountain or not has no importance. He CHOSE it. He took an ordinary article of life [and] placed it so that its useful significance disappeared under the new

title and point of view."[23] One could make the same claim for the verbal-visual texture of Pound's *Cantos*.

In an important essay of 1960, Haroldo de Campos, one of Pound's greatest heirs and translators, takes his cue from Benoît Mandelbrot's theory of "informational temperature," to argue that the greater the verbal "energy" (ratio of verbal variety to total word count) in a given text, the higher its verbal temperature.[24] He begins by citing the following passage from Pound's 1936 preface to his famed edition of Ernest Fenollosa's "The Chinese Written Character as a Medium for Poetry." The reference is, paradoxically, to C. K. Ogden's *Basic English* (1929):

> Many of the nouns in the Ogden list of 850 words could very well serve as verbs, thereby giving considerably greater force to that brief vocabulary I suggest also that the limited gamut of actions included by Ogden in this essential vocabulary might be considered almost a declension of a yet briefer set of main root possibilities.[25]

Evidently, Haroldo posits, Pound is making the case for a "basic poetry," on the model of Basic English, a poetry that "has its lexical potential not as a function of a reduction in language to facilitate semantic communication but as a function of the communication of a poetic product for the accomplishment of which the basic concision is a structural principle" (*Novas*, 229). The "richness" of the *Cantos*, Haroldo suggests, is a function of its "high informational temperature," or accurately, its high "*referential temperature*," which is to say that "its richness is less due to lexical diversification than to referential complexes—to facts, events, characters, cultural contexts, implying a corresponding continuous variation and incorporation in style, from the Dantesque mode to colloquial American, from Provençal cantabile to the archaic English of *The Seafarer*" (*Novas*, 229). And he cites a 1935 letter from Pound to Ogden, declaring, tongue-in-cheek, "I propose starting a nice lively heresy, to effek, that gimme 50 more words, and I can make Basic into a real licherary and muledrivin' language, capable of blowin' Freud to hell

and gettin' a team from Soap Gulch over the Hogback. You watch old EZ do a basic Canto."[26]

By "basic," Pound does not, of course, mean the linguistic reduction of Basic English that Ogden is talking about, but, by analogy, the maximum concentration and condensation of the constellation or ideogram. As Haroldo explains it:

> This "basic Canto" is implicit in the very ideogrammatic macrostructure of *The Cantos*, where discursive language (from which Pound has not completely dissociated himself) is criticized. As the work progresses, however, along with a stylistic plurality, which aspires to monumental craftsmanship, there occurs a parallel fragmentation of discourse. The device of ideogrammatic montage invades the microstructure of the composition and—beginning with the Pisan Cantos—it can be said that the tension for the "basic Cantos" constantly shows up in details. (*Novas*, 230)

And Haroldo gives a set of examples from the *Cantos*, arguing that "the selection of a structure, the choice among 'x number of' structural possibilities of that one which best renders the particular problem of the poem," is the best way to increase the text's "negative entropy" (*Novas*, 232–33). The poetic ideogram, in other words, is not just the individual Chinese character, but what Joyce called, in *Finnegans Wake*, the *verbivocovisual* complex that includes it.

Consider Haroldo's first example (given without commentary), from Canto 79, lines 105–11 (figure 3.1):[27] In parsing this and related passages from *The Pisan Cantos*, a little background is necessary. Pound wrote the bulk of this segment (Cantos 74–84) in his prison cells (at first a cage with direct exposure to the hot sun, then an officer's tent) at the US Army's Disciplinary Training Center (DTC) north of Pisa in the spring and summer of 1945. Arrested without notice for treason at his wartime home in the hills of Sant'Ambrogio (he had been making pro-Fascist radio broadcasts for Rome Radio throughout World War II), he had managed to put in his pocket a small Chinese-English dictionary and a copy of James Legge's translation

"The price is three altars, multa."
 "paak you djeep oveh there."
 2 on 2
105 what's the name of that bastard? D'Arezzo, Gui d'Arezzo
 notation

黄

 3 on 3
 chiacchierona the yellow bird
 to rest 3 months in bottle

鳥

110 (auctor)
 by the two breasts of Tellus

止

 Bless my buttons, a staff car/
 si come avesse l'inferno in gran dispitto
 Capanaeus
115 with 6 on 3, swallow-tails
 'as from the breasts of Helen, a cup of white gold
 2 cups for three altars. Tellus γέα feconda
 "each one in the name of its god"
 mint, thyme and basilicum,
120 the young horse whinnies against the sound of the bumm band;
 to that 'gadgett,' and to the production and the slaughter
 (on both sides) in memoriam
 "Hell! don't they get a break for the whistle?"
 and if the court be not the centre of learning...
125 in short the snot of pejorocracy...
 tinsel gilded
 of fat fussy old woman
 and fat snorty old stallions
 "half dead at the top"
130 My dear William B. Y. your ½ was too moderate
 "pragmatic pig" (if goyim) will serve for 2 thirds of it
 to say nothing of the investment of funds in the Yu-en-mi
 and similar ventures
 small arms 'n' chemicals
135 whereas Mr Keith comes nearest to Donatello's
 O Lynx, my love, my lovely lynx,

■ 65

3.1 | Ezra Pound, Canto 79, *The Pisan Cantos* (1948), p. 65, lines 105–11.

of Confucius's *Four Books*. At the DTC, deprived of his books and papers and at first allowed no visitors, he had to rely on memory, and accordingly the *Pisan Cantos* are much more autobiographical than earlier or later sections of the long epic poem.

How does Pound's memory poem work? In the extract from Canto 79, line scansion is subordinate to the overall visual design of the page. The reader's eye immediately takes in "2 on 2" and "3 on 3" as well as the centrally placed Italian word "chiacchierona," followed, three lines later, by the Latin word, again centrally placed, "Tellus," both juxtaposed to the vertical column of Chinese ideograms to their right. Or again, when we hear the passage read aloud, the colloquial speech of "What's the name of that bastard" is juxtaposed to the arithmetical information ("2 on 2", "3 on 3") and the high style of "by the two breasts of Tellus."

Pound's spacing makes each word in the passage prominent. The abbreviated reference to the tenth-century music theorist Guido d'Arezzo (already invoked on the previous page of the Canto ("thus what's his name," *Pisans*, 64, l. 10), who devised the "notation" system of hexachords, developing the two-line staff into the present one of five lines — "2 on 2" and "3 on 3." The latter is juxtaposed to another "3 on 3" — three Chinese ideograms — "yellow," "bird," "rests," — on three successive lines at the right margin, the ideograms translated in the lines adjacent to them — "the yellow bird / to rest" — and the "yellow bird," in its turn, designated by its Italian epithet *chiacchierona* ("cackler"). Pound then treats us to a third instance of 3 — "to rest 3 months in bottle" — (a reference to what is, evidently in the opinion of the "auctor" (poet), modestly cited in the right-hand column of line 110, the proper way of aging wine, followed by another instance of 2 — "two breasts of Tellus," the earth goddess.[28]

The high referential temperature, in this case, depends upon the "negative entropy," whereby the numbers 2 and 3 are recycled, as are the ideograms repeated in translation. Syntactic coherence is replaced by innovative spacing: visual image, recurrent sound, and semantic reference are packed into eight lines containing thirty-three words, many of them paradoxically part of Basic English, like

"what's the name," "2," "3," "to rest," and so on. The resulting con-
stellation is a tightly woven ideogram evoking the prisoner-poet's
memory complex—a memory of happier Italian days—days of Olga
Rudge (Pound's mistress) playing tetrachords, of bird song, and of
the wines indigenous to the local earth—the "breasts of Tellus." The
three Chinese ideograms, far from being extraneous, as Octavio Paz
posited, are an integral part of the constellation, binding the hori-
zontal lines together, and emphasizing their trinity.

Or again, consider Haroldo's second example, *"Hot hole hep cat"*—
line 180 of Canto 80—reproduced here as part of figure 3.2. Three of
the four monosyllables could be items in Ogden's *Basic* English, and
the fourth is standard military lingo, as in "Hep [or 'hup'] two three
four." But *hep* also applies to the cat, evidently a hep one, seen emerg-
ing from a "hot hole" (note the sexual innuendo of hole = pussy)—
a reference to Pound's hellish outdoor prison cage, on which the sun
beat down. Two lines earlier, Pound refers to the "cat-faced eucalyp-
tus nib" (l. 178), which, we learn further down the page (l. 195), is a
talisman, hidden away in the "bacon box . . . now used as a wardrobe."
Meanwhile, in line 184, the cat reference is picked up in "Prowl-
ing night-puss," the latter being cautioned that there is no cat food
and so it had better "come here at meal time / when meat is super-
abundant," for "you can neither eat manuscript nor Confucius / nor
even the hebrew scriptures" (lines 189–90). Note that the "heb" of
"**heb**rew" echoes **hep**, tying the two words together. The abrupt ref-
erences to "manuscript," "Confucius," and "hebrew scripture" give
us a kind of shorthand picture of Pound's poetic activity at Pisa:
he is producing manuscript based on Confucius—the book Pound
managed to bring from home—and he has, like all prisoners, been
given a copy of the Bible. Manuscript—Confucius—Hebrew scrip-
ture: such juxtapositions create an ideogram that gains resonance
from its place within the larger page design in which it occurs.

Scanning the page, the reader's eye is immediately arrested
by the the juxtaposition of the italicized and spaced words
"Hot hole hep cat" with the two ideograms forming a
vertical unit at the right margin. As it happens, the ideograms are
translated in the table Pound appends to Canto 77 (*Pisan Cantos*,

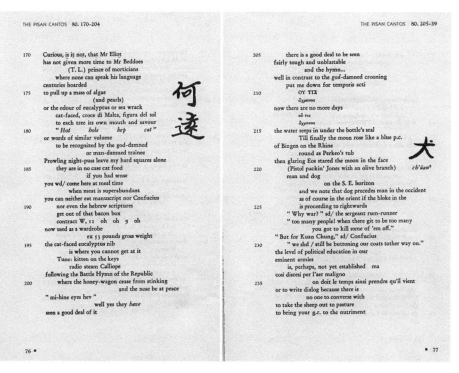

3.2 | Ezra Pound, Canto 80, *The Pisan Cantos* (1948), pp. 76–77, lines 170–239.

54): the first, transliterated as *ho*, means "how (is it)"; the second, *yuan*, means "far." In Canto 77, these ideograms are placed in the text next to line 54, "How is it far, if you think of it?" The source for this line, the *Analects* of Confucius (IX, 30), translates, so Sieburth tells us, as "The flowers of the prunus japonica deflect and turn. Do I not think of you dwelling afar? He said: It is not the thought. How can there be distance in that?" In other words, "How is it far if you think of it?" Just so, in the context of the page in question, the poet is trying to tell himself that "it"—his memory world—cannot be far if he can think of it here and relate it to his present.

Now consider the larger context. The first memory on the page is Pound's tongue-in-cheek reference to Eliot's dislike of the Romantic poets. "Mr. Eliot"—T. S. Eliot, whose *Ash Wednesday* has been alluded to on the previous page (ll. 166–69), with reference to the lines "And God said / Shall these bones live?" and who figures again in the allusion to the *Waste Land*'s line "Those are pearls that

were his eyes," from Shakespeare's *Tempest* (l. 176)—should have given "more time" to "Mr. Beddoes / (T. L.) [Thomas Love Beddoes] prince of morticians," the Romantic poet who wrote *Death's Jest Book*, seeing as the latter contains a meditation on *luz* (see l. 169 on previous page), the seed-shaped bone believed, in Hebrew scriptures, to be the only part of the body that resisted decomposition after death and hence an emblem of immortality (ll. 171–74). "Curious," the poet opines irrelevantly, that Eliot had no use for Beddoes, given that both wrote about the resurrection, after death, of bones. Chuckling to himself, the prisoner at the DTC sustains himself with these "whispers of immortality," also represented by the cat-faced eucalyptus nib, the eight-pointed Cross of Malta, and the image of the sun setting behind the trees. *How is it far if you think of it?*

But now reality intrudes in the form of the sounds evidently coming over the DTC's loudspeaker as a military drill takes place—sounds like "'*Hot hole hep cat*' / or words of similar volume / to be recognized by the god-damned / or man-damned trainee," who is, of course, the poet-prisoner himself. And the sound **cat** introduces the real cat scrounging for food and warned to "get out of that bacon box / contract W, II oh oh 9 oh / now used as a wardrobe." The inscription *W110090* is evidently the serial number on the packing box, here given a phonetic spelling and prominent spacing so as to constitute what is surely the poet's own cry—**oh oh . . . oh**—in his loneliness and misery.

Dove sta memoria—Pound's leitmotif (see, for example, Canto 76, l. 3)—refuses to let him dwell on the pain. In the last eight lines on this page, the "prowling night-puss" morphs into the "kitten on the keys"—a reference to the ragtime song by that title by Zez Confrey (1923), which leads, in its turn, to the period's "radio steam Calliope"—a comic reference to the muse of the steam organ (l. 198)—and to the opening words of the "Battle Hymn of the Republic," "My eyes have seen the glory of the coming of the Lord," here spelled phonetically to mimic the pretentious accent of Southern churchgoers. Indeed, the "Battle Hymn" is here linked to a less reverential Southern song, namely the pop tune "Way down be-

low the Mason-Dixon line / Down where the honeysuckles are en-
twined," which is parodied in the reference to the "honey-wagon,"
the vehicle used in the early twentieth century to remove refuse,
bystanders here cautioned to let "the nose be at peace" (200–201).
And, good-humoredly, the poet now follows up "mi-hine eyes hev"
with the wry comment, "well yes they *have* / seen a good deal of
it." A reminder that this narrator, referred to on the next page as
"ΟΥ ΤΙΣ" (no man)—an allusion to Odysseus's self-identification
when confronted by the Cyclops in *The Odyssey*—has been through
his share of pain and tragedy.

"*Relations*," Fenollosa remarked in "The Chinese Written Char-
acter," "*are more real and more important than the things that they
relate.*"[29] A more conventional poet would have told us something
like "I tried to distract myself, on these lonely prison days, by re-
membering my favorite poems as well as those old songs I used to
know." Pound will have nothing to do with such lyric confession:
he strenuously avoids first-person pronouns, defining his situation
in a series of seemingly unrelated image complexes. First, death
and immortality, as seen by his fellow poets from Shakespeare
to Beddoes to Eliot. Second, the cat references, in all their varia-
tion. And third, those sound and music references, ranging from
march—"*Hot hole hep cat*" to the ragtime and steam organ of
his American youth, to a Southern love song and the "Battle Hymn
of the Republic," the irony here being that this hyperpatriotic song
should be intoned by an ostensible traitor to his country, impris-
oned for treason.

On the bottom of the following page (ll. 236–37), there is men-
tion of the need "to write dialog because there is / no one to con-
verse with." Dialogue is indeed the rhetorical mode of the *Pisan
Cantos*. As Richard Sieburth points out in an interview with Al
Filreis (2007) that appears on the Ezra Pound page on Penn-
Sound,[30] Pound's poetry is unique among the Modernists in its
polyvocalism, its orchestration of many voices (of different char-
acters and time periods) and tones, here ranging from "Curious, is
not, that Mr. Eliot," to "W, II oh oh 9 oh." The narrator of

the Cantos remains "ΟΥ ΤΙΣ," *outis* (l. 211) — a man of no fortune and with a name to come. And not only *outis* but, in the word that follows it, "*achronos*," timeless — a man of no fortune taken out of time as well as out of his normal space.

Citational collage, Pound demonstrates here and throughout, can paradoxically provide a more compelling account of one's personal state of mind than can lyric utterance. One is what one remembers and thinks about, what one's consciousness makes of the images, slogans, citations, and songs that come across one's radar screen. In this, Pound's nocturne, every word, every line counts and relates backward and forward across these two pages, and, beyond those pages, across the whole Canto and into the larger sequence of the *Pisan Cantos*. The words "ΟΥ ΤΙΣ ΟΥ ΤΙΣ Odysseus," for example, are introduced on the very first page of the very first Pisan Canto (Canto 74).

The movement, backward and forward, is also sideways. Here the role of the ideogram comes in. Paz, we remember, complained that Pound's ideograms had either to be translated or to be considered mere "magical traces." But if we consider the Canto's vocovisual dimension, a third possibility emerges. The visual design of the *Cantos*, far for being a score to guide oral performance, as is usually the case in poetry, is often at odds with the poem's sound structure. In our extract from Canto 80, for example, the ideograms, visually striking as they are, remain unsounded, when the poem is read aloud, or at least this is the case in Pound's own reading. The words *Ho* (how) *yuan* (far) thus play no part at all in the poem's sound structure, whereas visually the ideogram stands out (being about four times the height of the individual letters in Pound's adjacent text), promising a special emphasis on the Canto's Confucian theme of the just ruler.

Are Pound's ideograms then merely decorative? No, because their very presence represents an alien or oppositional element in these Cantos — an element that will become much prominent (and integral) in the next two sequences: *Rock-Drill* (85–95) and *Thrones* (96–109). If we think of a given Canto page as a visual constellation, meant to be *seen* as a whole rather than read linearly, the ideograms ("silent" in an oral rendition of the poem), receive pride

of place, dominating the whole. It is as if Pound were saying that the Chinese ideograms, here derived from Confucius, provide an alternative perspective to the Western linear drive that insists on forward movement from A to B to C. The ideograms, in this scheme of things, are again *achronos*—outside of time.[31]

Other features support this achronicity. The indentation of individual lines, with phrases like "(and pearls)" set far over to the right, forces us to read line by line rather than by couplet or stanza. There is neither stanzaic unit nor metrical continuity: "to break the pentameter, that was the first heave" now becomes a reality. Proper names—Mr. Eliot, Mr. Beddoes (T. L.), Malta, Confucius, Calliope—stand out, defying the containment of a given line. And the continuous indentation enhances the Canto's departure, not only from pentameter but from lineation itself as we know it. Suppose, for example, lines 170ff were printed as follows:

Curious, is it not, that Mr. Eliot
Has not given more time to Mr. Beddoes
(T. L.) prince of morticians
where none can speak his language
centuries hoarded
to pull up a mass of algae
(and pearls)

A fixed metrical pattern, or even just the use of columnar verse, would make us look for a continuity that is vigorously denied in this "writ[ing] dialogue," which is built on deviation. Indeed, no two lines are quite alike, syntactically or with respect to spelling, typography, and abbreviation, the main feature being an element of continual surprise.

This is true at the rhythmic and phonic level as well. As in "The Coming of War: Actaeon," Pound's favorite sound figure continues to be the five-syllable rhythmic group or Adonic foot (/ x / x x), as in

prince of morticians
centuries hoarded

croce di Malta
used as a wardrobe

There are many variants on this figure, for example: an initial trochee preceding the Adonic foot, as in

wórds of símilar vólume

Or an initial dactyl followed by two trochees, as in

(nor) éven the hébrew scríptures

All of these are minor variations of what is the predominantly falling rhythm of the Cantos: almost every line ends with a kind of dying fall, as in the first six lines, which give us "Éliot," "Béddoes," "mortícians," "lánguage," "hoárded," and "álgae." The trochaic rhythmic figure is further enhanced by phonemic repetition, as in "Curious, is it not, that Mr. Eliot / has not . . ."

What further complicates this pattern is that, as with the Chinese ideograms, what you see is not necessarily what you hear. "Mr. Eliot" must be pronounced "Mister," gaining a syllable; "ex 53 pounds" becomes "ex fifty-three pounds"; "on the S. E. horizon" (l. 222) is heard as "on the South East horizon." Indeed, the tension between visual and vocal in the Canto looks ahead to such compositions as John Cage's *Roaratorio*, where the mesostic string J-A-M-E-S-J-O-Y-C-E down the middle of the page is seen but not fully heard, given the silent **e**'s, even as the accompanying sounds heard (the plashing of water, the mooing of cows) are not to be seen. And of course, Cage's music for Merce Cunningham's dance pieces is often intentionally at odds with the movements seen rather than serving as conventional musical accompaniment.

Relatedness, Pound suggests throughout *The Pisan Cantos*, is never a simple correspondence between the poem's spatial and sonic patterns, nor does Canto structure allow for narrative continuity in any conventional sense. The reader of *The Cantos*—even the most scholarly and devoted reader—can hardly be expected to

remember just where a particular line or passage comes in. And yet to scrutinize a single page as I have done here is to see that every word counts, that it has been chosen with respect to context, as in the case of "hebrew scriptures" or "kitten on the keys." As one moves outward from a specific page to its larger context, the pattern reappears, though always with variation, the individual item repeatedly finding echoes, sooner and later, in what is Pound's spatial structure. The Stephen Dedalus of Joyce's *Portrait* could indeed read these verses backward and find them "charged with meaning." For Pound's individual items, from the "mass of algae" to the striking Chinese ideograms in the margins, have their place in a verbal-visual-sonic construct where every word counts.

Afterlife

"We can hardly distinguish," wrote Hugh Kenner in *The Pound Era*, "what Pound instigated from what he simply saw before it was obvious. He is very likely, in ways controversy still hides, the contemporary of our grandchildren."[32] And Guy Davenport, in his obituary essay for Pound in 1972: "Every school of poets writing in English was under his influence. . . . The power of his instigation has not flagged."[33]

The epithet "the contemporary of our grandchildren"[34] has turned out to be more accurate than Kenner could have realized. For although Pound's "children"—from the William Carlos Williams of *Paterson* to the Louis Zukofsky of *"A"* and the Charles Olson of *The Maximus Poems*—did write their long poems under the sign of Pound, adapting his use of collage, his eclectic free verse, and his incorporation of citation and even pictogram into their texts, when I open these books today, I am struck by how much more conservative than the Canto model these long poems are. The rapid-fire cuts of the *Cantos*, the continuous shift in register from one language to another, from high style to dialect, and so on, is not really duplicated, and neither is the use of Classical metrical figures interrupted by speech rhythms, the spatialization of the narrative, or the invocation of proper names and ideograms within shifting contexts.

On first Looking out through Juan de la Cosa's Eyes

> Behaim—and nothing
> insula Azores to
> Cipangu (Candyn
> somewhere also there where spices
>
> and yes, in the Atlantic,
> one floating island de
> Sant
> brand
> an

1

St Malo, however
Or Biscay Or Bristol.
Fishermen, had,
for how long,
talked
 Heavy sea,
snow, hail. At 8
AM a tide rip. Sounded.
Had 20 fath. decreased from that to
15, 10. Wore ship.

 (They knew
Cap Raz

(As men, my town, my two towns
talk, talked of Gades, talk
of Cash's

drew, on a table, in spelt,
with a finger, in beer, a
portulans

3.3 | Charles Olson, "On first Looking out through Juan de la Cosa's Eyes," *Selected Poems* (1960), p. 253.

Take, for example, Charles Olson's "On first Looking out through Juan de la Cosa's Eyes" (figure 3.3), one of the *Maximus Poems* quite obviously written under the sign of Pound. The poem is a meditation prompted by a late fifteenth-century map of the European world, evidently the first ever produced that incorporated the Americas, made by the great Castilian navigator-cartographer Juan de la Cosa. Unlike earlier voyages to the East Asian spice islands, De la Cosa's Western journeys, documented on his map, took him across the treacherous Atlantic, from the Bay of Biscay past islands

like St. Malo, to the New World. Local Gloucester fishermen, the poet recalls, are still given to swapping stories over a beer, for instance, about a particularly bad storm at sea near Cap Raz on the Brittany coast. In the rest of the poem, the early days of Gloucester, the shipbuilding town, are further commemorated. Indeed, Olson's is intended as a kind of history canto on the Pound model. And the visual design of his opening page recalls Pound, what with its short irregular units of verse and indented dropped lines, like "Sant / brand / an." Poundian too are the colloquial locutions ("As men, my town, my two towns talk"), the documentary citations ("At 8 / AM a tide rip"), and the abbreviation of "fathom" as "fath."

The difficulty is that in Olson's poem the *"relations,"* to come back to the Fenollosa–de Campos precept, do not seem to be more important than the things they relate, and *choice*—Pound's great principle—is not always inspired. Take the name "Behaim" in line 1— a reference to another fifteenth-century navigator-cartographer, Martin von Behaim. The proper name, dropped in line 1, has no integral role to play in the poem, whether semantically, sonically, or visually. Indeed, on Olson's page, neither lineation nor sound structure seem to exhibit any sort of relation or inner necessity: why, for example, does "de / Sant / Brand / an" (Saint Brendan's Island, off the coast of Ireland) get the elaborate four-step lineation Olson gives it when St. Malo and later Cap Raz and Gades (Cadiz) do not? Or again, suppose I shifted the passage beginning with "Heavy sea" to read

> Heavy sea,
> snow, hail. At 8 AM
> a tide rip. Sounded. Had
> 20 fath. decreased from
> that to 15, 20. Wore ship.

Would anyone notice the difference? The tension between fixed rhythmic figures and spatial variation, so notable in Canto 80,

doesn't exist here. The verse is literally free, and that is the prob-
lem. In his famous "Projective Verse" essay, Olson talks a great deal
about "the smallest particle of all, the syllable," as, together with the
line, "the king and pin of versification," and he insists that "the line
comes (I swear it) from the breath, from the breathing of the man
who writes, at the moment that he writes."[35] But breath is at best
an arbitrary unit of composition, and the "free" verse it generates is
thus just that—free. Olson does introduce the valuable concept of
"composition by field," but field composition requires some formal
principle, whether of the recurrent metrical groupings, as in *The
Cantos*, or some other form of repeat with variation. In the Juan de
la Cosa poem, the "freedom" of the verse goes hand in hand with
the mere addition of images and references, none of them reflexive
enough to create much density. Images and incidents, moreover, all
belong to a single radius of discourse: the cartographic story, in its
revelations as to the dangerous and exotic voyages to the Americas
in the Age of Discovery.

For the Poundian afterlife, then, we need to look elsewhere: in
the work, for example, of such American "grandchildren" as the Su-
san Howe of *The Non-Comformist's Memorial* or the Charles Bern-
stein of "Lives of the Toll Takers." Or, when we look beyond the US
to the greater Americas, whose cause Olson pleads in his poetry,
there is the astonishing case of the Brazilian Concrete poets, espe-
cially Augusto de Campos, whose later work is still going strong at
this writing.

Concrete poetry has often been misunderstood. In the origi-
nal Pilot Plan for *Noigandres* 4 (São Paulo, 1958), the de Campos
brothers (Augusto and Haroldo, with Décio Pignatari) declared:

Concrete poetry begins by being aware of graphic space as struc-
tural agent. Qualified space: space-time structure instead of mere
linear-temporal development. Hence the importance of the ideo-
gram concept, either in its general sense of spatial or visual syntax or
in the specific sense (Fenollosa/Pound) as a method of composition
based on direct—analogical, not logical-discursive—juxtaposition
of elements.[36]

This sounds for all the world like a description of Pound's *Cantos*: the "space-time structure" rather than a linear-temporal one, the use of ideogram, the "analogical" method of proceeding, the Cubist rather than "logical-discursive" juxtaposition of elements. As forerunners, the manifesto cites Mallarmé's *Un coup de dés* ("typographical devices as substantive elements of composition"), Joyce's *Ulysses* and *Finnegans Wake*, Apollinaire's *Calligrammes*, and e. e. cummings's "atomization of words," as well as two major Brazilian precursors—Oswald de Andrade and João Cabral de Melo Neto. But my own impression, judging from the previously cited paragraph, is that it is Pound's "ideogrammic method"—the "tension of word-things in space-time" (Pilot, 218) that is the heart of the matter. "The concrete poem," the authors go on to say, "is an object in and of itself, not the interpreter of exterior objects and/or more or less subjective feelings. Its material: word (sound, visual form, semantic charge). . . . The concrete poem, using phonetics (digits) and analogical syntax, creates a specific linguistic area— *verbivocovisual*" (Pilot, 218).

The somewhat misleading descriptor here is "object in and of itself," which has led readers to assume that Concrete poetry has no political or ethical concerns. But all the poets really meant, I think, is that Concrete poetry rejects the notion that poetry is representational, a mimesis of some external reality, or that it can communicate the poet's "true" feelings. The Pilot Plan, in any case, reprinted again and again, as, for example, in Mary Ellen Solt's first major anthology, *Concrete Poetry* (1970), needs some qualification: Haroldo de Campos himself adds an important note in an essay called "The Ghost in the Text (Saussure and the Anagrams)."[37]

Drawing on the recently published notebooks of Ferdinand de Saussure, which take up the question of the anagrammatic character of language, Haroldo discusses the importance of the pun, the paragram (the figure that "inserts a simple name into the complex array of syllables into a poetic line; its function will be to recognize and reassemble its leading syllables," *Novas*, 280), and other forms of wordplay that intensify the semantic charge of a given phrase or word group. All such devices further the "programmatic

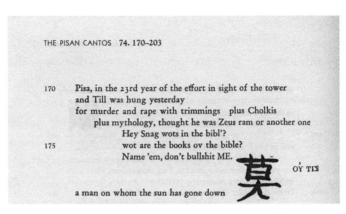

THE PISAN CANTOS 74. 170–203

170 Pisa, in the 23rd year of the effort in sight of the tower
 and Till was hung yesterday
 for murder and rape with trimmings plus Cholkis
 plus mythology, thought he was Zeus ram or another one
 Hey Snag wots in the bibl'?
175 wot are the books ov the bible?
 Name 'em, don't bullshit ME. OΫ TIΣ

 a man on whom the sun has gone down

3.4 | Ezra Pound, Canto 74, *The Pisan Cantos* (1948), pp. 8–9, lines 170–78.

denial of the dogma of linearity" in a given passage. In Augusto de
Campos's "Lygia Fingers," for example, there is "a true, gradual
anagrammatization of the theme-name, running through the en-
tire piece, with all of its complete or partial phonemes redistributed
through other words (*digital, linx, felyna, figlia*, etc.), which them-
selves function as metonymic or metaphoric emblems of femininity
and its attributes."[38]

What Haroldo de Campos is implying here is that Concrete po-
etry, often accused of having no possible political or ethical dimen-
sion, indeed of being merely decorative, can use its phonic and vi-
sual material precisely to create semantic depth. Concrete poetry
can thus be understood as the logical outcome of what we have seen
to be Poundian practice: "Dichten = condensare."

Consider, in conclusion, a passage from Canto 74 (*Pisan Cantos*,
8, ll. 170–76), about an African-American fellow prisoner at the
Pisa DTC named Till (figure 3.4). By sheer coincidence, this Louis
Till was, so Richard Sieburth's note tells us, the father of the now
famous Emmet Till, "whose cold-blooded murder at age fourteen
by two white men in Mississippi in 1955 sparked the Civil Rights
Movement in the South" (*Pisan Cantos*, 122). Pound could not, of
course, have known this when he composed these lines in 1945: we
know the date from the first line of the extract, which refers to the
Italian Fascist calendar, in which all events were dated from Mus-
solini's March on Rome in 1922.

Till, we learn from the matter-of-fact reference in lines 171–72, "was hung yesterday / for murder and rape with trimmings." The accused man's violence is compared to that of Zeus's fire-eating, golden-headed ram at Colchis who tried to defy Jason's plunder of his Golden Fleece. But Pound had evidently been on friendly terms with Till, who is here depicted quizzing the poet about the books of the Bible — "Name 'em, don't bullshit ME." Thus we find the poet mourning for this "no man" — the Chinese ideogram depicts the figure of a man on whom the giant sun presses down — again the "ΟΥ ΤΙΣ" of Homer — whom we meet throughout the *Pisan Cantos* — "a man on whom the sun has gone down."

Or does the Chinese ideogram, coupled with the Greek epithet, refer to the poet himself? The answer, of course, is that it refers to both. Narrator and character merge in a spatial construct that telescopes at least seven different time periods: the ancient world of Greek mythology, the age of Homer who recorded its tales, the Old Testament period, the ideogram making of the Chinese fifth century, the weeks of daily banter between Pound and Till, the immediate past (yesterday) of the execution, and the present of the opening line, when the poet is writing what we read. The whole is dominated by the prominent and beautiful black ideogram, emphasizing the fate of the "man on whom the sun has gone down," whether that man is Till or the poet. Given the impossibility of distinguishing between the two, the reader is forced to wonder whether and when the poet himself might expect to face execution.

It was in the work of the Brazilian Concrete poets from mid-century to the present that the condensation and "high temperature" of the Poundian Canto complex was carried to its logical conclusion. From *Hot/hep/hebrew* to *fala prata* and *luxo/lixo*: the stage was now set for a new generation of "robbers" from the grave.

4

Word Frequencies and Zero Zones

Wallace Stevens's Rock, *Susan Howe's* Quarry

I am, after all, more moved by the first sounds of the birds on my
street than by the death of a thousand penguins in Antarctica.[1]

This wry distinction, found in a 1949 letter from Wallace Stevens
to his Irish poet friend Thomas McGreevy,[2] sets the stage for the
brilliant sequence of poems in Stevens's final volume *The Rock*.[3]
No more exotic metaphors or reliance on inherently poetic topoi
like Greek ruins or Florida sunsets or penguins in Antarctica, the
seventy-year-old poet tells McGreevy. Rather, he would turn in-
creasingly to the contours of his own Connecticut landscape, with
its particular geography and its extremes of weather and seasonal
change. "What I am trying to get at at the moment," Stevens ex-
plains, is "the bare idea [that] makes everything else seem false and
verbose and even ugly" (*LWS*, 631).

Stevens's rigorous pursuit of the "bare idea"—of "a poetry di-
vested of poetry"—took place, most of his biographers and critics
would have it, at a dark time in the poet's personal life. Here is Joan
Richardson on his last decade:

What did Stevens, looking back with the notion of nobility in mind,
see? A man who had always abstracted himself from things as they
were, who continued to search for the "central" while he looked at

the peripheral, who turned the pathos of human experience into the streaked and rayed lines of poems. A man who, because of the august activity of imagination, had evaded the essential facts of his life, a man who saw his wife completely dependent on him . . . a man who saw the life of his child—now with her own child—as a failure, a life he wanted to break up. . . . He was out of joint with his time, and he did not know why. From having been the chorister whose "c" preceded the choir [the allusion is to the 1953 poem "Not Ideas about the Thing but the Thing Itself"], he became a most inappropriate man in a most unpropitious place.[4]

The reference here is to Stevens's family situation. His daughter Holly, who had dropped out of Vassar in her sophomore year (1942), had married—and soon divorced—an improvident young man of whom both her parents strongly disapproved. As for the beautiful but remote Mrs. Stevens (Elsie), who had, after all, never been able to share the poet's intellectual or poetic interests, Stevens—so the narrative goes—had to watch her become increasingly withdrawn and eccentric. Not only was she no company for her husband; she also made it impossible to invite guests to their home or indeed to have any meaningful social life. Stevens was thus bereft—emotionally as well as sexually. Indeed, Helen Vendler reads many of the late poems—for example, "The Dove in Spring"—as poems of extreme sexual deprivation. The "small howling of the dove," Vendler suggests, is "the expression of an anger that a mind so designed for adoration never found adoration and sensuality compatible; they remained locked compartments, a source of emotional confusion and bitterness."[5]

I find such assessments strange because Stevens's letters, so rich in insight and moment-to-moment detail, give a very different impression—an impression borne out, moreover, by the recollections of professional colleagues and friends collected by Peter Brazeau in his *Parts of a World: Wallace Stevens Remembered* (1985). To begin with, we should never underestimate the role the poet's chosen profession played in his life. In his early seventies, let's recall, this vice-president of the Hartford Accident and Indem-

nity Company was still going to the office every day and evidently taking great satisfaction in solving problem cases. "Stevens's specialties, surety and fidelity," observes Peter Schjeldahl in a 2016 essay for *The New* Yorker, "turn profits from cautiously optimistic bets on human nature. (Surety covers defaulted loans and fidelity employee malfeasance.) Something very like such calculated risk operates in [Stevens's] poetry: little crises in consciousness, just perilous enough to seem meaningful. The endings are painstakingly managed victories for the poet's equanimity. The aim, he once explained, was a 'vital self-assertion in a world in which nothing but the self remains, if that remains.'"[6]

But the insurance work was not the poet's only satisfaction. In his last decade, Stevens finally experienced fame, winning a host of prizes, from the Bollingen (1949) to the National Book Award (1955), and making his name on the lecture circuit from Harvard and Yale to Holyoke and Bard College. Students were writing their PhD dissertations on his work, and the famous Italian critic Renato Poggioli, now based at Harvard, was translating his earlier poetry. How could such attention not be a source of pride and pleasure, especially since Stevens had never engaged in any sort of active self-promotion? Indeed, he had little use for the poetry circuits, much less for literary gossip. "There isn't a chance of my taking part in a poetry festival," he tells Allen Tate upon an invitation from the latter in 1948 (*LWS*, 583), and he regularly turned down invitations to contribute to essay collections or write recommendations or blurbs (e.g., for his old friend William Carlos Williams). Indeed, in Stevens's later years, his favorite correspondents—Tom McGreevy, Barbara Church, José Rodrîguez Feo, Paule Vidal, Leonard C. Van Geyzel—were safely overseas. McGreevy, who shuttled back and forth between Paris, London, and Dublin in his role as critic and museum director, was a treasured correspondent for almost six years before he and Stevens finally met in person in 1954—and then only once.

In this respect, Stevens was a great deal like Marcel Proust: just as the latter dreamed of Venice but kept putting off his visit there for fear that the real Venice could not match up to the magical city of

his imagination, so Stevens adored the Paris he knew so well from books and journals but had never laid eyes on. *Distance* appealed to his imagination. Thus he regularly declined proposed lunches in Manhattan or even New Haven with Allen Tate and the repeated invitations from William Carlos Williams to pop over to Rutherford, New Jersey. Such offers were evidently not tempting, and not just because Stevens could not leave Elsie home alone or bring her along. At the same time, he still regularly took the train from Hartford to New York to visit museum exhibitions and art galleries, as well as to purchase books and his favorite wines.

Perhaps it was the exacting routine of his life that made it possible for Stevens to take note of the most minute differentials in nature—the tiny snowdrops, for instance, rearing their heads "at the earliest ending of winter." In its treatment of the natural world, *The Rock* looks ahead to an important poetic text by another, more recent Connecticut poet, like Stevens a winner of the Bollingen and other leading prizes; like Stevens, indifferent to changing poetry fashions and extraordinarily sensitive to what she calls "word frequencies and zero zones." That poet, Susan Howe, has a collection of "essays" called *The Quarry* (2015) that opens with a long piece on Stevens called "Vagrancy in the Park"—a hybrid text, part prose, part poetry; part formal analysis, part lyric fragment that is at once an homage to Stevens and a foray into the new and different poetic world of the twenty-first century. To read Stevens's late work through the lens of Howe's essay, I want to suggest here, is to come to understand Stevens's own practice in a genuinely new way and to see it, not as the expression of diminished capacities and frustrated desire, but as a complex response to the aesthetic challenges that had haunted him throughout his career.

"A Cure of the Ground"

Let's begin with titles. A *quarry* is defined in the *Oxford English Dictionary* as "an open-air excavation from which stone for building or other purposes is obtained by cutting, blasting, or the like;

a place where the rock has been, or is being, cut away." Just so, Howe's *Quarry* cuts into Stevens's *Rock*, excavating words and lines that Howe recharges, holding them up for inspection and making them her own. The word *quarry* also refers, of course, to the object of a hunt: in this sense, the poetry of Stevens is Howe's particular quarry. Then, too, by uncanny coincidence, Susan Howe lives at 115 New Quarry Road in Guilford, Connecticut, roughly an hour's drive northwest to Stevens's home at 118 Westerly Terrace in Hartford.

"A mythology," as one of the late lyrics puts it, "reflects its region" (*CPPS*, 476). Stevens is often regarded as a philosophical poet—one whose abstract formulations express a complex phenomenology of being. But, as Howe reminds us, "no matter how many theoretical and critical interpretations there are, in the end each new clarity of discipline and delight contains inexplicable intricacies of form and measure."[7] And again, "As a North American poet writing in the early twenty-first century, I owe [Stevens] an incalculable debt, for ways in which, through word frequencies and zero zones, his writing locates, rescues, and delivers what is various and vagrant in the near at hand" (*Quarry*, 3).

Word frequencies and zero zones: to understand and appreciate Stevens, Howe suggests, one must begin with the poet's "intricacies of form and measure." *Form* here refers, not only to a given poem's metrics or stanzaic structure but also to the internal "frequencies" of sound and word repetition that bind phrase and line together. "Our words," W. B. Yeats insisted, "must seem to be inevitable"[8]— a motto both Stevens and Howe have clearly absorbed. However casual a given phrase or line may seem and however "simple" its diction, each word has been *chosen* with care. Then, too, "zero zones"—what is *not* said, represented in poetry by ellipsis, both verbal and visual, is central to both poets' sense of form.

The Quarry's opening essay, "Vagrancy in the Park," is a case in point. Its first section, "Roaming," has as its epigraph:

"March . . . Someone has walked across the snow,
Someone looking for he knows not what." (*Quarry*, 3)

.

This is the first couplet of a ten-line poem in *The Rock* called "Vacancy in the Park," which continues as follows:

> It is like a boat that has pulled away
> From a shore at night and disappeared.
>
> It is like a guitar left on a table
> By a woman who has forgotten it.
>
> It is like the feeling of a man
> Come back to see a certain house.
>
> The four winds blow through the rustic arbor,
> Under its mattresses of vines.
>
> (*CPPS*, 434–35)

The blankness of early March, when one looks in vain for signs of the coming spring, is a dark season for this poet—a "zero zone" when the consciousness experiences what is called, in the words of a neighboring poem, "an indigence of the light, / A stellar pallor that hangs on the threads" ("Lebensweisheitspielerei," *CPPS*, 429). The boat that has "pulled away / From a shore," the "guitar left on a table"—these images of loss are presented starkly with three repetitions of "It is like" and their placement in a context of flat, abstract vocabulary, as in line 2, whose nine syllables, with their falling or uneasily teetering rhythm, refuse to coalesce into any sort of metrical figure:

> Sómeône loóking fór he knóws nôt whát.

The sense of absence is intensified by the absence of the first-person pronoun: not "I have walked across the snow" but "*Someone* has walked across the snow, / Someone looking for he knows not what," and again in line 7, "It is like the feeling of a man . . ." For Stevens, "*je est un autre*" (I am somebody else), as Rimbaud put it—the ability

to distance oneself from the representation of one's own experi-
ence—is central to the poetic discipline.

Critics have suggested that "Vacancy in the Park" is one of Ste-
vens's many poems about the premonition of death: the boat, after
all, has pulled away from the shore at night.[9] But to read "Vacancy"
as a death poem is to ignore the turn in the last two couplets. Un-
like the lost boat and forgotten guitar, the "someone" does not
disappear into the snowy landscape; he "come[s] back to see a
certain house"—one with a "rustic arbor, / Under its mattresses
of vines." Howe doesn't comment directly on this reverse move-
ment, but consider the photographs on the essay's title page and
the page facing the start of section 2, "Ring around the Roses"—
both, Howe tells us, of a small pavilion or "rustic arbor" in Elizabeth
Park in Hartford. The first snapshot (figure 4.1) is taken in the dead
of winter, the second (figure 4.2), evidently in summer, when the
gazebo is covered by thick climbing plants and surrounded by lush
greenery.

Elizabeth Park, whose entrance is only two blocks from 118 West-
erly Terrace, where Stevens lived from 1932 until his death in 1955,
was one of the poet's sacred places. He walked the two-mile route
through the park to and from his office every day. In "Ring around
the Roses," Howe describes the "vivid green . . . still redolent with
morning dew," of Elizabeth Park in late August: she marvels that in
this, "the oldest municipal rose garden in the United States," bushes
and ramblers bear such names as Dainty Bess, Carefree Delight,
Shreveport Grandiflora, Moonstone Hybrid Tea, and Hiawatha
Rambler (*Quarry*, 19). Across the road from the rose garden, color-
ful annuals abound:

> . . . we saw high banks of white phlox, varieties of marigolds (Mari-
> gold Galore Orange, Marigold Galore Yellow, Marigold Little Hero
> Yellow, Marigold Bonanza) we saw impatiens, nasturtiums, forget-
> me-nots, ugly begonias, all sorts of lilies, some of the tiger ones
> a gaudy vermilion. I go on with these flower names not only because
> I enjoy making lists—but also to remind you, the reader, how words

Vagrancy in the Park

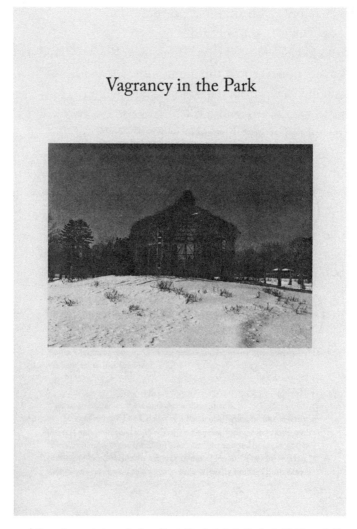

4.1 | Susan Howe, photograph of pavilion in Elizabeth Park, Hartford, CT, Winter, in *The Quarry* (2015), p. 1.

supersede and displace the reality of an object sensed in space and time. According to William James: "Both the sensational and the relational parts of reality are dumb. They say absolutely nothing about themselves. We it is who have to speak for them. This is what Wallace Stevens does—he sounds the myriad of ever shifting sensations— fragmentary, unpredictable, unspoken, invisible—of seemingly simple objects or events. (*Quarry*, 19–20)

4.2 | Susan Howe, photograph of pavilion in Elizabeth Park, Hartford, CT, Summer, in *The Quarry* (2015), p. 18.

Yes, but it is important to note that, unlike the Imagists of the early twentieth century, unlike his contemporary and poet-friend William Carlos Williams, and quite unlike such younger poets who came of age in the 1950s as Frank O'Hara, whose use of specific detail and proper names is legendary, Stevens was a poet of synecdoche: he preferred a single telling detail—the part for the whole—to a string of images.

The winter landscape of "Vacancy in the Park" bears almost no trace of human intervention; we only know that "the four winds blow through the rustic arbor, / Under its mattress of vines." The word *mattress* is apropos because the once-green vines have no doubt turned papery gray, barely covering the gazebo's wrought-iron frame. But the image of absence is followed by return: the "four winds" that "blow through the rustic arbor" will soon cover those dead vines with new growth, and the dank and torn mattresses (a man-made product) will soon be replaced by warm *natural* beds, as new green vines make their way up the walls of the little pavilion. The four winds blowing will conspire to usher in the spring.

"The real," Stevens declares in his aphoristic notebooks, "is only the base. But it is the base" (*CPPS*, 917). The poet took this axiom quite seriously. In "Vacancy in the Park," he takes a perfectly ordinary incident—a walk through the park on a dreary March day—and sparingly uses imagery and simile to create the poem's mood of lassitude and recovery. Note that the "vacancy" is both visual and sonic—the boat is out of sight, the guitar is not being played, and "mattress" implies that the "certain house" to which the man returns has no real bed. Then, too, the title of the poem is itself two-edged: *vacancy* is a synonym for emptiness but a notice of a "vacancy" is also an invitation for someone or something—perhaps the poet's words—to fill the empty space.

Sound structure reinforces the poem's tentativeness of statement. The abrupt designation "March," followed by three dots denoting a pause, followed by the flat sentence, "Someone has walked across the snow," makes for a line impossible to scan, and this first line is followed by a second ungainly line, whose scansion similarly evokes ambivalence. The remaining four couplets are even less melodious, the threefold repetition of "It is like . . ." creating a sense of deadlock, as if the voice is about to give out but wants to make its case. "Pleasure," as Susan Howe puts it, "springs from the sense of fluid sound patterns phonetic utterance excites in us" (*Quarry*, 3).

Howe's own sensitivity to "fluid sound patterns," to "word frequencies and zero zones," can be seen in her subtle—we might say

infrathin—transformation of "Vacancy in the Park" into "Vagrancy in the Park." What a difference two phonemes can make! Howe's poetic text transforms its source: her role, she makes clear to the reader, is to be a *vagrant* in Stevens's "park," following his lead but singing her own "spells," spells that fuse Stevensian consciousness with that of a female poet born more than half a century later. The word *vagrant*, for that matter, recalls Thoreau's play on the cognate word *extravagant* (which has the same Latin root). In the conclusion to *Walden*, we read:

> I fear chiefly lest my expression may not be *extra-vagant* enough, may not wander far enough beyond the narrow limits of my daily experience, so as to be adequate to the truth of which I have been convinced. *Extra vagance!* It depends on how you are yarded. The migrating buffalo, which seeks new pastures in another latitude, is not extravagant like the cow which kicks over the pail, leaps the cow-yard fence, and runs after her calf, in milking time. I desire to speak somewhere *without* bounds. . . . Who that has heard a strain of music feared then lest he should speak extravagantly any more forever?[10]

Howe's *Quarry* is certainly an *extra-vagant* book in the Thoreauvian sense: the text cuts back and forth in time, place, and poetic register, creating an assemblage of citations, borrowings, paraphrases, lyric fragments, allusions, critical texts, and autobiographical observations. But Stevens is always, so to speak, in the eye of the hurricane, whether in his poems, letters, aphorisms, or anecdotes about him. *The Quarry* is characterized by its "Roaming" (the title of the first section of "Vagrancy in the Park"), both visual and auditory, as in Howe's citations from Stevens's "Certain Phenomena of Sound," with its "Redwood Roamer," a "voice taller than the Redwoods" (*CPPS*, 256; *Quarry*, 15). For Howe, "the Roamer's / Story" *CPPS*, 256) also demands a documentary realism, which gives a special spin to the lyric density of the poems themselves. For example, she cites a letter of 20 April 1948 to Tom McGreevy:

I took your letter home last night and read it in my room. . . . As a matter of fact, a man who writes poetry never really gets away from it. He may not continue to write it as poetry, but he always remains a poet in one form or another. Perhaps your book on drawings of Mr. [Jack] Yeats is your present form of being a poet. . . . If you don't mind, and if you don't think he would, could you take a copy of your book with you some evening when you are going to spend an hour or two with him and have him do a profile of you in the blank pages in front which both of you could then sign. This would give me something that would be precious to me. . . . Ireland is rather often in mind over here. Somehow the image of it is growing fresher and stronger. (*Quarry*, 24)

The request for the double autograph gives the lie to the going image of a cool and distant Wallace Stevens, playing his cards close to his chest and avoiding human contact. Howe relates the poet's request for the Irish signature to Stevens's late poem "The Irish Cliffs of Moher" (*CPPS*, 427; *Quarry*, 26), where the "parent before thought, before speech, / At the head of the past" connects to Susan Howe's own Irish ancestry. And her collaging of the McGreevy letter illustrates nicely Stevens's assertion that, whatever material form the poet chooses, "he always remains a poet in one form or another." The Irish link, the Connecticut link: Stevens, we learn, is Howe's ghostly father. And she adds:

I don't often remember Stevens poems separately except for the early ones but they all run together the way Emerson's essays do into a long meditation moving like waves and suddenly there is one perfect portal. The quick perfection. "Night's hymn of the rock, as in a vivid sleep." (*Quarry*, 24)

With this note in mind, let's return to Howe's own "portal" in the first section of *The Quarry*. In its second paragraph she cites the great early poem "The Snow Man" ("Nothing that is not there and the nothing that is"), as "eerily similar" to the late lyric "The Course of a Particular." "Both fifteen-line poems," she notes, "progress

in tercets from 'one,' to 'no one.'" Indeed, the "second cold pas-
toral" can profitably be read as a "spectral refraction" of the first
(*Quarry*, 4):

> Today the leaves cry, hanging on branches swept by wind,
> Yet the nothingness of winter becomes a little less.
> It is still full of icy shades and shapen snow.
>
> The leaves cry . . . One holds off and merely hears the cry.
> It is a busy cry, concerning someone else.
> And though one says that one is part of everything,
>
> There is a conflict, there is a resistance involved;
> And being part is an exertion that declines:
> One feels the life of that which gives life as it is.
>
> The leaves cry. It is not a cry of divine attention,
> Nor the smoke-drift of puffed-out heroes, nor human cry.
> It is the cry of leaves that do not transcend themselves,
>
> In the absence of fantasia, without meaning more
> Than they are in the final finding of the ear, in the thing
> Itself, until, at last, the cry concerns no one at all.
>
> (*CPPS*, 460)

This, I must confess, was never one of my favorite Stevens poems,
and since he didn't include it in *The Rock*, I thought maybe it was
not one of Stevens's favorites either.[11] The "cry of the leaves" struck
me as too obviously gloomy—a bit stagey in its repetition—and
I found the explanation that "It is the cry of leaves that do not tran-
scend themselves" overstated. Howe, however, illuminates "The
Course of a Particular" by taking it quite literally:

> Most critics read the season as autumn. For me, its lyric austerity
> defines late February weather in Guilford, Connecticut. Often on
> afternoon winter walks out on the quarry during this coldest month,

there is hardly any foliage to cry in the raw air. Some brittle oak leaves still cling to their branches like tattered camouflage while tiny salt hay spindles scud across withered grass and frost-worked asphalt. Smoke-drift from indoor woodstoves [a reference to line 11] is another vagrant variant. So is the coldness of green. The idea that green can be cold comes to me from Thoreau, who notes pine-green coldness in winter woods and the way light *straggles*. (*Quarry*, 4)

Howe's recognition, in this richly figured and sounded passage, itself a kind of prose poem, that *cold* at its most extreme is synonymous, not with the "cry of the leaves," but with the silence of the raw air after the last leaf has fallen, reminds us how careful Stevens is to select the precise detail. As in "Vacancy in the Park," his interest is not in bemoaning zero-degree winter—that would be easy—but in capturing a moment of anticipation, in this case, the moment before the worst sets in, when there are still a few leaves "hanging on branches swept by wind." Paradoxically, the cry is thus a sign of life—"the nothingness of winter becomes a little less. / It is still full of icy shades and shapen snow." "'Shapen,'" Howe remarks, "is an obsolete past participle. This wild word relic softly and serenely concerns no one. Its pastness echoes in the sound of wind soughing through pitch pines" (*Quarry*, 5). But the recognition that it concerns no one becomes increasingly hard to bear: "there is a resistance involved; / and being part is an exertion that declines." The cry, after all, is not human, not our own: it "concerns no one at all."

The sound structure of the poem tracks this growing awareness. The form—the open unrhymed tercet—is one that late Stevens uses frequently. Here there are five such tercets, the whole visually unremarkable given that the long, loose lines are more or less even in length, although they range from twelve to fifteen syllables, from four to seven stresses per line. It is as if Stevens wanted to make the overall form intentionally bland, monotonous, in keeping with the narrator's refusal to create a "fantasia" out of what he sees and feels. But the repetition of the word "cry" (it recurs nine times

within the poem's fifteen lines) offsets the monotony, the long harsh sound of *cry*, with its voiceless stop (**k**), fricative (**r**), and long open vowel (**y**), resounds in our consciousness, impossible to ignore. The "final finding of the ear" thus comes to us with the abrupt demand to accept "the thing / itself," in all its indifference to the human re-action. Soundscape defines the process of de-definition: "the cry concerns no one at all."

Howe's own "vagrancy," however—her own response to "the sound of wind soughing through pitch pines," leads her elsewhere:

> On my way home I see a small stream rushing along under ice. Maybe the nature of a particular can be understood only in relation to sound inside the sense it quickens. Setting sun. A mourning dove compounds invisible declensions.
>
> "Deep dove, placate you in your hiddenness." (*Quarry*, 5)

The line belongs to an earlier Stevens poem called "The Dove in the Belly" (*CPPS*, 318), in which the unseen dove, its nest "hid-den" in the trees, animates the entire landscape around it with its song so that "the rivers shine and hold their mirrors up," even as "the wooden trees stand up / And live and heap their panniers of green / and hold them round the sultry day." "The Dove in the Belly" is a summer poem, and so the fact that Howe here invokes it marks a change in mood, a renewal, as in the case of the "small stream rushing along under ice," of life and energy. But the "invis-ible declensions" of the "mourning dove" in the penultimate line also refer the reader to the famous conclusion of "Sunday Morning," where "casual flocks of pigeons make / Ambiguous undulations as they sink, / Downward to darkness, on extended wings" (*CPPS*, 56). And further: in a related Howe book, *Spontaneous Particulars: The Telepathy of Archives*,[12] the dove is the Psalmist's dove (Psalm 55), invoked by Jonathan Edwards's sister Hannah Wetmore, mourn-ing her brother's death—"Oh that I had wings like a dove! *for then* would I fly away, and be at rest" (52)—and, by extension, Henry James's *The Wings of the Dove*, one of Howe's own sacred texts. In

Spontaneous Particulars, James's heroine Milly Theale becomes a spectral emblem of suffering, even her name, T H E A L E, suggesting an "aspirate puff of breath [that] co-implicates his fictional bird-woman with wealth, theatricality and death."[13]

"Certain Phenomena of Sound"

Henry James, Jonathan Edwards, the book of Psalms, Wallace Stevens: Howe's syncretic imagination, drawing on such highly disparate sources, is finally quite different from that of her beloved mentor. What we might call the *côté Ezra Pound* of Susan Howe manifests itself in the appropriation of different voices, time frames, narratives, and historical data, woven together to make a dense mosaic. Thus the intense lyricism of "Deep dove, placate you in your hiddenness," with its homage to Stevens's own highly charged lyric, gives way to postmodern collage—the method of *The Quarry*. In a move more representative of our current moment than that of Stevens's own, Howe introduces, not only related literary, mythological, or biblical texts, but relevant biographical documentation like the following:

> In an essay titled "The Present State of Poetry," Delmore Schwartz recalled: "In 1936 Stevens read his poems for the first time at Harvard—it was probably the first time he had ever read his poetry in public—and the occasion was at once an indescribable ordeal and a precious event: precious because he had been an undergraduate and a poet at Harvard some thirty-seven years before and had not returned since then, in his own person, although he had often gone to the Yale-Harvard games incognito. Before and after reading each poem, Stevens spoke of the nature of poetry, a subject which naturally obsessed him: the least sound counts, he said, the least sound and the least syllable. His illustration of this observation was wholly characteristic: he told of how he had wakened that week after midnight and heard the sounds made by a cat walking delicately and carefully on the crusted snow outside his house. (*Quarry*, 5)

Schwartz's reference to the "cat walking delicately and carefully on the crusted snow" brings to mind William Carlos Williams's "As the cat" rather than Stevens's own description of the cat walk in "The Irrational Element in Poetry":

> A day or two before Thanksgiving we had a light fall of snow in Hartford. It melted a little by day and then froze again at night, forming a thin, bright crust over the grass. At the same time, the moon was almost full. I awoke once several hours before daylight and as I lay in bed I heard the steps of a cat running over the snow under my window almost inaudibly. The faintness and strangeness of the sound made on me one of those impressions which one so often seizes as pretexts for poetry. (*CPPS*, 781–82)

Howe obviously knows this descriptive passage; her interest, no doubt, is in Stevens's reference to the "cat running over the snow *almost inaudibly.*" *Her* Wallace Stevens, unlike the Wallace Stevens of so many critics, is one "obsessed"—the word is Delmore Schwartz's—with "the least sound and the least syllable." How can the poem capture the "almost inaudible" sound of the unseen and running cat? One expects Howe to cite one of Stevens's winter poems, but she turns instead to the opening line of the earlier "Somnambulisma" (1947):

> "On an old shore, the vulgar ocean rolls"
>
> (*CPPS*, 269; quoted in *Quarry*, 5)

Somnambulisma: fragments, evidently, shored up from a bad dream, "the vulgar ocean" endlessly washing against the "hollow shore," like a "thin bird, / That thinks of settling, yet never settles, on a nest," a bird whose "claws keep scratching on the shale, the shallow shale." Stevens's landscape here is not only bleak but doomed: the repetition of sound and phrasing points to a "geography of the dead" that is redeemable only by the "man feeling everything"—the scholar-poet—who can transform the dreary re-

ality of "generations of the bird" and "ocean, falling and falling on the hollow shore," by the sheer energy of his imagination.

In the title essay of her 2015 book *The Ocean, the Bird, and the Scholar*, Helen Vendler takes "Somnambulisma" as Exhibit A for her thesis that poetry is, as Stevens puts it in one of his *Adagia*, "the scholar's art" (*CPPS*, 906): "What is necessary, asks 'Somnambulisma,' for creative effort? Emotion, desire, generative energy, and learned invention—these, replies the poem, are indispensable in the artist"—and, by extension, in the reader of poetry as well.[14]

This is to read the poem as moral allegory: by Vendler's account, Stevens teaches us how to discipline the emotions so as to have the "right" poetic outcome for both poem and reader. But such prescriptions would seem tendentious, were it not for the remarkable sound structure of the poem. Howe cites the opening line, whose extreme lassitude, produced by the slow-motion of its rhythm and the incantatory repetition of chiming o's, n's, l's, and sh's, is striking:

ón an óld shóre, | the vúlgar ócean rólls.

And further, Howe posits, the network of alliteration, assonance, and internal rhyming, here and especially in the late poems, is complicated by the treatment of the letter *r*:

The letter *r* is frequently indicated as a characteristic mark of vulgarity. "R is the dog's letter and hurreth in the sound" (Ben Jonson, *English Grammar*, 1640). "R. Young pious RUTH / Left all for Truth" (*New England Primer*, 1691). *R* is the eighteenth letter of the modern and seventeenth letter of the ancient Roman alphabet. In general, the character denotes an open voiced consonant formed when the point of the tongue approaches the palate a little way behind the teeth: in many languages this is accompanied by a vibration of the tongue, in which case the *r* is said to be trilled. This trill is almost altogether absent in the *r* of modern standard English, which retains its consonantal value only when it precedes a vowel. In American English in all words spelled with *r* the sound occurs simultaneously

with the vowel after it. The vowels in such cases are said to be re-colored. "Like rubies reddened by rubies reddening."

How carefully did Stevens plan the order for the poems included in *The Rock*? I often wonder if the many scattered *r* letters and sound combinations are there by chance, habit, or plot. "A repetition / In a repetitiousness of men and flies," "A new knowledge of reality," "Red-in-red repetitions never going." (*Quarry*, 5–6)[15]

"By chance, habit, or plot": Stevens may or may not have been aware of the force the single letter *r* could exert in a poem like "Somnambulisma," but once Howe has made us aware of the *r* game here and elsewhere in the poems, it becomes unforgettable. For consider the implications of the fact that *r* "retains its consonantal value only when it precedes a vowel," as in "rubies" or "redness." What happens when the vowel or diphthong precedes the letter? Post-vocalic **r**, designated by phonologists as *schwa* [ə] and pronounced **er** or **uh**, is one of the most common sounds in English; think "father," "mother," "letter," "together," "weather," "torch," "search," or my own name, P*er*loff. Accordingly, when Howe calls attention to "An Old Man Asleep," with its closing couplet—

The redness of your reddish chestnut trees,
The river motion, the drowsy motion of the River R:—

we should note, not only the heavy alliteration of "redness," "reddish," "trees, "drowsy," and "River **R**," but the curious oscillation between sounded and unsounded r's—between, so to speak, presence and absence (*CPPS*, 427; see *Quarry*, 6).

One can go further and observe that in Stevens's poetry, sound is often opposed to sight so as create distinctive patterns. Take the word *river* (**rivə**), in which the first **r** is offset by the absence of the second. In "The River of Rivers in Connecticut," Stevens's great ode to the "great river this side of Stygia" (Styx, the river of forgetfulness), which Howe discusses toward the end of "Roaming" (*Quarry*, 14), the "gaiety" of the water "flashing and flashing in the sun," defies those deathly "first black cataracts" in its path. This

river, on whose banks "No shadow walks," and which is controlled by "no ferryman" (Charon) rowing the dead over to Hades, is defined by the continuous play between the *river* as presence, as its first **r** denotes, and its feared disappearance, encoded in its second unsounded syllable **er** (*CPPS*, 451).

Stevens refuses to mythologize his Connecticut River, to associate it with Hades or the Styx. Its "unnamed flowing" past local villages like Haddam and Farmington, whose steeples are seen "flashing and flashing in the sun," is finally understood as flowing "nowhere" (again note the unsounded **r**). Thus, this **river** can be compared to a **sea**, with its long open vowel sound, promising continuity. Becoming a sea, the river functions as "curriculum" and a "local abstraction." And its name, *Connecticut*, Howe notes, "derived [as it is] from the native American designations Quonehtacut or Quinatucquet, or Quenticut meaning 'long tidal river,'" is sui generis, as the absence of the **r** sound signals (*Quarry*, 14). Further, Howe notes, "Connecticut," a combination of "connect" and "cut" is ambiguous: does the river connect the five states through which it flows from the Canadian border or "cut" them apart? The name, in any case, stands out as a special one, "the folk-lore / Of each of the senses." A ferryman, writes Stevens, "could not bend against its propelling force" (*CPPS*, 451).

"The least sound counts . . . and the least syllable." One of the great poems in *The Rock* in this regard (Howe doesn't discuss it in *The Quarry*, evidently because it is so well known) is the very last poem in the *Collected*—"Not Ideas about the Thing but the Thing Itself":

At the earliest ending of winter,
In March, a scrawny cry from outside
Seemed like a sound in his mind.

He knew that he heard it,
A bird's cry, at daylight or before
In the early March wind.

The sun was rising at six,
No longer a battered panache above snow . . .
It would have been outside.

It was not from the vast ventriloquism
Of sleep's faded papier-mâché . . .
The sun was coming from outside.

That scrawny cry—it was
A chorister whose c preceded the choir.
It was part of the colossal sun,

Surrounded by its choral rings,
Still far away. It was like
A new knowledge of reality.

(*CPPS*, 451–52)

The privileged moment dramatized in this poem has its origin in daily (or should we say nightly) life as it was lived by Stevens on Westerly Terrace. Like "The Course of a Particular," this is a late February–early March poem, the threshold season that Stevens found especially challenging. "On Feb. 16," he writes Barbara Church on 19 February 1951, "I found the first snow-drop in the garden, under some hemlock boughs used for covering. The next day two more appeared. There will be new ones every sunny day. These flowers withstand freezing and last a long time—the same ones already up will be there at the end of March when the beds will be uncovered. For the present, however, it is still midwinter. The warm days are days of illusion" (*LWS*, 707). And again on 9 March: "Our snow is all gone once again and, given another two weeks, all danger of any set backs will be gone. When the sun filled my room at half-past six this morning it made me happy to be alive—happy again to be alive still—and I walked half-way to the office."[16]

Of such ordinary mornings in Hartford, Stevens's late great poems are made. The title "Not Ideas about the Thing but the Thing

Itself" is delicately ironic. "The thing itself" is Kant's *Ding-an-sich*, the object independent of observation and of course unknowable. Stevens knows this very well, and in any case, he was never an advocate of, say, William Carlos Williams's call for "No ideas but in things." "Not all objects are equal," he insists in the *Adagia*, "The vice of imagism was that it did not recognize this" (*OP*, 187)." But "ideas about the thing" need not be figments of the imagination: they can be intuitions derived from close observation of the phenomena themselves. In "Not Ideas about the Thing," the "**scrawny cry**" of a bird that awakens the poet before dawn on a wintry March morning—note the repetition of **cr**—initially seems to be a sound occurring only in his mind, perhaps in a dream, But its persistence, coupled with the first rays of early morning sunshine—"The sun was rising at six"—gradually awaken the poet to the fact that sound and light are "coming from outside" himself, that they are "real." The recognition of the renewal of life triggers a moment of ecstasy: the unseen bird, now transformed into a "chorister whose c preceded the choir" (more sounded **r**'s except for that in "choir," whose open sounds drifts gradually into silence), ushers in a newly radiant "colossal sun / Su**rr**ounded by its choral **r**ings." In this epiphanic moment, the poet experiences a profound but inexplicable feeling of joy and renewal: "It was like / A new knowledge of reality." To make such a broad claim may seem tendentious, but the poem qualifies the epiphany by noting that it was only *like* such knowledge, not quite the knowledge itself. The sun, after all, is "Still far away."

Now consider the poem's form. On the surface, this is a perfectly conventional free-verse lyric in tercet form, proceeding in linear fashion from the composition of place (indoors, presumably the poet's bedroom) and time (predawn on an early March morning) to the recognition of the renewal of nature in the poet's transformative vision. But the forward movement of the six tercets is repeatedly offset by the poem's abrupt, irregular rhythm and qualification: "seemed like a sound in his mind," "daylight or before," "It would have been outside," "Still far away," "It was like." And the sense of uncertainty is reinforced by repetition—"a scrawny cry," "a bird's cry," "That scrawny cry"; or, again, "from outside," "It would have

been outside," "The sun was coming from outside." Beginning with the threshold experience of the oxymoronic "earliest ending of winter," we watch the poet trying to convince himself that the sound is not just "in his mind," that it is coming from *outside.*

From inside to outside: in order to come to terms with this new knowledge of reality, the poet must lay to rest those fantastic and surreal images that have haunted his sleep: the sun as "a battered panache above snow" (the shadow of sun on snow, seen as feathery nest), the sun as misshapen shadow rising from "the vast ventriloquism / Of sleep's faded papier-mâché." Putting ventriloquism behind him, the poet can now turn from the conditional "it would have been" to the indicative "it was," repeated three times in the last two tercets. *It was . . .* What actually happened is what matters.

"The earliest ending of winter": Stevens, as I remarked above, has a special predilection for threshold moments—"the edge / Of one of many circles," as he calls it in "Thirteen Ways of Looking at a Blackbird." The minimalism of that early poem comes to dominate *The Rock*, where a line can take the ungainly form of "Still far away. It was like" and yet be intensely poetic. Yet Stevens never abandoned his reliance on the basic lyric frame, with tercets or couplets, and sometimes longer stanzas, placed centrally on the page with a justified left margin and a ragged right margin that does not violate norms of lyric decorum. Here is where Susan Howe's *Quarry* parts company with *The Rock*: *vacancy* in the park gives way to *vagrancy.*

As the text of "Roaming" unfolds, each prose section develops some aspect of "the sound inside the sense it quickens." An inventory of Spinoza, "by profession a lens-grinder," who understood that "A poem is a glass, through which light is conveyed to us," and snatches of citation from George Santayana, for whom Stevens wrote his own great elegy, "To an Old Philosopher in Rome," are juxtaposed to the song of Whitman's "solitary sea-bird" in "Out of the Cradle Endlessly Rocking" and to the image of Virginia Woolf's Mrs. Ramsay in *To the Lighthouse*, "cover[ing] the boar skull on the nursery wall with her green shawl." In the face of death, whether Santayana's or Mrs. Ramsay's, *The Quarry's* mood becomes more meditative, more phantasmagoric:

As we grow old we return to our parents. Their absent submission to the harsh reality of Death renders the tangle luminous. A stellar pallor hangs on strips of silver bubbling before the sun. The spell is broken. There they are—embarking with other happy couples for Cythera. (*Quarry*, 12)

Poetry is the scholar's art. Howe's reference is evidently to Watteau's famed silvery painting *The Embarkation for Cythera*, with its delicately drawn and fragile, shadowy figures. Cythera is the southern Greek island devoted to the cult of Venus. The third sentence, tightly structured by its repetition of **st**, **l**'s, **b**'s, the **u** of "bubbling" and "sun," and the internal rhyming on terminal schwa [ə] of "stellar," "pallor," "silver," and "before," might well be lineated, its first line a trochaic pentameter:

A stéllar pállor hángs on stríps of sílver
Búbbling befóre the sún.

Yet Howe chooses to embed the sentence in prose, acknowledging that "The spell is broken." The tone now turns conversational—"There they are"—as the poet imagines her parents "embarking with other happy couples for Cythera." And as the fantasy inspired by Watteau dissolves, the poem interjects a note of contemporary realism:

These days I listen to the high speed Acela Express rushing through the remaining traces of woodland surrounding this four and a half acre, exurban almost suburban lot on the Northeast Corridor en route to Boston, New York City, Philadelphia, Baltimore, and Washington. Amtrak owns the land immediately bordering the tracks. Recently there has been a lot of hammering into the rock at night for some reason connected with a five-year plan for deploying free Wi-Fi internet service on all trains including slower regional ones.

It's the new millennium. Post 9/11, spangled bleeding banners, war's carnage, the global War on Terror, Guantánamo, metadata,

relationships, fracking, plastic bags, nuclear power plants, climate change, global warming, black holes, possible human extinction. If we have nothing but truth to leave, how do we distinguish ideas of what we were from ideas of what we are in vibrant contemporary compost jargon trash landfill (*Quarry*, 14–15)

A little reality check, just a shade tongue-in-cheek, cataloging those items most poets in our own moment are writing about. There is no Cythera at the end of the Acela line, only a passage through "Hartford in a Purple Light"—a town first stumbled upon in June 1636 by a group of pilgrims traveling the hundred-plus miles from Cambridge "through a hideous and trackless wilderness":

> "Of Hartford in a Purple Light"
> "About the beginning of June, 1636, Mr. Hooker, Mr. Stone, and about a hundred men, women, and children, took their departure from Cambridge, and travelled more than a hundred miles, through a hideous and trackless wilderness, to Hartford. They had no guide but their compass; made their way over mountains, through swamps, thickets, and rivers, which were passed only with great difficulty. They had no covering but the heavens, nor any lodgings but those which simple nature afforded. They drove with them a hundred and sixty head of cattle, and by the way subsisted on the milk of their cows. Mrs. Hooker was borne through the wilderness on a litter. The people generally carried their packs, arms, and some utensils. They were nearly a fortnight on their journey. (*Quarry*, 16)

Howe's documentary insertion—the passage she cites is from Benjamin Trumbull's *Complete History of Connecticut, Civil and Ecclesiastical* (1898)—gives a fascinating historical analogue to the geography so central to Stevens's poetry, as to her own. The swamps, thickets, and rivers Trumbull describes have been domesticated, but their bleakness persists and the weather remains largely the same. By injecting the historical note, Howe heightens the poem's drama.

But "Vagrancy in the Park" is by no means a nostalgia trip: hard upon her citation about the 1636 journey through the wilderness, Howe interjects a personal note:

> Late last night when I couldn't sleep I wondered at how the cold reversal of moonlight on snow from outside brightens the common-place stillness of the house and how quietly night stands open to us, and sits up for us. Not fastening the door (*Quarry*, 16)

There is no period after "door." No closure in this twenty-first-century elegiac poem, no Miltonic "fresh woods, and pasture new" as the poet finds herself—a kind of Molly Malone figure from the popular Irish song, bearing her cockles and mussels ("Fishmonger")—"on the beached margin after long pilgrimage, waving to the quiet moon." On this Coleridgean note, "Roaming" ends.[17]

A few pages earlier, when Susan, on a clear night in February," is reciting her "Star light, star bright" prayer to herself, she notes that she cannot recite the poem indoors because "looking at a new moon through glass was and is terribly unlucky according to my mother's divinations so I can't take a chance of accidental sightings" (*Quarry*, 11). But of course, accidence can never be wholly avoided. To be true to Stevens's spirit, the door should stay open, but it is also the case that "A Quiet Normal Life" should prevail:

> It was here. This was the setting and the time
> Of year. Here in his house and in his room,
> In his chair, the most tranquil thought grew peaked.

One becomes, in the poet's words, "obedient / To gallant notions on the part of cold" (*CPPS*, 443).

Stevens's rock, that "gray particular of man's life, / the stone from which he rises, up—and—ho, / The step to the bleaker depths of his descents" (*CPPS*, 447), is a continuing presence for both Stevens and Howe, the emblematic stonescape of their shared Connecticut, here rendered, curiously enough, in bright color:

Turquoise the rock, at odious evening bright
With redness that sticks fast to evil dreams;
The difficult rightness of half-risen day.

<div align="right">(CPPS, 447)</div>

Turquoise, red: these garish colors of "the difficult rightness of half-risen day" (note that the sound figure of that third line — "diff-"/"day"; "diff-"/"half"; "-cult"/"right"; "rightness"/"risen" — is itself "difficult") give way, at poem's end, to a very different note: the mellifluous "midnight-minting fragrances, / Night's hymn of the rock, as in a vivid sleep." Both Stevens and Howe, in their very different ways, opt for that "vivid sleep," taking as their impetus the ethos defined in the final tercet of "A Quiet Normal Life":

Babbling, each one, the uniqueness of its sound.
Theirs was no fury in transcendent forms.
But his actual candle blazed with artifice. (CPPS, 44)

The last line here — "But his actual candle blazed with artifice" — with its elaborate design of a's and l's, perfectly enacts the "artifice" of which Stevens speaks. And not only Stevens. Change the pronoun of that last line to "her" and the reference seems entirely appropriate to Howe's own *vagrancies*. Neither poet opts for a "fury in transcendent forms" above and beyond language, but for each, the construction of Daedelian forms built from word frequencies and zero zones, from etymology and sound repetition, makes the poet's "actual candle [blaze] with artifice."

5

"A Wave of Detours"

From John Ashbery to Charles Bernstein and Rae Armantrout

"Life as it is actually lived"

In "A Note on Pierre Reverdy" for the *Evergreen Review* (1960), John Ashbery, then an outspoken and little-known young poet, took pains to distinguish Reverdy from his Surrealist contemporaries. "Automatic writing as practiced by the Surrealists," he declares, "seems to have been merely a euphemism for extreme haste." Indeed, most Surrealist poetry, "is uninteresting from the standpoint of language, and language is poetry, as Mallarmé knew." And there is the further problem that the Surrealists, for all their "spontaneous" dream imagery, "were careful to observe the conventions of grammar and syntax."

Reverdy, Ashbery posits, was quite different:

[His] poetry avoids the disciplines of Surrealist poetry, and is the richer for it. He is not afraid to experiment with language and syntax, and it is often difficult to determine whether a particular line belongs with the preceding sentence or the one following it. The lines drift across the page as overheard human speech drifts across our hearing: fragments of conversation, dismembered advertising slogans or warning signs in the Métro appear and remain preserved

in the rock crystal of the poem. And far from banishing poetry to the unconscious, he lets it move freely in and out of the conscious and unconscious. Since we do not inhabit either world exclusively, the result is moving and lifelike. Sometimes his preoccupations seem infinitesimally small—the shadow of a coin on a book of matches, for instance. . . . But the small object can suddenly become enormous, be "all there is," by means of a split-second crescendo like the ones that occur in Webern's music. Reading a poem by Reverdy, one can have the impression one moment of contemplating a drop of water on a blade of grass; the next moment one is swimming for one's life.

It is a disconcerting kind of poetry, but one feels it must be very close to life as it is actually lived.[1]

I cite this passage at some length because it so aptly characterizes Ashbery's own poetry: the "overheard human speech drift[ing] across our hearing," the "dismembered advertising slogans or warning signs," the dismantling of conventional grammar and syntax, creating uncertainty as to "whether a particular line belongs with the preceding sentence or the one following it," the tonal shifts that make "small object[s] . . . suddenly become enormous," and the pronominal indeterminacy for which Ashbery has become famous— these are the features of what Ashbery here calls "a disconcerting kind of poetry, but one feels it must be very close to life as it is actually lived" (*Selected Prose*, 21).

The device of displacement or dislocation—what the Russian Formalists called *sdvig*—is often associated with collage: Ashbery himself has used the term to describe his own work, and a number of recent exhibitions have displayed the actual paper collages he has made throughout his life.[2] But unlike the visual collages, his poems foreground connectives—*and, but, if, though, when, now, yet, so, still, nearly, after, which, so that, what if,* and especially *as*—as in "As we know" or "If this is the way it is." The reader soon understands that these are largely *faux* connectives, the items related by "as" or "so that" frequently not being related at all but, on the contrary, acting so as to give the poet a certain cover: a given poem, whether in verse or prose, will flow along in a seemingly spontaneous and

natural way. The resulting discourse is, in many ways, close to this poet's actual *talk* to "you" or "us" over lunch or coffee. At the same time, this lifelike poetry is studded with often arcane literary, historical, musical, visual, and pop culture references. The Reverdy essay, for example, juxtaposes allusion to Mallarmé and Webern to the *Catalogue* [more accurately, *Le Manufacture*] *d'armes et cycles de St-Etiènne,* which was the world's first mail-order catalogue, predating Sears Roebuck, and specializing in items like guns, tools, and bicycles. "Close to life" must thus be qualified as "close to Ashbery's life"—but not exactly to the lives of most of his readers, who are less likely to have come across *Le Manu,* as that "celebrated catalogue" was known in France. Then, too, the choice of verse forms counters the "close to life" mode of a given poem: Ashbery writes sestinas, pantoums, sonnets, centos, and two-column poems, and even his typically long-lined "free" verse is structured by various rules and devices. The poems in one of his later books, *Planisphere* (2009), for example, are arranged alphabetically by title. Indeed, in his interview for *L'Oeil de boeuf,* Ashbery tells Olivier Brossard that he had long been writing Oulipo "avant la lettre."[3]

What makes Ashbery's signature stylistic devices so unusual is that they are often contradictory. The surplus of connectives produces a level of abstraction that is oddly countered by the intimacy of address. And complex verse forms like the sestina or pantoum act as containers for the flat, conversational rhythm of the lines themselves—lines that are likely to break off at the most unpredictable places and that avoid the sonic and visual figurations one finds in, say, Pound's poetry. Indeed, when one hears Ashbery's poems read aloud (especially by the poet himself in his flat upstate–New York accent), it is difficult to tell whether one is hearing "verse" or "prose," a given passage from *Three Poems* (prose) not sounding appreciably different from a verse paragraph in, say, *Houseboat Days.*[4] Then too, with the exception of *The Tennis Court Oath,* Ashbery avoids all displays of individual graphic and spatial design, no doubt in order to simulate the "close to life" quality that he so values. His is, in other words, a poetry whose verbivocovisual temperature is intentionally low, all but precluding memorability. Try memorizing

an Ashbery poem, even a very short one, and you will see the difficulty. In minimizing sound and visual effects, the poet forces us to give our attention to his poetry's extraordinary verbal and syntactic richness—a complexity that continues to challenge and excite readers.

Before his death in 2017, Ashbery was regularly referred to as "America's pre-eminent living poet," that epithet appearing on the dust jacket of the Library of America volume (2008) of his *Collected Poems 1956–1987*. He was the first living poet (W. S. Merwin was the second) to be published by the Library of America series (the US counterpart of the French Pléiade Editions). The first volume runs to over a thousand pages and takes us through three decades, from *Some Trees* (1956) to *April Galleons* (1987); the second, equally long, although it covers less than one decade, extends from *Flow Chart* (1991) to *Your Name Here* (2000), and since Ashbery subsequently published at least ten more volumes of poetry, there is surely another thick volume to come. Indeed, one might conclude from such data, as well as from the glowing obituaries he received, that Ashbery is, in the end, an Establishment wolf in experimental sheep's clothing: the Library of America, after all, is, by definition, committed to the canonical, and during his life, Ashbery won every Establishment prize there is, from the Guggenheim and the Pulitzer to a MacArthur Fellowship.

Then again, consider the following comment, made by the Language poet Ron Silliman on his then widely read blog, on the occasion of the publication of Ashbery's collection *Chinese Whispers*:

> It is intriguing, perhaps even shocking, that Ashbery should turn out
> to be the great cross-over hit of U.S. poetry, the one New American
> beloved by the schools of quietude. His work consistently parodies
> such modes, sometimes (as in *Self-Portrait in a Convex Mirror*) with a
> viciousness that makes you question just why Ashbery puts so much
> energy into mocking a poetics he so evidently despises, as if some
> how he believes (fears) that the realm of the [John] Hollanders, of
> the [Harold] Blooms & [Helen] Vendlers, were all that was the case.[5]

Here Silliman reverses the equation: for him, the "real" Ashbery is the young experimental poet—the author of the cut-ups in *The Tennis Court Oath* (1962) or the list poems in *The Vermont Notebook* (1972)—whereas the "serious" lyric meditations in *Self-Portrait* (1975) or *Houseboat Days* (1977) and later volumes can only be justified if they are understood as parodic, obliquely mocking the Blooms, Hollanders, and Vendlers of the Establishment.

Have, then, the mass of Ashbery critics from, say, Bloom himself—the first major critic to single out Ashbery's special place among postmodern poets—to Mark Ford, the English poet-critic who was chosen to edit the Library of America volumes as well as a number of other important books relating to Ashbery, merely been conned?[6] Or is it the other way around: is Silliman's claim for an oppositional Ashbery just wishful thinking? Or is Ashbery sometimes "experimental," sometimes traditional? In tackling these tricky questions, one runs into a further conundrum. Given the large amount of critical prose Ashbery has produced, and the even larger amount of such prose devoted to his work, who are the poets who have never been invited to the party, who have, that is to say, remained excluded from the Ashbery conversation?

Ashbery's name has always been linked to those of W. H. Auden and Wallace Stevens, Marianne Moore and Elizabeth Bishop. He has written very perceptively on Gertrude Stein and expressed admiration for William Carlos Williams and Hart Crane.[7] The T. S. Eliot connection, originally downplayed by both the poet and his critics, myself included, seems more palpable every year.[8] Behind these great Modernist poets, in any case, stand the great English Romantics, whom Ashbery obviously knew intimately, even as, in his Charles Eliot Norton Lectures for Harvard (*Other Traditions*), he singled out the "minor" Romantics John Clare and Thomas Lovell Beddoes for special treatment. "It will be noted," Ashbery remarks dryly in the opening Norton Lecture, "that a number of major twentieth-century poets don't figure in [my] list, but one can't choose one's influences, they choose you, even though this can result in one's list looking embarrassingly lopsided."[9]

The missing figure in the poet's twentieth-century carpet is obviously Ezra Pound, and indeed the entire Pound tradition. H. D. is never mentioned, nor are the Objectivists, the Black Mountain poets (with the slight exception, in Ashbery's later years, of Robert Creeley), or the poets of the so-called San Francisco Renaissance, like Kenneth Rexroth. The Beats, contemporaries and friends as many of them were in the New York of the 1950s and 1960s, are not taken very seriously. The alignments in Donald Allen's *New American Poetry*, we might note, are hardly equivalent to Ashbery's own. And further, although Ashbery was an early admirer of John Cage's music, he seems to have had no particular interest in Cage's poetic texts or those of such related figures as Jackson Mac Low, David Antin, and Jerome Rothenberg.

All of the above are usually classified, in a broad way, as poets of the Pound tradition: recall Allen Ginsberg's repeated declaration that, despite Pound's anti-Semitism, he was the great poet of his generation.[10] Not surprisingly, then, the converse has also been true: Pound scholars and critics, ranging from Hugh Kenner and Guy Davenport to Peter Nicholls and Richard Sieburth, and admirers of Zukofsky and Oppen in France, from Jacques Roubaud and Anne-Marie Albiach to Abigail Lang or Hélène Aji, have had little to say about Ashbery. Clearly, terms regularly used in discussion of Ashbery and, say, Zukofsky or Mac Low—terms like anti-lyric, collage, dislocation, dispersal of the unitary ego, nonreferentiality, linguistic innovation, generic breakdown—don't quite tell the story.

We need, accordingly, to rethink the poetic alignments of the late century as they look to us in the 2020s. I propose here to go back to basics by looking more inductively than has recently been the case at the premises—and working out—of Ashbery's poetics. In his case, this is entirely possible because, as most readers would agree, his lyric mode has not really changed appreciably in the course of his career: we do not, in other words, have a case like early versus late Yeats here, although the late poetry is more loosely structured than the earlier and more open to topical references. In what follows, in any case, I take as my example a characteristic but

not much discussed poem of the middle years. Here is "Variant," which appeared in the volume *Houseboat Days* (1977):

> Sometimes a word will start it, like
> Hands and feet, sun and gloves. The way
> Is fraught with danger, you say, and I
> Notice the word "fraught" as you are telling
> Me about huge secret valleys some distance from
> The mired fighting — "but always, lightly wooded
> As they are, more deeply involved with the outcome
> That will someday paste a black, bleeding label
> In the sky, but until then
> The echo, flowing freely in corridors, alleys,
> And tame, surprised places far from anywhere,
> Will be automatically locked out — *vox
> Clamans* — do you see? End of tomorrow.
> Don't try to start the car or look deeper
> Into the eternal wimpling of the sky: luster
> On luster, transparency floated onto the topmost layer
> Until the whole thing overflows like a silver
> Wedding cake or Christmas tree, in a cascade of tears."[11]

"The small object can suddenly become enormous," Ashbery wrote of Reverdy's lyric; it can be "all there is." *Variant*, with its enigmatic title (a variant on what?), begins as if in medias res with a casual assertion — "Sometimes a word will start it" — an assertion that implies that the poet's addressee — the "you" of line 3 — knows what he's talking about, what "it" is. The reader, as with most of Ashbery's poems, is thus put into the position of listening in on a personal conversation. But the examples given never clarify the narrative: "like / Hands and feet, sun and gloves" — what can these words "start"? "Hands and feet" are an obvious pair, but "sun and gloves" don't go together: we don't wear gloves to protect us from the sun. Will the words trigger a memory? Begin a train of thought? Or prompt "you" to rehearse a familiar story or poem? The cliché "fraught with danger" in line 3 suggests that the poet's companion responds by

referring parodically to an old-fashioned story—perhaps a scene from a Victorian novel or a fairy tale or even an old film.

The conversation, in any case, is squarely between two people, although we cannot say who or what they are. Friends? Lovers? Acquaintances at a party? The "you," of course, needn't be consistent; the long quoted passage (lines 6–18) could, for that matter, just as easily be spoken by a third party, quoted from a book, or refer back to the "I." It doesn't really matter because the tone of *intimacy* that characterizes "Variant" has been firmly established. Speech is not so much heard as overheard, with the reader in the position of someone, say, on a train or at the next table, trying to make sense of the bits and pieces of other people's conversation. What to make, for example, of "you are telling / Me about huge secret valleys some distance / from the mired fighting." Those valleys make me think of the scenery in a film like *The Charge of the Light Brigade*, where the battle is suddenly visible in the open plain. But the phrase "mired fighting" is faintly absurd since fighting is by definition likely to be "mired" in blood or mud. Again, "huge secret valleys" suggest emptiness, but these are "lightly wooded" and have something to do with an eventual outcome, "someday," when a "black, bleeding label" will be pasted "In the sky." The banner of the victors? Veronica's Napkin with the imprint of Christ's bloody face? A shooting star? A second fearful portent, this one heard, not seen, is "the echo" (line 10), penetrating "corridors, alleys, / And tame, surprised places far from anywhere . . . automatically locked out." If those tame places are so "far from anywhere," how do we know the echo penetrates them? And note that the corridors, alleys, and "tame" places are not surprising, as one would expect, but, in what we might call an infrathin move, "surpris*ed*," the past participle granting those places their own agency.

But now the register shifts: "*vox / Clamans*—do you see?" The reference here is evidently to John Gower's *Vox Clamantis,* the long (ten-thousand-line) fourteenth-century poem that recounts in elegiac verse the events and tragedy of the 1381 Peasants' Rising under the reign of Richard II. The *Vox Clamantis* has a moral and prophetic charge, excoriating all orders of mankind and social class for their

corruption and need for reform. "The way . . . fraught with danger," the "mired fighting," the "bleeding label / In the sky": all of these could relate to Gower's dark political tale.

But what is the prophetic charge here? Why the *vox clamans*? the poem has no sooner introduced the *portent* than in a typically Ashberian use of *sdvig*, it turns playful. "Do you see?" in line 13 is the turning point. No use worrying about the "end" when it's the end, not of today, much less imminent, but the "end of tomorrow" — on the face of it, an absurdist locution since we can't know with certainty what the *end* of tomorrow will bring. At the same time, we do know that tomorrow will "end" — it always does even as the sun sets every evening. Whatever the "portent," now, in one of those split-second shifts that Ashbery has spoken of vis-à-vis Reverdy, the mysterious landscape of empty valleys morphs into the world of modern film. "Don't try to start the car," observes the speaker — a warning that brings to my mind the famous scene in Alfred Hitchcock's *Shadow of a Doubt*, where young Charlie (Teresa Wright) tries to start the car her dangerous Uncle Charlie (Joseph Cotton) has tampered with and she is almost asphyxiated in the family garage. It is, after all, Charlie's attempt to find out the truth — to "look deeper / Into the eternal wimpling of the sky" — the medieval word "wimpling," suggests impenetrability (literally a woman's head covering) or rippling — that gets our heroine into trouble. And, come to think of it, *Shadow of a Doubt* is full of portents — signs to be read and echoes to be heard and deciphered. The truth will out, "luster / On luster, transparency floated onto the topmost layer."

So what exactly is happening? Despite the warning not to "look deeper / Into the eternal wimpling of the sky," there seems to be a flash of light — "luster / On luster" — above what may be layers of cloud. Or is the "topmost layer" that of the "silver / Wedding cake" about to dissolve and "overflow"? The preposition "like" introduces another false analogy; neither wedding cakes nor Christmas trees are normally silver unless the reference is to one's silver wedding or an artificial little Christmas tree, all sparkly, from the drugstore. Again, neither Christmas trees nor wedding cakes melt (except in the popular 1960s song "Macarthur Park," which Ashbery surely

knew);[12] hence how can they overflow? And since these are em-
blems of happy occasions, why should the "overflow" produce "a
cascade of tears"? Perhaps the memory that was triggered in line 1
of "Variant" is too painful, triggering a Wordsworthian "overflow"
of powerful feelings. The poem's "you" did warn the "I" that the way
might be "fraught with danger." And now there is not only a pool
but a veritable cascade of tears. Or has the tale told proved to be
cathartic, allowing for the tears to be tears of joy?

I have purposely submitted "Variant" to what may seem an overly
pedantic reading so as to dispel some common misconceptions
about the Ashberian poetic mode. It will not do, for starters, to say,
as many readers have, that this poem has no subject matter or that
it is designedly "non-sensical," or nonreferential. Clearly, this is a
memory poem, the two (or more?) friends (or lovers?) sharing their
recollection of a haunting, mysterious—and evidently painful—
event or set of events. But it is true that the suspension of meaning
allows for an unusually high latitude in interpretation. As Charles
Bernstein has remarked of the poetic syntax in *Rivers and Moun-
tains* (1966):

> Ashbery introduces a nonlinear associative logic that averts both ex-
> position and disjunction. Ashbery's aversion (after *The Tennis Court
> Oath*) to abrupt disjunction gives his collage-like work the feeling of
> continuously flowing voices. . . . The connection between any two
> lines or sentences in Ashbery has a contingent consecutiveness that
> registers transition but not discontinuity. However, lack of logical or
> contingent connections between every other line opens the work to
> fractal patterning. . . . In order to create a third way between the hypo-
> taxis of conventional lyric and the parataxis of Pound . . . and his own
> "Europe" in *The Tennis Court Oath*, Ashbery places temporal con-
> junctions between discrepant collage elements, giving the spatial sen-
> sation of overlay and the temporal sensation of meandering through.[13]

Brian Reed has called this mode *attenuated hypotaxis*—a sequence
of "tenuously interconnected" clauses and phrases "possessing
some relation of subordination to another element," but with the

connections blurred, "inhibit[ing] the formation of clear, neat, larger units."[14] Such "nonlinear associative logic" is reinforced by the verse form itself: note the suspension of line endings, as in "Sometimes a word will start it, like," where the reader has to wait to resolve the question "like what"? and when the answer is given in line 2, the mystery remains unresolved.

What Bernstein calls "a third way" between the parataxis of collage and the hypotaxis of conventional lyric, here depends on the dialectic between overheard intimate speech ("do you see"?) and the artifice produced by echo: here, literally "the echo, flowing freely in corridors," but also the echo produced by the odd sense that every line has already been spoken elsewhere in another context. Everything we see could also be otherwise, as Wittgenstein put it. Indeed, "Variant" is, as the title indicates, a variant on the poet's other approaches to the same subject as well as a variant on many earlier poems, from Wallace Stevens's "The Idea of Order at Key West," with its own "*vox / clamans*" of the girl who "sang beyond the genius of the sea," and whose "fragrant portals" are echoed in Ashbery's "eternal wimpling of the sky," to Eliot's "Gerontion," where "Signs are taken for wonders," to the Victorian motif of the "cascade of tears," the latter phrase recalling *Alice in Wonderland*. Every phrase in this and related poems sounds just familiar enough to recall something else, and yet the collocation of narrative fragments and meditational bits is entirely Ashbery's own. Indeed, when we call this poetry "very close to life," what we mean is that, while something is actually happening, we often cannot understand what it is, especially when the small function words which, as Duchamp taught us, are such precise markers, are regularly occluded. But because that discourse is so capacious, so charged with "news that stay news" whether literary, filmic, operatic, or pop cultural, the reader feels challenged to participate. Indeed, with each reading something new will strike us: when I reread the last three lines of "Variant" in the light of the poem immediately following it in *Houseboat Days*, "Collective Dawns," with its glacier "shot through / With amethyst," I think of the silver showers of fairy tale and legend, where the heavens suddenly open in a parched land, providing

a silver flow of water, a cascade or waterfall of tears. Certainly in animated film there are many such scenes.

Now let us reconsider what Silliman called Ashbery's "cross-over" appeal. For Harold Bloom, poems like "Variant" can be seen to carry on the Romantic visionary tradition: the poet, meditating on a particular situation is moved, by a series of perceptions and memories, to epiphany, to what Stevens calls in "Not Ideas about the Thing but the Thing Itself," "a new knowledge of reality." For the poet Susan Stewart, a scholar of Classical and English Renaissance poetry, it is important that an Ashbery title like "As One Put Drunk into the Packet-Boat" comes from the first line of Andrew Marvell's 1650 satiric poem "Tom May's Death," spoken in the voice of Ben Jonson. Stewart traces the threads of allusion in this, the opening poem of *Self-Portrait in a Convex Mirror*, "the kind of book," she notes, "you can read again and again, constantly churning your first-hand knowledge into second-hand knowledge, holding a pencil or a blue pen or black pen in your hand over and over until just about every line has its underlining and every word is englobed, watching your handwriting change over time, noticing your marginalia become deeper . . . the wave of your own history of reading washing over the pages and your sense of things not developing, but changing, turning into a better fit, a more capacious sense—which is, in the end, what we mean, I would guess, by style."[15]

For Bloom and Stewart—two very different critics—it is Ashbery's "misreading" of earlier English literature that is especially fascinating. At the other end of the spectrum, there are those—say, the Language poets—who admire Ashbery for precisely the opposite quality—not for his ability to carry on the great Renaissance or Romantic traditions, but for what is taken to be his radical deconstruction of the neo-Romantic lyric—the postwar first-person mode of a Mark Strand or Seamus Heaney—in which a consistent and coherent voice is heard throughout, a definable subject relating to the world of external objects outside the self. Such lyric, it has been argued, has none of Ashbery's tonal and emotional range, his deconstruction of voice, his quick shifts from high to low, his syntactic deformations and inversions, reflecting on the state of our culture.

Ashbery's poetry thus draws heavily on the prior experience and preconceptions of his readers: he is much easier to make over in a given reader's own image than is, say, Charles Olson, the historical and geographical parameters of whose work allow no such variability of response. For the critic, the danger of the Ashbery mode has been the ease whereby readers can trace one thread in the poetry, ignoring the ones that interest them less and making one particular thread *the* Ashbery signature. In her review of *A Wave*, for example, Helen Vendler reads the opening poem, "At North Farm," as a deeply Keatsian lyric (it has lines like "Yet the granaries are bursting with meal"), downplaying the very un-Keatsian conclusion, "Sometimes and always, with mixed feelings."[16] John Shoptaw's *On the Outside Looking Out* (1994) finds a queer erotic subtext pervasive, as when he asserts that the lines "'This honey is delicious / *Though it burns the throat*'" ("'They Dream Only of America,'" *CPA*, 44) refer to sperm—a suggestion Ashbery, for one, rejected emphatically, insisting that when he said honey he meant honey.[17] And the assertion, made by Language poets early on, that Ashbery's best volume of poetry was *The Tennis Court Oath*—because here he dared to really Make it New—is a judgment that flies in the face of the reality that in the twenty-plus books that have followed, the cut-up mode of "Europe" has rarely been recycled and that Ashbery himself has tended to disavow it (*Ford*, 54).

The Anxiety of Ashberian Influence?

If criticism has tended to foreground one thread in Ashbery's poetics at the expense of others, what about Ashbery's legacy to later poets? In an enthusiastic essay for Susan Schultz's collection *The Tribe of John* (1995), John Koethe, who was certainly a charter member of that "tribe,"[18] describes the "generic [Ashbery] poem of today" as follows:

The tone is liable to be nostalgic, and its motions those of reverie. Its predominant feelings are passive ones like resignation and loss; its language is resonant and suggestive; the use of the narrative past

tense invests it with a mythological quality; and its overall effect is one of tenderness. It dissociates itself, especially in its transitions and patterns of inference, from everyday ideas of rationality and control; its awareness of language is informed by a sense of its limitations. . . .

This poem is constituted in large part by qualities that have been associated with Ashbery's work since its public reception in the seventies—passivity, an acquiescence in indeterminacy, an avoidance of rationality, and self-reflexivity.[19]

Influential as this paradigm has proved to be, its results, Koethe reluctantly admits, have been "somewhat disappointing." "What seems lacking are substantial bodies of work by individual poets that manifest [Ashbery's] influence but have a distinctive character of their own" (Koethe, 87).

And there's the rub. A poetic signature as unique as Ashbery's allowed for little breathing room among the poets who originally considered themselves his heirs. A notable exception, Koethe believes, is Douglas Crase: in *The Revisionist*, the "high meditative style that emerges in Ashbery from 'Clepsydra' on" is adapted to a more public model; the "private phantasmagoria" characteristic of Ashbery gives way to "the common locales and features of the contemporary American landscape." Indeed, says Koethe, Crase "recovers Whitman through Ashbery—or put another way, he enlists the rhetorical and psychological strategies of the poet many castigate as our most private and hermetic in the service of a public, Emersonian project of reclamation of his own."[20]

Readers will readily recognize Ashbery's rhetoric in such Crase titles as "Heron Weather," "Color Peak Weekend," and "The One Who Crossed the Hudson," and in such opening lines as

What we bring back is the sense of the size of it ("Blue Poles")

The sound of it is always there ("Locale")

The way the physical things add up ("The House at Sagg")

So many versions at any time are all exemplary ("The Lake Effect")

As in Ashbery, the "it" remains undefined, the references indeterminate, and the discourse shifts imperceptibly from concretion to abstraction, from the conceptual to the names of persons and places. At the same time, Crase's verse smooths out the Ashberyan bumps, as in this section (#7) from the title poem:

It wasn't a real season when I saw you last.
Between clouds maybe, because the sun makes me
Remember it as if autumn was rattling
In the air: it was only California though.
It could've been fall but I'd need a calendar
To tell.

Maybe, as if, only, could've been . . . Despite the tentativeness, the poet goes on to give a perfectly coherent account of happy days with his lover in a newly discovered San Francisco, taking in "the view from the top / Of one of those hills, Russian or Telegraph" — days bound to come to an end when "you figure[d] out a way to remain," even as

I'd return overland the way we came,
Through the vast states that entered the Union
At various times, past the little towns
Empty of population and holding their names
On metal sticks at the side of the road:
Fair Haven, Buena Vista, Pleasant View

(Crase, 8–9)

Here Crase's mapping of the cross-country trip is indeed, as Koethe says, more "public" than Ashbery's, if by public we mean accessible. On the other hand, it is also less interesting: the irony of those pretty place names is obvious enough, and the poem's narrative does not allow for the complex layering of meanings found in such Ashbery poems as "Variant," with its "silver / Wedding cake" and "*vox / Clamans.*" Crossing the all-too-huge continent, the solitary lover finds himself in those "little towns / Empty of population"

in "vast states that entered the Union / At various times." Gently elegiac, the poem displays Ashbery's manner without the master's matter—without the sense that, in Ashbery's words on Reverdy, "one can have the impression one moment of contemplating a drop of water on a blade of grass; the next moment one is swimming for one's life."

But in 1981, in the wake of what were often taken to be the intractable obscurities of Ashbery's poetry, such lowering of the temperature must have come as a relief. *The Revisionist* won its hitherto unknown author a Guggenheim as well as a MacArthur Fellowship. "This is the most powerful first book I have seen in a long time," declared John Hollander on the dust jacket, and David Kalstone compared *The Revisionist* to such first books as Wallace Stevens's *Harmonium* and Elizabeth Bishop's *North and South*.[21] This emphasis on "first books" turned out to be unfortunate because *The Revisionist* turned out to be not only Crase's first book of poems but his only one—and one out of print until its recent reissue in a new edition edited by Mark Ford.[22] In the intervening years, Crase has written charming essays as well as art criticism, but he seems to have understood, better than his early admirers, that when it came to poetry his was a performance that could not quite be repeated; indeed, *The Revisionist* is best understood as a symptom of the willed indirection and abstract meditation practiced by Ashbery's followers—a combination that soon hardened into a period style. As Crase himself put it in a poem called "Felix Culpa Returns from France" (72), "As the fact is too difficult to forgive / It seems unnatural to resume" (lines 1–2).

In interviews, Ashbery always insisted that the label "New York School" was misleading, at least so far as the poets rather than the painters were concerned, and that he, Frank O'Hara, Kenneth Koch, and James Schuyler just happened to be good friends who exchanged their work and sometimes collaborated. Thus, in an address written for the National Book Awards symposium of 1968, Ashbery wryly remarks:

On the whole I dislike the name [New York School of Poets] because it seems to be trying to pin me down to something. That's the trouble

with all these labels like Beat, San Francisco School, Deep Image, Objectivist, Concrete and so on. Their implication seems to be that poetry ought to be just one thing and stick to it. If you start out writing haikus, man, then it's haikus from here on in sort of thing.[23]

Rather than such prescriptions, Ashbery insists, the poet should be free to do what he wants, "without feeling that someone is standing behind him, telling him to brush up on his objective correlatives or that he's just dropped an iambic foot."[24] He cites Henri Michaux's insistence that "he wasn't a Surrealist, but that Surrealism for him was *la grande permission*." "The big permission," concludes Ashbery, "is, I think, as good a definition as any of poetry, of the kind that interests me at any rate" (116). Ashbery uses the phrase *la grande permission* again in an essay for *Art News*, "The Heritage of Dada and Surrealism," where he is critical of Surrealism but praises its opening of the field—an opening that permitted later poets to take certain chances.[25] What, we might now ask, has Ashbery's own *grande permission* made possible for poets writing in the twenty-first century?

Influence, of course, never moves in a straight or predictable line. In the 1950s, William Carlos Williams wrote enthusiastic essays on such of his disciples as Norman MacLeod, Merrill Moore, Reed Whittemore, Parker Tyler, and Eli Siegel—disciples now largely unread. At the same time, later "strong" poets, to use Harold Bloom's term, eluded Williams's grasp: he did not like the direction Allen Ginsberg's work was taking in *Howl*—"His longer lines don't seem to fit in with the modern tendency at all"—even as he regularly complained to Louis Zukofsky that the latter's language was too "abstract."[26] Even Robert Creeley, a poet clearly in Williams's debt, came to invert the program of "No ideas but in things." Conversely, Pound's highly particularist collage mode, repudiated as it was by American poets of the post–World War II era, turns up in the Concrete poetry of Brazil of the 1950s, the poets Augusto and Haroldo de Campos naming their journal *Noigandres* in honor of the *Cantos*, where the mysterious word first appears.

When we try to assess Ashbery's place in contemporary poetry,

therefore, we must look beyond the immediate family, the "tribe of John" from John Ash to John Yau, and follow some other leads.[27] When, in their 2002 "conversation," Mark Ford asked Ashbery whether he had been following the experiments of the Language poets, Ashbery responded: "Yes, but from a distance. . . . Probably like Surrealism it will become more fascinating as it disintegrates—or like Minimalism in music: it's like there's a certain hard kernel that can stand the pressure only so long, and then it starts to decay, giving off beneficial fumes" (*Ford*, 65).

This is not as silly as it sounds. What Ashbery is saying, I think, is that whereas the hardcore theorizing of the Language movement of the 1980s and 1990s did not speak to him, as the movement has, over time, like all movements, "disintegrated"—opened up, become less doctrinaire—a number of its individual practitioners have come to seem congenial to him. Two such poets are Rae Armantrout, a poet Ashbery warmly praised,[28] and Charles Bernstein, whose work the elder poet had come to admire by 2010, when he wrote the following blurb for the dust jacket of *All the Whiskey in Heaven*: "Charles Bernstein's poems resemble each other only in being unexpected. Simultaneously mad, tragic, and hilarious, they seem written to illustrate the truth of his lines 'thing are / solid: we stumble, unglue, recombine." *All the Whiskey in Heaven* is "a vast department store of the imagination."[29]

The link between A(shbery) and B(ernstein) seems at first glance improbable. The reticent, gay, Protestant poet from an upstate New York farm, who comes squarely out of the Romantic lyric tradition and considers the writing of literary or art criticism, as well as teaching, as strictly secondary activities, seems wholly unlike the New York City Jewish poet-theoretician, purposely brash and culturally oriented, more than twenty years his junior, who has always been heavily engaged in group activities, making his early reputation as the co-editor, with Bruce Andrews, of the journal $L=A=N=G=U=A=G=E$ (1978–81) and the movement it spearheaded (the homemade little journal had no cover, and its pages were photocopied and stapled together), then as the founder

of the Buffalo Poetics Program and, with Al Filreis, the creator of PennSound at the University of Pennsylvania, where he held an endowed chair. Although Bernstein is now himself something of an *eminence grise*, whose poetry has been widely translated and disseminated around the world, he has never had anything like the universal acclaim accorded to Ashbery. For many mainstream poetry readers and reviewers, he is still the "bad boy" of poetry—incomprehensible, incoherent, and hypertheoretical. Even those who admire his contribution to poetics—Bernstein's extensive theorizing—have tended to be skeptical about the poetry itself. But now that Bernstein is seventy and a recent winner of the Bollingen Prize (Ashbery was close to fifty when *Self-Portrait* made him famous), a more accurate picture is emerging. The two poets have read together at various venues, and Bernstein was one of the poets invited to contribute an essay, on *Rivers and Mountains*, to the important *Conjunctions* portfolio commemorating Ashbery's eightieth birthday in 2007.

What, then, is the "permission" the elder statesman has given to the radical younger poet? The most overtly Ashberian poems in Bernstein's *All the Whiskey in Heaven: Selected Poems* (2010) are, ironically, the earlier ones: for example, "Dysraphism" (from *The Sophist*, 1987). The title is taken from a medical dictionary: when it was first printed in *Sulfur* in 1983, Bernstein provided the following headnote:

> "Dysraphism" is actually a word used by specialists in congenital diseases, to mean "dysfunctional fusion of embryonic parts"—a birth defect. . . . "Raph" of course means "seam," so for me dysraphism is mis-seaming—a prosodic device! But it has the punch of being the same root as rhapsody (*rhaph*)—or in Skeats—"one who strings (lit. stitches) songs together, a reciter of epic poetry." cf. "ode" etc. In any case, to be simple, Dorland's [the standard US medical dictionary] does define "dysraphia . . . as "incomplete closure of the primary neural tube; status dysraphicus'; this is just below "dysprosody" [*sic*]: "disturbance of stress, pitch, and rhythm of speech."[30]

This elaborate definition was removed in all subsequent printings of "Dysraphism": evidently, Bernstein—and Ashbery would surely agree—found the elaborate explanation too pedantic, too extra-poetic. The long poem begins:

> Did a wind come just as you got up or were
> you protecting me from it? I felt the abridgement
> of imperatives, the wave of detours, the saber-
> rattling of inversion. *All lit up and no*
> *place to go.* Blinded by avenue and filled with
> adjacency. Arch or arched at. So there becomes bottles,
> joshed conductors, illustrated proclivities for puffed-
> up benchmarks. Morose or comatose. "Life is what
> you find, existence is what you repudiate." A good example
> of this is 'Dad pins puck.' Sometimes something
> sunders; in most cases, this is no more than a hall.
>
> (*Whiskey*, 114)

The entry into the poem's conversation in medias res, with the direct address, or rather question, to an unnamed "you" is certainly Ashberian, as is the lack of continuity between question and answer. Like Ashbery, Bernstein emphasizes the confusion and contingency of contemporary life: if the authority of imperatives is abridged, dissolving in a wave of detours and threats of inversion, something is obviously wrong. Bernstein's allusions are even more absurd than Ashbery's: the italicized words in lines 4–5, for example, are a play on the common cliché, "All dressed up and nowhere to go," and this speaker sees his compatriots as "blinded," not, as the common phrase would have it, by love but by "avenue," as in Fifth or Madison Avenue, where wealth is displayed to fill us, not just with longing, but with "adjacency"—the sense that it rightfully belongs to us. As in Ashbery's poems, words pop up in surprising slots, and a phrase like "Arch or arched at," leads to a false connective, as does the "So" of "So there become bottles." "Life is what / you find," a burlesque version of "Truth is where you find it," is followed by insurance-

speak: Life Insurance is what one can manage to find even as one doesn't know how to handle one's very "existence." And of course the example given is again a *dysraphism,* an echo of "Pin the tail on the donkey" morphing into hockey (puck) and football (punt) talk.

Ashberian surprises and sudden shifts thus abound, as does wordplay, syntactic indeterminacy. But despite these similarities, Bernstein's discourse radius is rather different from Ashbery's: his lines are charged, not with erotic double entendre, as are the elder poet's, but with allusions to money, to business practices and cap-italist exploitation, as in "puffed- / up benchmarks." The clichés of modern urban life, whether of family or business life, the inanity of popular culture: these replace Ashbery's more personal and deeply literary discourse, and make for a nervous, urban speech unlike Ashbery's, which is primarily rooted in the natural landscape. Then, too, Bernstein's verse foregrounds artifice rather than casual talk; it is tightly constructed, with parodic internal rhyme ("Morose or comatose"), alliteration, and false parallelism ("Blinded by avenue and filled with / adjacency"). And Ashbery is a more narrative poet than Bernstein: memory and images of the past, so prominent in Ashbery, play little role in Bernstein's poetry of the *present.* Still, however, I would say that, stylistically and tonally, "Dysraphism" is more inherently Ashberian than is the poetry of Douglas Crase.

But—and this is where permission comes in—the more recent Bernstein—with his satiric list poems, ballads, and pseudo-songs—has moved in a rather different direction. Ashbery was never an aphoristic poet; by contrast, Bernstein, whether in the "Amphibo-lies" of *Shadowtime* or in "War Stories," is given to creating whole poems out of faux-aphorisms, like the following:

War is the extension of prose by other means.
War is never having to say you're sorry.
War is the logical outcome of moral certainty.
War is conflict resolution for the aesthetically challenged.
War is a slow boat to heaven and an express train to hell.

(*Whiskey,* 283)

And so it goes for another eight pages, a sequence much more overtly critical of US policy than anything we would find in the refractions of Ashbery's self-ironies. Even when the poems seem personal, the alienation dramatized is that of the social order rather than the self-questioning one finds in Ashbery. Consider a later ballad called "Doggy Bag":

Have you seen my doggy bag
hate to nag, hate to nag
have you seen my emerald chain
hate to brag, hate to brag

I ate the supper in the village
lunch at the lodge
if you don't give me back my
upper teeth
I am going to drool like a

man that once had silver
man that once had gold
man that once had everything
but a tune of his own

so have you seen my nodding mare
my lurking pony, my sultry donkey
have you seen my cuts and jags
hate to frag, hate to frag
have you seen my broken drum
hate to gab, hate to gab

the toilet seat is down now
it's there I plan to sit
until I find that doggy bag
I lost while just a kid

(*Whiskey*, 241–42)

The plaintive opening question is absurd: a doggy bag is a paper or plastic receptacle used by restaurants to wrap up leftovers the customer chooses to take home and thus is hardly valuable. Then again, the epithet "doggy" suggests that the question is a young child's. The stanzas that follow with their faux fairy-tale content and childish rhymes, bear this out: expectations are repeatedly raised only to be deflated, as when in stanza 2, "lodge" doesn't rhyme with "teeth," and the "child" turns into a toothless and drooling old bum, wholly disoriented and without a "tune of his own." But the crescendo comes in stanza 4, where the rhyming on "bag," "nag," "brag," leads us to "frag"—army slang, dating from the Vietnam War, for killing one's own officer with a fragmentation bomb or hand grenade. The war over, *frag* came into use in video games, designating the act of knocking off someone on one's own side. In this context, the "cuts and jags" and "broken drum" of stanza 4 take on a much more sinister air, as does the village of stanza 2 and the mysterious "nodding mare," "lurking pony," and "sulky donkey"—animals that seem to emerge from a Grimm fairy tale.

But, again as in Ashbery, the story presented is hardly coherent. If this is, as "frag" suggests, a war poem, it is also a ballad of narcissism and regression: in the end, the sulky "I" announces grandly that he is sitting on the toilet seat, "Until I find that doggy bag / I lost while just a kid." "Kid" fails to rhyme with "sit," the sonic deflation pointing to the absurd bravado of this speaker, wounded physically or at least mentally, who has obviously never grown up. "Doggy Bag" is hilarious in its inconsequentiality, its comic air of self-importance. It is also a very sad little poem.

"Have you seen my emerald chain . . . my sultry donkey"? In his late poetry, Ashbery often constructed similarly absurd catalogues, as when, in a poem called "Mottled Tuesday," the speaker complains:

Hey, you're doing it, like I didn't tell you
 to, my sinking laundry boat, point of departure,
 my white pomegranate, my swizzle stick.[31]

The curious frisson of such lists depends on the possessive pronoun "my." What, in the current climate, *is* ownership? "The Binomial Theorem," a neighboring poem in Ashbery's *A Worldly Country*, begins with chitchat about "shortfalls" and the "chattering classes," only to turn, as suddenly as that water drop in Reverdy, to the urgent question "What time is it? Or was it?" And then:

> Imagine that you can have this time any way it comes
> easily, that a doctor wrote you a prescription
> for savage joy and they say they can fill it
> if you'll wait a moment. What springs to mind? (48)

Wouldn't it be nice to have such a prescription filled? Almost as comforting as a doggy bag to take home. But the reality is very different: the poet walks out of the drugstore, trying to catch "the bus that stops at the corner of 23d Street," only to have the traffic light change from red to green; the bus chugs off, leaving him "out of breath and silly from running."

It is the archetypal New York experience. But what happens next? Does our protagonist have a heart attack? Or trip on the curb? No, he is irrelevantly accosted by "Someone standing near the door" who is "doing a survey / of transit users." Life, this poem reminds us, is like that: the mathematical theorem is never solved. Rather:

> All the way home we argued about whether
> refunds would be made in cash or against future purchases.
> It's the only way you said. We'll end up wanting these anyway.

In this, the poem's conclusion, the slapstick of the traffic incident takes a dark turn. The references to "future purchases," "the only way," and "we'll end up" turn metaphorical: there are no rebates against death.

"Funny odd or funny peculiar?" Bernstein quips in the poetic preface to *Content's Dream*, denying the two alternatives posed by the familiar children's question, "Funny ha-ha or funny peculiar?"[32] The irreducible oddity (hardly a joke!) of private as of public

life is as central to Ashbery's poetics as it is to Bernstein's. The introspective mode of Romantic lyric is no longer an option, given the "new trends in passionate landscapery" (*Worldly Country*, 48) that characterize our preposterously mediated present—a present where the *event* has always already been replaced by a new version of its parameters.

Funny odd or funny peculiar? What I see happening in poetry today is that the "circulation of the nowhere seen, everywhere disturbed," presented in *Content's Dream* (10) and so poignantly and comically conveyed in Ashbery's famous ruminative lyrics, is increasingly being grafted onto its supposed other: the literalist, highly concrete and nominalist Poundian mode, made up of ideograms, images, and proper names that have long been absent from lyric, including Ashbery's own. From Bernstein's "Dysraphism" and "Doggy Bag," to Peter Gizzi's juxtapositions in his Ashberian "The Outernationale" or the mock-troubadour "Phantascope," with its echo of Pound's "Cino"—"I have twirled, dropped crumbs, / spent days in archives"—to the documentary lyricism of Cole Swensen's *Ours* or Elizabeth Willis's *Turneresque*, to Craig Dworkin's ekphrastic *Dure*, whose deconstructive play on a Dürer drawing represents a latter-day version of *Self-Portrait in a Convex Mirror*, the two modes begin to fuse. Here I come back to that other Language poet I cited above: Rae Armantrout.

In a perceptive foreword to Armantrout's 2001 collection *Veil*, Ron Silliman observed that "Armantrout belongs to what might be characterized as the literature of the vertical anti-lyric, those poems that at first glance appear contained and perhaps even simple, but which upon the slightest examination rapidly provoke a sort of vertigo effect as element after element begins to spin wildly toward more radical (and, often enough, sinister) possibilities."[33] The "vertigo effect" Silliman speaks of is applied by Armantrout herself to Ashbery's poetry in a commemorative op-ed piece for the *New York Times*.[34] "Ashbery's poems," she writes, "are like involved daydreams from which, as with real dreams, there is no obvious exit. . . . The action is always in transit, always hovering somewhere between the last line and the next in a sort of quantum superposition."

Silliman's term "vertical anti-lyric," thus links Ashbery to Armantrout's particular variant of Language poetry. Her first published poems, she herself recalls, "were minimalist and neo-Imagist," in the tradition of Williams and Robert Creeley.[35] At Berkeley in the mid-1970s, Armantrout took a poetry workshop from Denise Levertov, who taught her, she recalls, the importance of line breaks.[36] But unlike Levertov—or Williams and Pound before her—Armantrout was never quite comfortable with Imagism or the reliance on what Pound called the "luminous detail." She was soon breaking the Williams mold, and her mature poems, prosodically similar as they are to her precursor's, are more radical than his or Levertov's in their syntactic and semantic indeterminacy—a calculated ellipsis that recalls the Ashbery of "Variant." Here is a poem called "Close" from *Next Life* (2007):

1

As if a single scream
gave birth

to whole families
of traits

such as "flavor," "color,"
"spin"

and this tendency to cling.

2

Dry white frazzle
in a blue vase—

beautiful

a frozen swarm
of incommensurate wishes.

3
Slow, blue, stiff
are forms

of crowd behavior,

mass hysteria.

Come close.

The crowd is made of
little gods

and there is still
no heaven[37]

At first sight, "Close" and its neighboring poems look like such Williams poems as "Between Walls":

the back wings
of the

hospital where
nothing

will grow lie
cinders

in which shine
the broken

pieces of a green
bottle[38]

Here the denotative meaning of each word and the poem's syntax are perfectly coherent, however much the poem's distinctive linea-

tion (as in "will grow lie") and ellipsis creates wide possibilities for interpretation. "Close" is quite different, its language much more abstract and syntactically ambiguous. The poem's three sections (seven, five, and nine short lines, respectively, with no line having more than five words) seem at first quite unrelated, the opening "As if" serving, as in Ashbery's poems, as a false analogy. The setting in which the poet's ruminations occur is not given, but one surmises from neighboring poems like "Theory of Everything" (13), where we read "but Mother / was no longer playing," that the scene may be a hospital room and the dying patient the poet's mother—a mother who wants her daughter to feel "close" to her. The "single scream," whether actual or metaphoric, reminds the poet that the *closeness* in question guarantees the inheritance of "whole families / of traits." But the validity of family resemblances is immediately undercut because the "traits" evoked—"'flavor,' 'color,' / 'spin'"—are not really traits at all: "flavor" is a matter of taste, "color," a racial marker, and "spin," perhaps a reference to the mother's (or other person's) attempt to slant the facts as well as to display "this tendency to cling." But is such a tendency a trait one can inherit? It doesn't help much to learn that, as Armantrout explained it at a poetry reading, the words in question come from the nomenclature of particle physics, that these are the properties assigned to subatomic particles. For just how, the reader wonders, is this nomenclature relevant. The line breaks, in any case, further undermine the argument for genetic predisposition: these connections, Armantrout implies, are just a lot of "spin."

Armantrout's use of ellipsis and the silence of white space is radical: the reader is prompted to fill in many blanks in order to make any sense at all of her abrupt abstractions. In section 2, the poem shifts gears, the image now one of "Dry, white frazzle / in a blue vase"—evidently a bouquet of dying flowers, such as one sees in a hospital room. How can the visitor respond except to say *"beautiful"*? But underneath the politeness, the poet is cruelly—and with pointed alliteration—characterizing that "white **frazzle**" as "a **frozen** swarm / of incommensurate wishes." Whose wishes, the

poet's or the flowers' recipient's? One cannot know for sure, but the poem bristles with an understated hostility, a sense of fracture.

The third section, with its exhortation to "Come close" — close to the patient's bed, close to death, close to a new understanding — provides yet another twist to this narrative. The adjectives "Slow, blue, stiff," referring back to the vase of flowers, are now seen as characterizing the dead as well as "forms / of crowd behavior." Not the screaming crowd of political rallies or ball games, of course, but perhaps the moving crowd in a Fascist parade or a religious procession with its "mass hysteria." Such processions have a sort of beauty too, don't they? And the participants think of themselves as special people — "little gods." But — and here is Armantrout deflating her picture still further — "there is still / no heaven." The crowd of little gods gets nowhere, and as for the poet's daughter, who does not believe in an afterlife, death can bring no consolation.

"My poetry," Armantrout remarks in "Cheshire Poetics," "involves an equal counterweight of assertion and doubt. It's a Cheshire poetics, one that points two ways then vanishes in the blur of what is seen and what is seeing, what can be known and what it is to know. That double-bind."[39] This is an apt comment on what happens in a poem like "Close." As in Ashbery's lyric, so much depends, here and in Armantrout's other poems, on what is *not* said. Silence (or the white space of the page) is a central element in these poems, especially since they regularly begin in medias res. "As if a single scream / gave birth." To what is the scream being compared? And who is making the comparison? Armantrout's is, in John Ashbery's words in *Three Poems*, "an open field of narrative possibilities," although the narrative here is all but buried.[40] We can say that "Close" is "about" family tension, about DNA, family ritual, and self-delusion, and that for this poet, family rites and their religious counterpart are closely linked. But "Close" is also a poem about the difficulty of communication, of reaching out to a loved one and getting what feels like a busy signal. *Closeness* to death does not make the principals *close*. But that absence of *closeness* is troubling.

Armantrout's chief device — extreme ellipsis — recalls Ashbery,

although she carries the mode to its extreme, leaving the reader to fill in the blanks. Her allusions are less literary than Ashbery's, less political than Bernstein's, but all three poets share a studied obliqueness coupled with radical condensation and the reliance on what is *not said*. As Ashbery famously put it in the opening line of "And *Ut Pictura Poesis* Is Her Name," "You can't say it that way anymore"(*Houseboat Days*, 45). In its early stages, the Language movement, of which Armantrout was a charter member, set itself against the New York poetry of the 1960s, with its casual, colloquial diction and O'Haraesque "Personism," but I would submit that the treatment of *language* on the part of poets like Armantrout and Bernstein has its roots in the punning and fragmentary double entendre, the split-second time shifts, ellipses, and pronomial uncertainty that is Ashbery's signature. It is especially interesting to see how Armantrout's minimalist free-verse lines, seemingly written under the sign of Williams and Levertov, take on an unexpected hard edge:

> It both hurtles,
> and fidgets,
>
> otherwise
> it's empty space?[41]

The answer to the latter question is yes.

6

The Trembling of the Veil

Poeticity in Beckett's "Text-Soundings"

I am starting a Logoclasts' League. . . . I am the only
member at present. The idea is ruptured writing, so
that the void may protrude, like a hernia.
SAMUEL BECKETT[1]

The opening poem of *Echo's Bones and Other Precipitates* (1935), the
only volume of poems in English that Beckett published as a distinct
collection,[2] is called "The Vulture":

> dragging his hunger through the sky
> of my skull shell of sky and earth
>
> stooping to the prone who must
> soon take up their life and walk
>
> mocked by a tissue that may not serve
> till hunger earth and sky be offal
>
> (*CPB*, 5)

Beckett himself told friends that "The Vulture" alluded to Goethe's
famous "Harzreise im Winter," whose opening five lines were "for
ever in my head" (*CPB*, 261). That stanza reads:

Dem Geier gleich,
Der auf schweren Morgenwolken
Mit sanften Fittig ruhend
Nach Beute schaut,
Schwebe mein Lied.

Translated into English, "Like the hawk, its soft wings resting on heavy morning clouds, that watches for prey, let my song take flight."[3] In the German of Goethe's time, the noun *Geier* referred to any bird of prey—hawk, falcon, vulture—the point being that in Roman mythology, such birds were the companions of the ancient gods. The vulture, for that matter, has often been taken to symbolize the cleansing and renewal of the earth of the dead. Indeed, "Harz-reise im Winter" is a Romantic ode, calling on the gods to grant the poet the energy to transform his everyday world, even as he recognizes the negative forces that threaten his success. From its opening suspended line with its strong alliteration and assonance, Goethe's quest poem, complex and conflicted, looks to the natural world for sustenance.

Beckett turns Goethe's melodious ode inside out: his three uneven and unrhymed couplets present creativity as a vulture gnawing at the poet's skull, "mocked by a tissue" that dissolves into mere offal. Here inner ("skull") and outer ("shell of sky and earth") are one and the same, nature providing no more than what Gerard Manley Hopkins called "carrion comfort." To transmit this sense of waste, Beckett uses contorted syntax, curious nominal apposition (as in "till hunger earth and sky"), and intentionally grating rhythms.

The author of "The Vulture" as well as the Provençal-inspired *albas, enuegs, sanies,* and *serenas* of *Echo's Bones,*[4] was a deeply learned and deeply unhappy young man, writing in defiance of what we might call, following Charles Bernstein, "official verse culture"—the culture of his Irish Protestant family and community. In his early work, such *contra-diction* took the form of subversion: the task, whether in the novel *Murphy* or in the early poems, was to deconstruct the established poetic and fictional modes of the day by using inappropriate, even shocking, language, as in "Exeo in a

spasm / tired of my darling's red sputum" ("Enueg 1") or "like a Ritter with pommelled scrotum" ("Sanies 1"). Beckett's early letters, especially those to his great friend Thomas McGreevy, express, at every turn, this stance of tough sarcasm, for example:

> The abominable old bap Russell [the Irish poet George Russell, whose pseudonym was AE] duly returned my MSS with an economic note in the 3d person. . . . I would like to get rid of the damn thing but I have no acquaintance with the less squeamish literary garbage buckets.[5]

Or, to the editor Samuel Putnam: "How are things? Must try & arrange a proper booze before I return—like a constipated Eurydice to the shades of shit" (9 September 1930, *LSB*, 1:47). As for his own poetic efforts, he was given to intense self-criticism:

> Nothing seems to come off. . . . I began a poem yesterday . . . a blank unsighted kind of thing, but looking at it is clear that it can never turn out to be more than mildly entertaining at the best. The old story—ardour and fervor absent or faked so that what happens may be slick enough verse but not a poem at all. (to Thomas McGreevy, 13 September 1932, *LSB*, 1:121).

"Slick enough verse but not a poem at all": what Beckett doesn't quite say, and neither do critical discussions of *Echo's Bones*, my own included, is how traditional these would-be oppositional poems really were.[6] "The Vulture" may well be a dark parody of Goethe's expansive ode, but it respects the prescribed norms of lineation and stanzaic structure (as do the *enuegs* and *serenas* and *sanies*) and adopts the compact Symbolist mode of Beckett's forebears (some of whom, like Rimbaud, he was translating at the time) so as to create a neatly framed construction of images.[7]

The publication of Beckett's correspondence, especially the first volume (1929–40), has given us a whole new sense of what a slow starter Beckett was. The letters make painful reading: from his twenty-third year, when he sends James Joyce the corrections for

his forthcoming essay "Dante . . . Bruno. Vico . . Joyce," commissioned for *transition* (23 September 1929, *LSB*, 1:7), to the outbreak of World War II ten years later, Beckett, however learned, precocious, and brilliant, was essentially an author in search of a subject and method. *Making It New* via send-up and scatology could take him only so far. Indeed, his relationship to his precursors—English, French, Italian, and Classical—was characterized by an acute anxiety of influence. Augustine and Dante, Spenser and Milton, Yeats and Joyce (the former to become the hero of his later years, the latter, his early mentor): where could an astonishingly well-read, deeply literary young Irishman, teaching French in Dublin and Paris, find his own place? How to make the leap from a poetry he himself knew to be excessively mannered to what we have come to know as the Beckettian vision?

Here two letters, both of them often cited but difficult to parse, are germane. The first, to McGreevy, thanks his friend for praising one of his poems, but then goes on to say:

> My feeling is, more and more, that the greater part of my poetry, though it may be reasonably felicitous in its choice of terms, fails precisely because it is *facultatif*. Whereas the 3 or 4 I like . . . do not and never did give me that impressions of being *construits*. I cannot explain very well to myself what they have that distinguishes them from the others, but it is something arborescent or of the sky, not Wagner,/not clouds on wheels; written above an abscess and not out of a cavity. . . .
>
> There is a kind of writing corresponding with . . . fraudulent manoeuvres to make the cavity do what it can't do—the work of the abscess. I don't know why the Jesuitical poem that is an end in itself and justifies all the means should disgust me so much. But it does—again—more and more. I was trying to like Mallarmé again the other day, & couldn't, because it's Jesuitical poetry, even the Swan & Hérodiade. I suppose I'm a dirty low-church P. even in poetry, concerned with integrity in a surplice. I'm in mourning for the integrity of a pendu's emission of semen, what I find in Homer & Dante & Racine & sometimes Rimbaud, the integrity of the eyelids

coming down before the brain knows of grit in the wind. (18 October 1932, *LSB*, 1:133–34).

This passage seems contradictory. If poetry is excessively *construit* (constructed), how can it, at the same time, be *facultatif*, which is to say arbitrary? And what are those "fraudulent manoeuvres" that try to make the "cavity do what it can't do—the work of the abscess"? If we take the word "cavity" to refer to a given poem's genre and verse form, its lyric container, whether Provençal *alba* or Mallarméan sonnet (like "Le vierge le vivace, et le bel aujourd'hui," which Beckett cites as "the Swan"), the meaning of "abscess" becomes clear. Poetic constructions that are *facultatif*—what Beckett here calls "clouds on wheels"—are "fraudulent manoeuvres" because, although arbitrarily assembled, they are not designed to allow for surprise—the unanticipated reality which is unnamable—in Beckett's words, the "pendu's emission of semen." The reference here is to poetic *difference*—"the integrity of the eyelids coming down before the brain knows of grit in the wind"—which is a perfect example of the Duchampian *infrathin*.[8]

Poetry, Beckett is implying, cannot be constrained by *genre*. To think in terms of the individual lyric poem with its subgenres—ode, elegy, *alba*, epigram—is, he suggests, to privilege the "cavity" over the "abscess," which is the *matter* of the poem: namely, its language. In attacking the "Jesuitical poem that is an end in itself and justifies all the means," even when its proponent is the Mallarmé of the famous sonnets, is, to use Classical terminology, to subordinate *poiema* (a thing made, the poem) to *poiesis* (the making of poetry) and *poietike* (poeticity), the latter the favored term of such Russian Formalists as Roman Jakobson. Contemporary theoreticians like Jonathan Culler and Virginia Jackson take the lyric genre as their principle of classification, but Beckett's own unease with the designation anticipates the work of twentieth- and twenty-first-century poets.[9] From Eliot's *Waste Land* and Pound's *Cantos* to the present, *the lyric* no longer seems to furnish the most appropriate system of classification, there being, after all, no "dramatic poetry" (replaced by "drama") and barely any poetry that is predominantly

narrative. Beckett himself increasingly shifted from the dominant genres to radio and television plays, dance works, and especially what he called *texts* (as in "Texts for Nothing") or *pieces*—short "prose" compositions that defy traditional classification. And here the second important letter comes in—Beckett's letter to his friend Axel Kaun, originally composed in German:

> It is indeed getting more and more difficult, even pointless, for me to write in formal English. And more and more my language appears to me like a veil which one has to tear apart in order to get those things (or the nothingness) lying behind it. Grammar and style! To me they seem to have become as irrelevant as a Biedermeier bathing suit or the imperturbability of a gentleman. A mask. It is to be hoped the time will come, thank God, in some circles it already has, when language is best used where it is most efficiently abused. . . . To drill one hole after another into it until that which lurks behind, be it something or nothing, starts seeping through—I cannot imagine a higher goal for today's writer.
>
> Or is literature alone to be left behind on that old, foul road long ago abandoned by music and painting? Is there something paralysingly sacred contained within the unnature of the word, that does not belong to the elements of the other arts? Is there any reason why that terrifyingly arbitrary materiality of the word surface should not be dissolved? (9 July 1937, *LSB*, 1:512–21, p. 518)

If the deconstruction of genre is the first step, the second is the deconstruction of "Biedermeier" style and syntax—Beckett here linking the heavy, dark furnishings of the mid-nineteenth-century bourgeois household with what the Romantics dismissed as Poetic Diction: familiar phraseology, cliché, circumlocution, stale metaphor. The other arts, Beckett recognized, were way ahead of literature in this regard, painting, for example, having long since given up "realistic" representation in favor of Expressionist, Cubist, and Surrealist distortions. But in poetry, especially his own native poetry? Not even Joyce's "apotheosis of the word," Beckett explained to Kaun later in his letter, could serve as a model for the newly de-

sired breakthrough of the "word surface." Rather, "Gertrude Stein's Logographs come closer to what I mean. The fabric of the language has at least become porous, if regrettably only quite by accident." Beckett evidently took the view that Stein's was no more than automatic writing, but he sensed that she alone was "on the road toward this, for me, very desirable literature of the nonword" (*LSB*, 1:519–20).

But what would the "literature of the nonword" look like? Six months after formulating his critique of the "language veil," on the night of 6 January 1938, Beckett, while walking home from a Paris café late at night with friends, was accosted by a stranger and stabbed.[10] The knife barely missed his heart: after two weeks in the hospital, Beckett, recovering in his hotel room and still in pain, wrote McGreevy (27 January 1938), enclosing the following "poem" that "dictated itself to me night before last":

> they come
> different and the same
> with each it is different & the same
> with each the absence of love is different
> with each the absence of love is the same
>
> (*LSB*, 1:598)

This little poem has an interesting publishing history: "I sent 'they come' (translated by [Alfred] Péron as 'ils viennent!!')," Beckett tells McGreevy a few weeks later, "to *Ireland To-day*, where the great purity of mind & charity of thought will no doubt see orgasms where nothing so innocent or easy is intended, and reject the poem in consequence" (*LSB*, 1:597n11). Rejected it promptly was, but after the war it appeared in English in Peggy Guggenheim's memoir *Out of This Century* (1946) and then in French—translated by the poet this time—in Jean-Paul Sartre's journal *Les Temps modernes* (November 1946):

> elles viennent
> autres et pareilles

avec chacune c'est autre et c'est pareil
avec chacune l'absence d'amour est autre
avec chacune l'absence d'amour est pareille

(*CPB*, 91)

The "elles," according to an editors' note in Beckett's *Collected Poems* (375), referred to the three women—Suzanne (his future wife), Peggy, and Adrienne Bethell—with whom Beckett was entangled at the time of writing; the poet himself describes this and his other new poems (thirteen in all) published in *Les Temps modernes* as "French anacreontics," short poems in the manner of Anacreon, in praise of love or wine.[11]

"They come/elles viennent" may look slight, but it is certainly, as the editors note, the product of "a deliberate simplification and refinement of means and method, reducing if not wholly abandoning, allusions, [and] exploring the self-sustaining subtleties of syntax" (*CPB*, 373–74). One poet who perceived this was John Cage, who chose this particular "Anacreontic" as the source of his own minimalist poem, a thirteen-word mesostic.[12] In "they come," as in the other *Poèmes 37–39* (see *CPB*, 91–102), Beckett does not yet abandon lineation—the texts still *look* like poems—but the removal of the "veil" he talks about in the letter to Kaun is the result, not merely of "simplification" but, more precisely, of mystification. There is not a word in "they come," that a reader must look up, and yet what is the poem saying?

The opening line can indeed, as Beckett tells McGreevy, refer to orgasm, but it can also mean literally that the unspecified "they" come to see the speaker. We know nothing about circumstances or the women's feelings, and Beckett avoids the first-person pronoun entirely, presenting the poem's statement as impersonally and anonymously as if we were looking at the procession of figures on a Greek vase. Yet the repetition of abstract nouns and adjectives is carefully designed to imply that the *difference* which is *sameness*, or sameness which is difference, is the manifestation of the poet's "absence of love." The English version has thirty-one words, the first ten being *different*, and the rest all the *same* except for the new

word "love" in lines 4–5. In the French, the ratio is slightly different (twenty-four words, the first eight different), with "amour" similarly introduced in line 4 and repeated in line 5. Syntax and repetition thus enact the very meaning itself.

"They come" was first written in English, but Beckett's close brush with death proved to be a watershed, transforming the tone of his personal letters and somehow, perhaps partly because of his new relationship with Suzanne Deschevaux-Dumesnil, who was to become his wife, triggering his shift to French as his literary language—a turn that would become definitive after the war. The new Beckett is no longer the angry young man of the previous year. "Everyone has been incredibly kind," he writes McGreevy from his hospital bed six days after the stabbing (*LSB*, 1:583); he forgives his assailant as "more cretinous than malicious," and, as for his mother, with whom he has always had such a difficult relationship, "I felt great gusts of affection & esteem & compassion for her when she was over" (589). After May Beckett's departure: "Mother is a marvel. She sat up all the way from Euston to Dun Laoghaire" (595). Released from the hospital and back in his Paris hotel, Beckett writes McGreevy, "How lovely it is being here. Even with a hole in the side. A sunlit surface yesterday brighter than the whole of Ireland's summer" (596).

The mood of contentment would not, of course, last, but the turn to French prefigures what is to come. By early April, Beckett is writing McGreevy, "I wrote a short poem in French but otherwise nothing" (*LSB*, 1:614), and two weeks later, "A couple of poems in French in the last fortnight are the extent of my work since coming to Paris" (620). By October 1938, he tells George Reavey, "I have ten poems in French . . . mostly short. When I have a few more I shall send them to [Paul] Éluard. Or get Duchamp to do so" (*LSB*, 1:645). It is interesting that Beckett is thinking of applying to Duchamp, in many ways a kindred spirit, whom he had come to know through their mutual friend Mary Reynolds.[13] But the war intervened, and the poems in question were not to be published until 1946. *Poèmes 37–39*, newly edited for the *Collected Poems*, includes such pieces as the following:

musique de l'indifférence
coeur temps air feu sable
du silence éboulement d'amour
couvre leurs voix et que
je ne m'entende plus
me taire

the music of indifference
heart time air fire sand
of silence the landslip of loves
cover their voices and let me
no longer hear myself
be silent

<div align="right">(CPB, 96, my translation)</div>

Here, as in "they come," the obscurity is not one of allusion, as in
Echo's Bones, but of ellipsis: all we can really deduce is that some-
how "the music of indifference" has given way to a desire to end
things, to silence both the voices of his "amours" and his own.
"Coeur temps air feu sable" ("Heart time air fire sand"): a whole
love story might be contained in this allusive catalogue of appo-
sitional nouns, but we only know that it ends in "éboulement"—a
landslide or total crash. What Beckett refers to in the letter to Kaun
as the dissolution of the "terrifyingly arbitrary materiality of the
word surface" here takes place before our eyes. The language, in
other words, is left *open* enough to suggest any number of scenarios
without giving in to realism on the one hand or to surrealist excess
on the other. Indeed, although Beckett evidently enjoyed translat-
ing André Breton and Tristan Tzara, his own poems avoided the
shock effect of Surrealist metaphor in favor of suggestive abstrac-
tion—a mode, we shall see, more Wittgensteinian than Freudian.[14]

It was, in any case, only after World War II—the real watershed
in Beckett's career—that the poet's *language* came fully into its own.
"Something crucial, if hard to describe," writes Dan Gunn, the edi-
tor of volume 2 (1941–56) of the *Letters*, "has changed when in 1944

Beckett returns from his years of hiding in Roussillon in the Free France Zone: less in the strength of ambivalence felt toward his own activities than in a new absence of hostility and recrimination, a lack of grievance toward the world and its inhabitants." As Gunn explains in his introduction to the volume:

> Just when one might expect umbrage or infuriation—at the years spent in hiding, at the loss of numerous friends deported and dead, at the disastrous conditions in the ruins of the bombed Normandy town of Saint-Lô where he works for the Irish Red Cross—what one in fact finds is resignation and reticence; gone, or almost, are the fizzling tirades of the early years, the self-pity, the rancor, and the occasional self-indulgent displays of cleverness, as if so much suffering witnessed had put the cap for ever on a merely personal expression of disadvantage or misprision; as if, perhaps, the sight of so much brutal activity had confirmed him for ever in his inclination to a—however paradoxically rigorous and positively charged—passivity. Not once does Beckett, who being Irish and therefore neutral in the War, rue his engagement with the cause of the French Resistance or regret what it has cost him: not once, indeed, does he even mention it. Very rarely does he voice resentment, as if bitterness had been transmuted into something more deeply reflective: not an acceptance of horror or injustice, but an awareness of the communality of loss and the reversibility of roles of victim and persecutor. (*LSB*, 2:lxv–vi).

I cite this passage at length because it is as relevant to Beckett's postwar poetry as it is to his correspondence. The shift is one from "merely personal expression of disadvantage" to "an awareness of the communality of loss." In the course of the war and his work in the Resistance, Beckett found not only his subject but also his language, which had, at least for the present, to be French.

Beckett was always reluctant to account for the shift to French and often declared that he had no idea why he had made it. But in a letter to the German editor and critic Hans Naumann, who had

written to Beckett, speculating that perhaps the French turn was prompted by "the impossibility of launching an Irish-language work beyond the borders of that small country," Beckett responded:

> Since 1945 I have written only in French. Why this change? It was not deliberate. It was in order to change, to see, nothing more complicated than that, in appearance at least. In any case nothing to do with the reasons you suggest. I do not consider English a foreign language. It is my language. If there is one that is really foreign to me, it is Gaelic. . . . I myself can half make out several [reasons] now that it is too late to go back. But I prefer to let them stay in the half-light. I will all the same give you one clue: the need to be ill-equipped (*le besoin d'être mal armé*). (17 February 1954, *LSB*, 2:461–65, 466n3).

Art must, in other words, contend with *difficulty*; it must pose a challenge that makes the poet drop all preconceptions and comfortable habits. Finding it difficult to write on the painting of Bram van Velde, Beckett remarked to Georges Duthuit, "It is perhaps the fact of writing directly in English which is knotting me up. Horrible language, which I still know too well" (*LSB*, 2:168, 170). It is precisely because Beckett was so well educated, so well versed in English literature, that the need was great to make language itself the other. He was always," as he told Naumann, "on the look-out for an elsewhere" (*à l'afflût d'un ailleurs*). And later, when he begins to translate his French works into English, the process proves to be even more difficult.

A Few Little Turds

On the look-out for an elsewhere: in his new incarnation, Beckett wrote few lyric poems, although those he did write, like the condensed and mysterious "je suis ce cours de sable qui glisse"/"my way is in the sand flowing," whose French and English versions were published on facing pages in *transition* (1948), are striking.[15] But, except in his translations, whether of Apollinaire's *Zone* or

of such contemporaries as René Char, the Beckett of the postwar years could no longer be constrained by lineation and "poetic diction." The dyad "Grammar and style!," so ardently rejected in the 1937 letter to Axel Kaun, surely included sound and rhythm as well. Having reinvented narrative in *Molloy* and *Malone meurt*, both published in 1951, and with the third book of the *Trilogy, L'Innommable* (*The Unnamable*)—a long prose monologue—completed, Beckett turned to short pieces. In April 1951, he writes to Maria Peron: "In Paris I still have a few little turds to show you, same kind as the two you have already seen. How to go on after *L'Innommable*? These are little text-soundings, trying out something different" (*LSB*, 2:241). And in September, in response to a request from Georges Belmont: "I don't think I have any other poems, apart from the two given to *84*. There will certainly not be any more, and that will be no misfortune. . . . And I have ten or so little texts, written recently, the afterbirth of *L'Innommable* and not be approached directly."[16]

There could hardly be a clearer statement of Beckett's farewell, at least in the interim, to the lyric poem, in favor of the genre called *text* or, here, *text-sounding*. Not many Parisian critics or editors seem to have been enthusiastic about these odd pieces, but Jerôme Lindon, who published *Nouvelles et Textes pour rien* in November 1955, pronounced the book Beckett's "finest, with *L'Innommable*" (*LSB*, 2:557–58). And Beckett himself, so often self-deprecatory, remained partial to *Texts for Nothing*. When the second edition, with drawings by Avigdor Arikha, appeared in 1958, Beckett wrote his new American editor-publisher Richard Seaver that he was planning on translating the *Textes* himself, "they being in the idiom more or less of *L'Innommable* which I have just finished translating. My idea was for the book to appear with you figuring as translator of the stories [*Le Calmant, L'Expulsé, La Fin*] and me as translator of the Textes."[17] What this suggests is that, whereas the three "stories" of *Nouvelles*, written in the late 1940s, retained elements of plot and traditional narration—and hence could be left to Seaver to translate—Beckett recognized the *Textes* as something different, demanding his own particular reinvention of the English language.

Although Text 1 was published in 1959, it was not until December 1966 that Beckett reported in a letter to Tom McGreevy that after "5 weeks of fierce assault, the entire translation was conquered."[18]

The thirteen short *Texts for Nothing* have always confounded readers, who assume that they are "short" fictions or narratives and, as such, unsatisfactory in what H. Porter Abbott has referred to as their "absolute frustration of structural 'onwardness.'" "If the trilogy," Abbott notes, "is not impeccably linear, if it enacts a gradual progress of unraveling and disembodiment rather than the triumphant arrival at a goal, it nonetheless collaborates in its progressive disembodiment with the linear orientation that the mind craves in narrative."[19] *Texts,* on the other hand, no longer satisfies that "craving." Alain Badiou has argued that "these texts tell us the truth of a situation, that of Beckett at the end of the fifties: what he has written up to that point *can't go on*. It is impossible to go on alternating, without any mediation whatsoever, between the neutrality of the grey black of being and the endless torture of the solipsistic *cogito*."[20]

The assumption behind such responses—and they are widespread—is that these texts aim to be narrative—that, like the stories that precede them in both the French and English editions (1965), they are would-be fictions—and hence unsatisfactory, given that *nothing* happens. Yet Abbott gives us a useful hint when he adds to his stricture that in *Texts for Nothing*, Beckett "exchanged the narrative genre of the quest for the broad nonnarrative genre of the meditative personal essay," including "the rich romantic tradition of associative lyrical meditations ranging from Rousseau's *Rêveries d'un promeneur solitaire* to Coleridge's Conversation Poems." Indeed, observes Abbott, "Much of the ambience of the Texts echoes that of the meditations of the English Graveyard Poets" (Abbott, 89–90).

The reference to the Graveyard Poets—especially Edward Young—is apt since Beckett explicitly refers to them and since darkness and death are certainly front and center in these pieces. But the word "meditation" is somewhat misleading for, as Abbott recognizes, "It is [the] sense of direction that is missing in the *Texts* and that gives it its radical newness"—specifically the "un-quest" in-

scribed in "the twelve gaps between these [thirteen] Texts," which represents that absence out of which something keeps miraculously coming" (94). The same phenomenon can be observed at the microlevel: within each Text, the obsessive repetition, whether of word or phrase, the jumpy, disjointed, and nervous rhythm, and the sudden introduction of erudite and obsolete diction into what is primarily a colloquial language base—all these produce the desired "dissolution" of what Beckett called, in his letter to Axel Kaun, the "terrifyingly arbitrary materiality of the word surface." Consider the opening of Text 4:

> Where would I go, if I could go, who would I be, if I could be, what would I say, if I had a voice, who says this, saying it's me? Answer simply, someone answer simply. It's the same old stranger as ever, for whom alone accusative I exist, in the pit of inexistence, of his, of ours, there's a simple answer. (*Texts*, 306)

These "scraps of fiction," writes Alain Badiou, "attempt to expose some critical questions (in Kant's sense) to the test of beauty. . . . To Kant's famous 'What can I know? What should I do? What may I hope?, comes the threefold response from *Texts for Nothing*: 'Where would I go, if I could go? Who would I be, if I could be? What would I say, if I had a voice?" But what Badiou doesn't say, as Daniel Katz has noted, is that, contra Kant, "the answers given [in Beckett's text] are necessarily hypothetical, as the litany of 'ifs' already tells us that, in fact, I *can't* go, I *can't* be, and I have *no* voice."[21] Indeed, throughout the piece, the self is decomposed into "I," "you," "we," and even "he," each version of the self addressing the others so as to create a state of extreme tension. And here sound and visualization come in. Suppose we break up the paragraph into line units, as its syntax and pauses seem to demand:

> Where would I go,
> if I could go,
> who would I be,
> if I could be,

what would I say,
 if I had a voice,
who says this,
 saying it's me?
answer simply,
 someone answer simply.
it's the same old stranger as ever,
for whom alone accusative I exist,
in the pit of my inexistence,
 of his, of ours,
there's a simple answer.

Here the "simple" monosyllabic diction, insistent repetition, the rhyme on *could*/*would* and childlike sing-song rhythms (tum-tidi-tum / ti tum ti tum) of the first six lines introduce a parodic representation of lyric subjectivity, what with that "I" in every line, here placed in the interrogative mode. The repetition is in fact not so simple: "what would I say," for example, breaks the pattern of the first quatrain, for the reader expects to find "if I could say" in line 6, but Beckett substitutes "if I had a voice," which complicates the issue because there are other forms of "saying"—for instance, in writing. Not surprisingly, then, in the next eight lines, "I" is replaced by "who," and the "me" not at all "simply" becomes "the same old stranger / for whom alone accusative I exist." And in the eleventh line the first-person plural is added: "of his, of ours."

The key word in this passage is surely *accusative*, here referring to the grammatical term—the accusative case, implying that the "I" is the *object* of the action of perception on the part of a self turned third-person "stranger." But "accusative" can also be an adjective so that "for whom alone accusative I exist" suggests that the "stranger" is leveling accusations at the "I." Notice that the rhythm of these unmelodious phrases—

It's the sáme óld stránger as éver
For whóm alóne accúsative I exíst

—reduces the original "I" to an unstressed position, preparing us for "in the pit of my inexistence," with its four short i's," further making way for a "his" that is now equivalent to "ours." What coherent identity can the poet's self possibly have in this scheme of things? "There's a simple answer," which is to say no answer at all.

The question remains: if lineation reveals such important micropoetic choices on the poet's part, why does Beckett choose prose for his *Texts from Nothing*? Here we can refer back to Beckett's avowed mistrust, conveyed in the letter to McGreevy above, of the *facultatif*, his longing for "the integrity of the eyelids coming down before the brain knows of grit in the wind." Embedded in what looks like perfectly normal prose with justified margins, and hence raising the reader's expectation that one can proceed in a linear fashion, Beckett's phrases becomes all the more disorienting. Who is this stranger and what does the "accusative" have to do with anything? And why does a "we" come in? It is as if Beckett is admonishing us that to understand the poet's state of mind, we must proceed slowly and cautiously, rereading the prose that is supposed to go forward. "There's a simple answer." And indeed, like a round or ballad, Text 4 ends by coming full circle, with a passage containing an elaborate echo structure, its key words being perfectly ordinary ones that gain their power from delicate shifts in meaning, as in "far again," "far story," "afar" (308):

> Yes, here are **moments** like this **moment**, when I seem almost restored to the feasible. Then it **goes**, all **goes**, and I'm **far again** with a **far story again**, I wait for me **afar** for my **story** to begin, to end, **again** this voice cannot be mine. **That's where I'd go, if I could go, that's who I'd be, if I could be.**

"The Hour of Night's Young Thoughts"

In the first of Edward Young's long blank-verse "Night Thoughts" (1742), we read:

Silence, how dead! and darkness, how profound!
Nor eye, nor listening ear, an object finds;
Creation sleeps. 'Tis as the general pulse
Of life stood still, and nature made a pause;
An awful pause![22]

Beckett, as we shall see, clearly had Young's poem, in which there is much disquisition on "silence," in mind when he wrote Text 8, one of the most complex and arresting in the series. Here is the opening, with its intricate repetition of sounds (especially **s**'s, **t**'s, and **d**'s) and words:

Only the **words** break the **silence**, all other **sounds** have **ceased**. If I were **silent** I'**d** hear nothing. But if I were **silent** the other **sounds** woul**d start** again, those **to** which the **words** have ma**de** me deaf, or which have really **ceased**. But I am **silent**, it sometimes happens, **no, never, not one s**econd. (*Texts*, 320)

Young knew what he meant by the "silence" of the dark night when "Creation sleeps" and "nature" makes an "awful pause." But in Beckett, "silence" is nothing if not ambiguous. "The silence," "if I were silent" (twice), "I am silent": each time the word *silent* is repeated, it changes valence ever so slightly. Why would the narrator hear "nothing" if *he* were silent, since presumably the words heard are those of others? What are those "other sounds," heard only when words cease? And if it "sometimes happens" that the poet *is* silent, how do we construe that final "no, never, not one second," which is a direct contradiction?

The intricacy of repetition in the passage is offset by simplicity of syntax, but simplicity is by no means equivalent to clarity. The "I" speaks of the "pauses" "between the words, the sentences, the syllables, the tears"—a curious apposition, further made strange by the assertion that "I confuse them, words and tears," with the afterthought, "my words are my tears, my eyes my mouth." Words can certainly be compared to tears—both signifiers of pain—but how are either equivalent to eyes and mouth? Words, I suppose, can be

the eyes that see and that point to the mouth that articulates them. Or again, perhaps the narrator is saying chiastically that words are to tears as mouth is to eyes. But that analogy is itself cryptic.

What gives the passage continuity, aside from its sound structure, is the ubiquitous lyric "I," but that "I" suffers from what we might call context deficiency. Indeed, if "the meaning of a word is its use in the language," as Wittgenstein has taught us, the ability to assess a given word's use-function here seems to have been oddly lost.[23] This was already true in *The Unnamable*, but in *Texts for Nothing*, where the narrative function of the novels has been all but short-circuited, the verbal texture becomes curiously porous. "It's forever the same murmur, flowing unbroken, like a single **end**less word and therefore meaningless, for it's the **end** that gives the meaning to words." Here "for" pretends to supply a causal connection, but the fact is that the *end* in the adjective "endless" —never ceasing—is not the same as the noun "end," designating conclusion.

Text 8 begins by exploiting speech rhythms that, as in Text 4, fall readily into linear units:

> But I am silent,
> it sometimes happens,
> no, never, not one second.

Or

> But I speak softer,
> every year a little softer.
> Perhaps.
> Slower too,
> every year a little slower.
> Perhaps. (320)

Yet, just when these colloquial and fragmentary phrases, accompanied by such asides as "it sometimes happens" or "It is hard for me to judge," draw the reader into the narrator's seemingly casual, everyday diction, the Beckett of this particular text, shifts registers.

The narrator has just posed the question, "What right have you then, no, this time I see what I'm up to and put a stop to it, saying, None, none," when we are confronted by the sentence:

> But get on with the stupid old threne and ask, ask until you answer, a new question, the most ancient of all, the question were things always so. (320)

Threne? How many of us would recognize this archaic designation for threnody or lament, the irony here being that the narrator goes on to insist that he cannot recover the past, whether his own or (absurdly) "how things were before (I was!), and by before I mean elsewhere."

What is a self? A lyric "I"? When we read, say, Keats's "Ode to a Nightingale"—"My heart aches, and a drowsy numbness pains / My sense, as though of hemlock I had drunk"—we respond to what is a coherent consciousness. But in Beckett? What can it mean that the "I" of Text 8, who asserts histrionically that "the past has thrown me out, its gates have slammed behind me," and whose speech opens with abrupt conversational fragments, turns out to have a mind stocked full of arcane and learned vocabulary like *threne, desinence* (a grammatical term, referring to the termination, suffix, or ending of a word), *convulsive, ventriloquist's dummy, pseudo-sepulture, habitat, apnoea, ferrule, bassamento* (basement), *sardonic synthesis, lacerated, excipient,* or *dream infirmities.* And not only does the word pool shift dramatically, the abstraction of the opening sentences gives way, two pages into the text, to curiously specific geographical references:

> what's the matter with my head, I must have left it in Ireland, in a saloon, it must be there still, lying on the bar, it's all it deserved. . . . (322)

> Whereas to my certain knowledge I'm dead and kicking above, somewhere in Europe probably. . . . (322)

But what is this I see, and how, a white stick and an ear-trumpet, where, Place de la République, at Pernod time, let me look closer at this, it's perhaps me at last. (322)

The stick gains ground, tapping with its ferrule the noble bassamento of the United Stores, it must be winter, at least not summer. (322)

The vacancy is tempting, shall I enthrone my infirmities, give them this chance again, my dream infirmities, that they may take flesh and move, deteriorating, round and round this grandiose square which I hope I don't confuse with the Bastille, until they are deemed worthy of the adjacent Père Lachaise. (323)

. . . at the terrace of a café, or in the mouth of the underground, I would know it was not me. . . . (323)

All of these references could apply to the "real" Sam Beckett, once haunting the bars of Dublin and shopping at the United Stores, later crossing the Place de la République at Pernod time, and walking past the Bastille to the Père Lachaise cemetery, where, like Edward Young, he can contemplate the gravestones "at the hour of night's young thoughts."

Text 8 is thus not only a pseudo-lyric poem—some sort of "threne"—but a generic autobiographical poem as well. "The white stick and an ear-trumpet" crossing the Paris streets is a synecdoche for the poet himself, a figure rather like Yeats's "tattered coat upon a stick" in "Sailing to Byzantium." The poet may claim that the gates of the past "have slammed behind me," but the past is everywhere the engine driving the poet's schizoid present. His is a composition of place, designed to control what might otherwise strike us as a descent into madness:

I'll be silence, I'll know I'm silence, no, in the silence you can't know. I'll never know anything. But at least get out of here, at least

that, no? I don't know. And time begin again, the steps on the earth, the night the fool implores at morning and the morning he begs at evening not to dawn. I don't know, I don't know what all that means, day and night, earth and sky, begging and imploring. (321)

Here the repetition of the word *silence* lacks the deliberation of the poem's opening ("Only the words break the silence . . ."). "**I'll** be **silence, I'll** know I'm **silence, no**, in the **silence** you can't **know**": these abrupt assertions make no sense, especially with the homonyms *no* and *know* regularly changing places and canceling each other out. No, you don't know, no. The poet then waxes poetic: "And time begins again, the steps on the earth, the night the fool implores at morning," but how can "time begin again," when the "fool" now implores the morning "not to dawn"? The noun "dawn" used here as verb (but not in the colloquial sense of "it dawned on me") creates an ominous note, as if to say that the narrator is praying for the sun not to come up—which is to say for eternal night or death. Or at least death of personhood. And so a few lines further down, having wondered, "whom can I have offended so grievously, to be punished in this inexplicable way," we now read—and I lineate according to the natural pauses, which heighten the incremental repetition:

> **It's not me.**
> **It can't be me.**
> but am I in **pain**, whether **it's me** or not,
> **frankly** now, is there **pain**?
> Now is **here**
> and **here** there is no **frankness**,
> all I say will be false
> and to begin with **not said by me**,
> **here** I'm a mere ventriloquist's dummy (321)

"Ventriloquist's dummy" nicely parodies the Romantic notion of voices speaking through me, of *Je est un autre*. And this ventriloquist is absurd, holding the poet "in his arms and mov[ing] my lips with

a string, with a fish-hook, no, no need of lips, all is dark, there is no one" (321).

Beckett, we recall, had told his friend Tom McGreevy that he wanted his poetry to avoid the *construit* by capturing "the integrity of the eyelids coming down before the brain knows of grit in the wind." In the language games of *Texts for Nothing*, with their elaborate structures of repetition, structures within which the most common words like *pain, time, space,* and *dark* are deprived of a reasonable context, we rely on sound structuring and incremental repetition to carry us forward: Take again that sentence, "I confuse them, words and tears, my words and my tears, my words are my tears." The poeticity of such a sentence is that we cannot paraphrase it, even as its rhythm speaks:

I confúse them
wórds **and** teárs
my wórds **and** my teárs
my wórds **áre** my teárs

Here primary stress shifts so that each time a different particle is emphasized: the passage moves very subtly from generality to the claim for possession and only then to the predication which is never really explained, thus letting us witness "confus[ion]" at work. **And** and **are** differ by only two letters, and yet it is that difference that matters. "Eat" is not the same as "ate," as Duchamp put it.

The poeticity adumbrated in *Texts for Nothing* was to become the paradigm of Beckett's poetry from the mid-1950s to the 1970s and includes such central Beckett texts as *Imagination Dead Imagine, Lessness, Enough, Ping,* and *Fizzles.*[24] But during the last decade of his life the poet's "need to be ill-equipped," which marks the turn to writing in French, begins to decline. The poetry of Yeats, once studiously kept at a distance, its grand rhetorical posturing held in contempt, now returns as a model: in her memoir, Anne Atik notes that Beckett knew many Yeats poems by heart and would regularly recite them after dinner.[25] And in his radio play *Words and Music* (1962) as well as the late television play *. . . but the clouds . . .*

(1977), whose very title comes from Yeats's "The Tower," Beckett repeatedly alluded to passages like "Does the imagination dwell the most / Upon a woman won or woman lost?" in "The Tower," and composed short runs in the trimeter of "Easter 1916 or section III of "The Tower."[26] In the end—and we see this in the late aphoristic *Mirlitonnades* as well—the Irish Romantic tradition, indeed the larger English literary tradition from Spenser and Milton to Yeats, was no longer a threat: Beckett could now acknowledge his roots with equanimity.

At the same time, these were afterthoughts. Beckett's great poems, I would maintain, are the "text-soundings" he begins to produce in the late 1950s in a form that has become increasingly central in the poetry of the twenty-first century. He understood, as did few poets of his day, that the distinguishing mark of poetry is not *genre*—he would have scorned our academic discussions of what is *the lyric?*—but its concentration on remaking poetic *language*. "Only the words break the silence." But what are words? what is silence? and what does it mean to "break" something?

Reconsider, for a moment, the archaic word *desinence*, already cited above. It occurs in this sentence:

> But it will end, a desinence will come, or the breath fail better still.

This sentence surprised me. I had always thought that the now-famous phrase "fail better"[27] first appeared in Beckett's late prose fiction (or is it a poem?) *Worstward Ho* (1983), where we read "Ever failed. No matter. Try again. Fail again. Fail better."[28] But *fail better* was already in place two decades earlier, although its appearance in *Texts for Nothing* has received none of the notice bestowed on it as part of the later, more aphoristic assertion. Perhaps that's what "fail better" is all about—the poet tries out a pregnant absurdity in a text that is, at its own moment, largely ignored, being neither quite recognizable as poetry nor acceptable as narrative fiction. But Beckett himself surely understood that, however "ill-equipped," he was preparing new ground. No desinence where none intended.

7

From Beckett to Yeats

The Paragrammatic Potential of "Traditional" Verse

Invitation . . . from Northwestern University for next spring to
celebrate W. B. Y.'s birth too soon to be influenced.
SAMUEL BECKETT[1]

Poets are the policemen of language. They are always
arresting those old reprobates the words.
W. B. YEATS[2]

When Beckett was an undergraduate at Trinity College, Dublin, in
the early 1920s, Yeats was at the height of his fame—internationally
acclaimed Great Poet, senator, soon-to-be Nobel Prize winner.
Himself a novice poet, Beckett remained aloof: he disliked what he
considered Yeats's preening and posturing, his excessive rhetoric,
his Irish nationalism and lingering taste for the Celtic Twilight. The
Yeats Beckett much preferred was the poet's younger brother,
the painter Jack Yeats, who became a close friend.

Invited in 1934 to write a review of "Recent Irish Poetry" for *The
Bookman*, Beckett dismissed Yeats as an "antiquarian":

> Mr. W. B. Yeats, as he wove the best embroideries, so he is more alive
> than any of his contemporaries or scholars to the superannuation of
> these, and to the virtues of a verse that shall be nudist. "There's more
> enterprise in going naked."

The reference is to the final poem in *Responsibilities*: "A Coat" (1914):

I made my song a coat
Covered with embroideries
Out of old mythologies
From heel to throat;
But the fools caught it,
Wore it in the world's eyes
As though they'd wrought it.
Song, let them take it,
For there's more enterprise
In walked naked.[3]

Beckett evidently appreciated that brilliant conclusion with the rhyme *take it/naked*, but even here, he can't seem to avoid sarcasm. "When [Yeats] speaks," he continues, "of the 'sense of hardship borne and chosen out of pride' as the ultimate theme of the Irish writer, it is as though he were to derive in direct descent the very latest prize canary from that fabulous bird, the Mesozoic pelican, addicted, though childless, to self-eviscerations." And Yeats's followers are dismissed as "the twilighters."[4]

Yet by the early 1960s, when Beckett, now a successful author in his own right, having produced, in French, the *Trilogy*, *Godot*, and *Fin de partie*, came to have a second look at his Irish precursors, it was not Joyce but Yeats he turned to. "I never felt more skeptical about my work," he writes his great friend Tom McGreevy in 1961, "But I couldn't have done anything else, or otherwise. Have been reading a lot in W. B.'s Collected Poems with intense absorption." And in 1963, to his friends Avigdor Arikha and Anne Atik, who sent him the newly published *Collected Plays*: "Merci de tout coeur pour les pieces de Yeats. Je suis très content de les avoir."[5]

It was not a matter of wanting to write like Yeats: born in 1906, a full forty years after the Great Precursor (1865), surely it was, as he wrote wryly to Barbara Bray, "too soon to be influenced." And in any case, Beckett's experimental *texticles,* as examined in the

preceding essay, could hardly be more unlike Yeats's lyric poems, which remained, from first to last, *"personal utterance,"*[6] displayed in traditional stanza forms from couplet to quatrain to ballad stanza, to sonnet and *ottava rima*, and written in traditional meters from trochaic trimeter to iambic pentameter.

For Yeats, free verse, as Pound and the Imagists were writing it in the 1920s and 1930s, and which was to become the normative verse of the later twentieth century, was taboo:

> Because I need a passionate syntax for passionate subject matter I compel myself to accept those traditional metres that have developed with the language. . . . If I wrote of personal love or sorrow in free verse, or in any rhythm that left it unchanged, amid all its accidence, I would be full of self-contempt because of my egotism and indiscretion and foresee the boredom of my reader. I must choose a traditional stanza, even what I alter must seem traditional.[7]

At the same time, Yeats did not care for blank verse—the staple of English poetry—because he preferred the control of rhyme to the continuity of unrhymed iambic pentameter. This Yeatsian demand for control no doubt strikes the contemporary reader as curiously old-fashioned. Then too, Yeats's elaborate symbolic system, as presented in his cosmology *A Vision* (1925) and his cult of personality, so prominent in his placement of the "I" in such imperious or imperative constructions as "And I call up MacGregor from the grave," or "I summon to the winding ancient stair," was likely to strike most later poets—from Eliot and Pound to Beckett—as excessive. Isn't poetry, as Eliot put it, "the escape *from* personality"?

Indeed, as I write this in 2020, Yeats, a poet still widely studied through the 1960s and 1970s and a favorite subject of dissertations (including my own),[8] is barely known in American universities. For one thing, even when Modern poetry is taught, it is almost always Modern *American* poetry from Robert Frost, Marianne Moore, Pound, and Eliot to the poets of the Harlem Renaissance and beyond. Or again, Whitman and Dickinson are on any standard American poetry reading list; Yeats the Anglo-Irishman is not. The

poet's own declaration, in "Coole Park and Ballylee, 1931," that "We were the last romantics—chose for theme / Traditional sanctity and loveliness" (*PWBY*, 491–92) has been taken at face value. Yeats, it is widely held, belonged to the nineteenth century. A Modernist, much less an avant-gardist? Hardly.

Sam Beckett was one of those who came to know better. Indeed, the poet who had once lampooned his eminent precursor, came, in his later years, to understand that real innovation was not a matter of writing free verse or choosing the right stanza form but of paying the closest possible attention to the bedrock of poetry, which is its language and rhythm. In her memoir *How It Was*, Anne Atik recalls, "From 1959 on, especially when we [Beckett and the Arikhas] were dining at home, Yeats was as often on the menu as Samuel Johnson and Dante.[9] Beckett evidently knew dozens of Yeats poems by heart and recited them in praise of their sonorities. For example:

When we read Yeats's 'Sailing to Byzantium," Sam would stop at

> But such a form as Grecian goldsmiths make
> Of hammered gold and gold enameling
> To keep a drowsy Emperor awake,

stressing the 'm' in 'form' and 'enameling,' the 'as' with a drowsy z-sound" (60)

Or again,

Reciting from Yeats's "Friends," in coming to the lines":

> While up from my heart's root
> So great a sweetness flows
> I shake from head to foot,

Sam would stand up and repeat them, saying "Imagine such feeling—'So great a sweetness flows / I shake from head to foot,' in amazement." (62)

Sound structure—rhythm, cadence, repetition, rhyme—structure that can itself create meaning, as the rhyme of "root" and "foot" do here—this was for Beckett the heart of the matter. As a pre-typewriter poet, Yeats was not yet someone who used striking spatial design, as Ezra Pound and William Carlos Williams were to do, but he revised his lyrics endlessly in the service of improving rhythm and rhyme. His were startling "verbivocal" structures, meant to be heard as well as read. The stanzas chosen might well be "traditional," but the linguistic choices came to be more and more original.[10]

The Flaming Circle of Our Days

"Years afterwards," wrote Yeats in "Reveries over Childhood and Youth," "when I had finished *The Wanderings of Oisin,* dissatisfied with its yellow and dull green, with all that overcharged colour inherited from the romantic movement, I deliberately reshaped my style, deliberately sought out an impression as of cold light and tumbling clouds. I cast off traditional metaphors and loosened my rhythm."

Yeats was one of the most self-critical of poets: in his later years, he understood exactly the limitations of his early lyric. He had already discovered what were to be his later preoccupations—Irish mythology, the occult, the sorrows of unrequited love—but formally, he was writing very much as a member of the Rhymers Club (Lionel Johnson, Edwin Dowson, Arthur Symons)—short and regular tetrameter and pentameter quatrains, as in "When You are Old" (1892):[11]

Whén you are óld and gréy and fúll of sleép,
And nódding bý the fíre, | tâke dówn this bóok
And slówly reád, and dreám of the sôft loók
Your éyes had ónce, and óf their shádows deép;

Hôw mány lóved your móments of glâd gráce,
And lóved your beáuty wíth lôve fálse or trúe,

But óne mân lóved the pîlgrim sóul in yóu,
And lóved the sórrows of your chánging fáce;

And bénding dówn besíde the glówing stárs,
Múrmur, a lîttle sádly, hôw Lóve fléd
And páced upón the moúntains ôverheád
And híd his fáce amîd a crówd of stárs.[12]

"When You are Old" is one of Yeats's well-known anthology pieces: I recall reading it in high school and finding the poet's admonishment to the beloved (always Maud Gonne), letting her know she would be sorry someday that she had rejected his love, quite moving. And the image of Love, not as the usual Cupid but as a kind of avenging angel, is striking. But the poem's language is a bit flat, and it has its share of cliché, from "old and grey" to the "shadows deep," with its inversion, "glad grace" and "glowing bars." The iambic pentameter quatrains are as straightforward as the syntax, the *abba* rhymes—*sleep/deep, book/look, grace/ face, true/ you, bars/ stars, fled/overhead*—having an almost childlike simplicity. There are a few metrical reversals, as in the first line "Whén you," and secondary stresses, as in "hôw Lóve fléd," but generally the verse form flows along with little double entendre or paragram. Beauty is beauty, love, even when personified, as in the third stanza, is love. It is all *there*: the sound merely has to accompany the straightforward statements in gentle, songlike fashion.

But *The Rose*, the volume that includes "When You are Old," does contain intimations of things to come. A remarkable instance is "The Lake Isle of Innisfree," one of Yeats's best-loved poems, which he recorded for Caedmon Records in 1937.[13] In his recording, as well as in his autobiographical *The Trembling of the Veil*, Yeats recalls the poem's genesis on a gray London day:

I had still the ambition, formed in Sligo in my teens, of living in imitation of Thoreau on Innisfree, a little island in Lough Gill, and when walking through Fleet Street very homesick I heard a little tinkle of water and saw a fountain in a shop-window which balanced a little

ball upon its jet, and began to remember lake water. From the sudden remembrance came my poem *Innisfree*, my first lyric with anything in its rhythm of my own music. (*Autobiographies*, 153)

Here is "The Lake Isle of Innisfree":

Í will aríse and gó nôw, | and gó to Ínnisfreé
And a smâll cábin buíld thêre, | of cláy and wáttles máde;
Níne beán-rôws will I háve there, | a híve for the hóney-beé,
And líve alóne in the beé-loûd gláde.

And Í shall háve some peáce there, | for peáce comes drópping
 slów
Drópping from the veíls of the mórning | to whére the crícket
 síngs;
There mídnîght's áll a glímmer, | and noón a púrple glów,
And évening fúll of the línnet's wíngs.

Í will aríse and gó nôw, | for álways níght and dáy
I heár lâke wáter lápping | wíth lôw soúnds by the shóre;
While Í stand on the roádway, | or ón the pávements gréy,
I heár ît || in the deép heârt's córe.

(*PWBY*, 117)

The poem has three stanzas rhyming *abab*; it is written in a meter rare in English poetry—iambic hexameter, the fourth line in the first two stanzas shortened to tetrameter. Yeats's hexameter lines often have extra syllables: line 6, for example, has fifteen rather than the normal twelve. The slow stately rhythm is maintained by the use of anapests and dactyls, so that the six-stress count is maintained:

Drópping from the veíls of the mórning | to whére the crícket síngs

Thematically, the poem is not remarkable: the poet, homesick for the Sligo lake country of his childhood, expresses, in almost biblical language ("I will arise and go now"), his longing to go home,

spelling out, in specific detail, his plans for his ideal dwelling, with its "nine bean-rows" and "hive for the honey-bee." What makes "Innisfree" so remarkable is not its articulation of this familiar theme, but its distinctive deployment of sound. Consider, for starters, the repetition of l's and d's: and the cluster of stresses on the long vowels of "bee-loud glade":

And líve alóne in the **bée-loûd gláde**

The liquid l's continue into the next stanza, this time embedded in nasals: "There **m**idnight's a**ll** a g**li**mm**e**r, and **n**oon a purple g**l**ow, / A**n**d even**ing** fu**ll** of the **li**nn**et**'s wings. "Glimmer" and "glow" are common enough poetic properties, but here the conjunction of laterals and nasals containing short i's and long o's produces its own special music.

The pièce de résistance comes in the final stanza. Following the repetition, in stanza 3, of "I will arise and go now," and further repetition of laterals in "always **n**ight and day / I hear **l**ake water **l**apping with **l**ow sou**n**ds by the shore," we come to the brilliant conclusion in the foreshortened final line:

Í héar ît ‖ in the déep heárt's córe.

Oddly, this line is only one syllable shorter (8 versus 9) than lines 4 and 8, but whereas both of those concluding lines have four primary stresses, line 12 has five, with a caesura after "it": "**I hear it**"—pause—and then after the unstressed "in the" we get to the heart of the matter, in the long stressed diphthongs and vowels of "**deep heart's core**." Then too, "heart" contains "hear," which is as it should be since the poet, not in fact in Innisfree, hears the lake water lapping only in his heart. And finally, "core," with its long open *o*, rhymes with "shore," and it is of course the lake *shore* which is at the *core* of the poet's vision.

In "Innisfree," sound is not just some sort of supporting mechanism: it enacts the very meaning itself. Similar effects are found in

many other early poems, for example, in "Who Goes with Fergus?" where we witness the very penetration of the "**d**eep **w**ood's **w**oven shade," and "the whíte bre**á**st of the dím se**á**," with its spondees and visual chiasmus of **eas**/**sea**. Very few poets achieve such intricate echo structures.

The short lyric of love and longing, developed in these early volumes, morphs into more experimental mode in Yeats's later poetry. Here are two lyrics, one from 1916, the other from 1933, that rely on abstraction rather than the concrete diction that was *de rigueur* in the 1890s, letting rhythm and sound repetition do the work. The first is "A Deep-sworn Vow:

> Óthers || becaúse you díd not keép
> That deép-swôrn vów have been friénds of míne;
> Yet álways whén I look deáth in the fáce,
> Whén I clámber to the heíghts of sleép,
> Or whén I grów excíted with wíne,
> Súddenly I meét your fáce.[14]

"A Deep-sworn Vow" has six lines of iambic tetrameter rhyming *abcabc*, but the last line is foreshortened (3 stresses), and instead of providing the *c* rhyme for "face," Yeats simply and surprisingly repeats the word itself, subtly changing its meaning. Thus, together with the trochaic reversal and strong stress on the rather neutral pronoun "Others" in line 1 and the internal rhyme on *keep/deep* in lines 1–2, what could be a hackneyed rendering of the poet-lover's obsession—I can't get you out of my mind—an obsession found in dozens of love songs like Cole Porter's "Night and Day / you are the one!"—is made strange and new.

"A Deep-sworn Vow" contains such well-worn phrases as "look death in the face," "clamber to the heights of sleep," and "when I grow excited with wine," as well as prosaic ones like "friends of mine." Indeed, there is no startling imagery or subtle self-fashioning here: the "I" speaks quite directly.

But it is the choice of the trochaic *others* in line 1 that matters:

Óthers || becaúse you díd not kéep
That deép-swôrn vów—

The initial stress is so pronounced that one would think Yeats is naming someone, as in, say, "Easter 1916," written the same year: "MacDonagh and MacBride / And Connolly and Pearse . . ." But who are those "Others," so separated from the rest of the regular tetrameter line? The whole point is that it doesn't matter who they are or whether there are two or ten willing to be the poet's "friends." The only thing that matters is that the "you"—the only beloved—has failed him, that she haunts his sleep and brings on thoughts of death. The drumbeat of *keep/deep*, the latter occurring a mere two syllables after the former, is enhanced by the secondary stress on "sworn" in the compound "deép-swôrn" and the subsequent stress on "vow," with its strong open vowel. Thus the idiom "to look death in the face" morphs into the real thing: "**Súddenly**," with a strong trochaic reversal, the face becomes a reality. But of course it too is only a dream.

In his radio play *Words and Music* of 1962, Beckett inserts a little song, imitating, in parodic form, Yeatsian trimeters and alluding to the key rhetorical question in Yeats's "The Tower," "Does the imagination dwell the most / Upon a woman won or a woman lost?"

> She comes in the ashes
> Who loved could not be won
> Or won not loved
> Or some other trouble . . .

The character "Words" (Joe) zeroes in on "The face in the ashes," after which Croak, the director of the pantomime, seems to withdraw into his own thoughts and enunciates only two words, repeated four times and punctuated by pauses—"The **face** [*Pause.*] The **face** [*Pause.*] The **face** [*Pause.*] **The face**"—an allusion already made by the narrator of *Krapp's Last Tape*, in his memory of the boat scene with the lost beloved, "The **face** she had!"[15] *Face* is a curious word to use in the context of lovemaking, lacking as it does the erotic potential of eyes or hair, much less lips or breasts. But Beck-

ett, following the Yeats of "A Deep-sworn Vow," understood that its very blankness—like the blankness of "Others"—works here to create excitement and mystery.

The love poems of the later 1920s and 1930s become harsher, more ironic, and they are often based on specific incidents. One of my personal favorites, "Quarrel in Old Age," refers to the bitter political arguments that came to take place between Yeats and Maud Gonne, beginning with her return from an English prison to Dublin in 1919, when she attempted to repossess her house in Stephens Green, which Yeats was occupying with his then-pregnant wife. The latter was suffering from the Spanish flu and being nursed around the clock. When Yeats wouldn't let Gonne inside, a huge verbal battle ensued, after which the two remained essentially estranged for years. Here is "Quarrel in Old Age" (1933):

> Whére had her sweétness góne?
> Whát fanátics invént
> In thîs blínd bítter tówn,
> Fántasý or íncidént
> Nót wôrth thínking óf,
> Pút her ín a ráge.
> Í had forgíven enoúgh
> That had forgíven óld áge.
>
> Áll líves that hás líved;
> Só múch is cértain;
> Óld sâges were nót decéived:
> Sómewhêre beyónd the cúrtain
> Óf distórting dáys
> Líves that lónely thíng
> That shóne befóre thêse eýes
> Tárgeted, tród like Spríng. (*PWBY*, 503–4)

Two stanzas of trimeter or tetrameter rhyming *ababcdcd*—hardly a new invention. But Yeats completely transforms the meter, using the short, lightly stressed lines with such variation (and sometimes

a secondary stress, as in line 3 or line 15) that it sounds almost like actual conversation, beginning with the immediacy of the opening question, "Where had her sweetness gone?" The extreme variation of stress count and off-rhyme—*go town, invent/incident, of/enough, lived/deceived, days/eyes*—is offset by the very tight structure of vocalic and consonantal repetition, as in "Wh**at fanatics invent**"/"**In** th**is blind bit**ter town"/"**Fanta**sy or **incident**." After the elaborate repetition of harsh stops and spirants, the softer nasals and fricatives of line 5, "Not worth thinking of," lead to the softer rhythm of "I had forgiven enough / That had forgiven old age."

The pathos of these two lines is striking: wasn't it enough, the poet asks ruefully, that he forgave his beloved for growing old and losing her beauty? Do we now have to have these nasty scenes as well? The second stanza turns the question back on itself, reminding the poet himself, as well as his reader, that one's essence doesn't change: "**All lives** that **has lived**." The "old sages"—no doubt Plato and Plotinus or a related pair—knew it all; the "distorting days" of line 13 cannot change the "lonely thing / That shone before these eyes." And now comes the extremely condensed conclusion, with its repetition of **t**, **r**, and **d**, "**T**a**r**ge**t**e**d**, **tr**o**d** like Spring." The target of the lover's eyes in the days when she "trod like Spring" reappears to haunt him. No quarrel, no rage or misunderstanding, can destroy that shining: the **target** remains intact, as the final full rhyme *thing/spring* underscores.

Yeats had been writing Platonic love poems to and about Maud Gonne ever since his youth: this one, published in his sixty-eighth year, seems to me one of the very best because of the poet's subtle turn-around, all without meaningful explanation. But there is in fact nothing in this poem to explain: no doubt, the town (Dublin) was just as blind and bitter as the poem asserts; no doubt Maud Gonne was no longer the sweet young girl Yeats had met at Bedford Park in the 1890s. But—wait a minute—the target remains somehow intact. Astonishing what one can do with the iambic tetrameter stanza base, when one chooses one's words and sounds with the care to conclude with the linkage of **targeted** and **trod**, mitigating those distorted days of the quarrel.

Among the Stones

From 1914 on, Yeats was much given to talking of the need for poetry to be based on "passionate, normal speech," "speech carried to its highest by intensity of sound and meaning." "'The natural words in the natural order' is the formula," as he tells Dorothy Wellesley,[16] but the truth is that the seeming "natural speech" Yeats loved to defend, was in reality the product of elaborate artifice. Consider the great title poem of *The Wild Swans at Coole*.[17]

> The trees are in their autumn beauty,
> The woodland paths are dry,
> Under the October twilight the water
> Mirrors a still sky;
> Upon the brimming water among the stones
> Are nine-and-fifty swans.
>
> The nineteenth autumn has come upon me
> Since I first made my count;
> I saw, before I had well finished,
> All suddenly mount
> And scatter wheeling in great broken rings
> Upon their clamorous wings.
>
> I have looked upon those brilliant creatures
> And now my heart is sore.
> All's changed since I, hearing at twilight,
> The first time on this shore,
> The bell-beat of their wings above my head,
> Trod with a lighter tread.
>
> Unwearied still, lover by lover,
> They paddle in the cold
> Companionable streams or climb the air;
> Their hearts have not grown old;

Passion or conquest, wander where they will,
Attend upon them still.

But now they drift on the still water,
Mysterious, beautiful;
Among what rushes will they build,
By what lake's edge or pool
Delight men's eyes when I awake some day
To find them have flown away?

<div align="right">(PWBY, 150)</div>

The Cornell Yeats, that magisterial scholarly project devoted to re-producing the extant manuscripts of Yeats's poems, has an entire volume devoted to *The Wild Swans at Coole*, edited by Stephen Parrish. Here we can see Yeats's compositional process at work from the earliest jottings and most basic ideas to the smallest (infra-thin) changes in word choice, punctuation, lineation, and rhythm. Figure 7.1 reproduces the very first extant draft:

~~The trees~~
~~Among the grey lanes~~

~~The leaves grow brown in Autumn~~
That water in the lake is low
The leaves turn brown
And [for "I"?] go out toward sun set
To number the swans.

~~There is little water in the~~ lake
 has
The autumn rains have not begun[18]

Coole Park in County Galway was the large country estate of Augusta, Lady Gregory, one of Yeats's closest friends and allies; from the late 1890s on, he spent much time as her houseguest: they col-

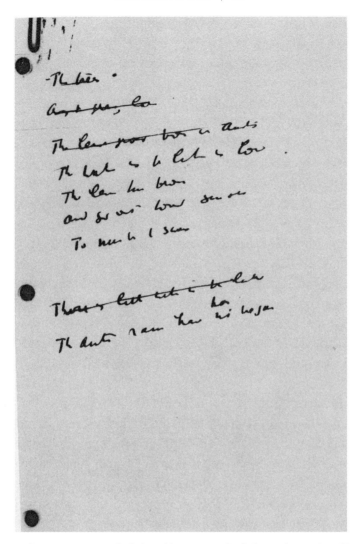

7.1 | W. B. Yeats, First Draft of "The Wild Swans at Coole" (before 1917). From *The Wild Swans at Coole: Manuscript Materials*, ed. Stephen Parrish (Ithaca, NY: Cornell University Press, 1994), p. 3.

laborated on collections of Irish folklore, the writing of plays, the founding of the Abbey Theatre, and much more. Coole lake is not remarkable. Its usually gray waters are surrounded by low woods, and when I visited the estate (now open to the public) some years ago, there were only a few scraggly swans to be sighted. For Yeats,

however, Coole came to be symbolic of the best of eighteenth-century Ireland and its legacy; then too the name **Coole** is notable for its beautiful open sound, rather as is "spool" (**spoooool**) in Beckett's *Krapp's Last Tape*. In *The Winding Stair* (1933), Yeats included two Coole Park poems—"Coole Park, 1929" and "Coole Park and Ballylee, 1931"—in homage to Lady Gregory, who died in 1932. But the earlier "Wild Swans at Coole" was written not for his great benefactress but on the occasion of his recognition, as a fifty-year-old bachelor in 1916, that if he didn't stop pining for Maud Gonne, who was never going to return his passion, and get on with his life (in 1917 he finally married Georgie Hyde-Lees and soon became a father), he would be miserable. Unrequited love and the horror of old age were two of Yeats's central themes: Beckett was to pick up on this twin obsession in "The Tower" in his plays *Words and Music* and . . . *but the clouds* . . .[19]

Not surprisingly, the first draft of "Wild Swans at Coole" gave autumn its standard valence: brown leaves, low lake water, "grey lanes," and the coming of rain. In the second leaf (Cornell, 5) the wild swans are introduced, as is the idea of "number" and "Year by year." And a few drafts further along, the poet appears in his own person, "From shore to shore I go / A little before the daylight's over I number the swans" (Cornell, 9). Thus the counting ritual of the finished poem, where nineteen years have elapsed since the poet's first visit to Coole Park and its lake—a ritual that signifies growing old—is in place. In one of the next drafts, the "shadow of grey stones" is introduced, and the second stanza is close to being finished:

> We are now at the nineteenth autumn
> Since I first made my count.
> I made no sound for if they heard me
> Suddenly they would mount
> ~~Scattering &~~
> And wheel above the waters in great broken wings
> And a slow clamour of wings.
>
> (Cornell, 11)

Here the choice of verse form—a standard ballad stanza with alternating four- and three-stress lines and rhyming *abcb*, followed by an irregular rhyming couplet with the stress pattern 5/3—is in place although the rhyme is not yet chosen, Yeats simply repeating "wings." This rather elaborate six-line stanza (there will be five of them) is followed by what will become the first three lines of the final stanza, although Yeats here introduces the less than poetic reference to "eggs": "Among what rushes will their eggs" (Cornell, 11).

It is the first stanza that caused Yeats the most trouble: eighteen drafts go by that can't seem to get beyond the following:

> The trees are in their autumn foliage
> The water in the lake is low,
> All pathways hard under the foot
> In the pale twilight I go.
> Among the grey stones I number the
> swans.
> Floating among the stones.

> (Cornell, 29)

Only in the final draft, did Yeats eliminate the first person ("I go," "I number") and come up with the ingenious wording of the finished poem. And even in the first printing in *The Little Review*, stanza 5 comes after stanza 2, thus dissolving the drama of the final question, "Among what rushes will they build / By what lake's edge or pool / Delight men's eyes when I awake some day / To find they have flown away?" Where, in other words, will the swans be nesting when I'm no longer alive to see them?

"The Wild Swans at Coole" is in many ways a belated Romantic ode in the tradition of Keats's "Ode to a Nightingale." The Keatsian motif—"Thou wast not born for death, Eternal Bird! / No hungry generations tread thee down"—is echoed in Yeats's contrast of his own fate to that of the natural world. It isn't, of course, *these* swans that will outlive the poet, but there will always be new ones on the lake: the linear passage of human beings from birth to death is set

against the cyclical life of nature, with its seasonal renewal and eternal return. Yeats's is a lyric of intense self-recognition.

Semantically "Wild Swans" is not a difficult poem; in a volume rehearsing many of Yeats's occult themes, as put forward in *A Vision*—for example, "Ego Dominus Tuus" and "The Phases of the Moon"—there is nothing in the title poem to look up, no arcane vocabulary, no Platonic or Plotinian motifs. Yet Yeats was surely aware of the difficulties of writing an ode on longing that would avoid bathos and sentimentality. So the drafts show us a poet patiently trying out this or that word and discarding it. It took draft after draft, for example, to get rid of "foliage" in line 1 and the reference to the waters being "low" in line 2 or 3; most important: in the finished stanza, there is no longer an "I" going to and fro, and the water, far from being ominously "low," is now in harmony with the sky.

> The treés are ín their aútumn beáuty
> The woódlând paths are **drý**.
> Únder the Octóber **twílîght** the wáter
> Mírrors a **stíll ský**.

The opening is quite low-key, seemingly matter-of-fact, a mere description of place, and the irregular syllable count—the 4/3/4/3 ballad stanza, which would normally have 8/6/8/6 syllables, here has 9/6/11/5—makes the opening look almost prosaic. It is the fourth short line that stands out, "**Mir**rors" receiving heavy initial stress and then being linked to "still" and "sky" by the assonance of short i's. Further, *mirroring* literally takes place as four of the letters in "still," perhaps the key word in the poem, is to be found in the "twilight" in the line above it. "**Sky**," moreover, echoes not only its rhyming partner "**dry**" but also the first syllable of "**twi**light." The other dominant consonant is t: "trees," "autumn," beauty," "October," "twilight" (twice), "water," "still." Note that "foliage" is discarded, perhaps because it adds nothing, trees obviously having foliage, whereas the second syllable of "beauty" gives us the **t** as well as a visual rhyme for **dry** and **sky**. And the word **beauty** has

falling rhythm, preparing the way for the falling rhythm of "**Un**der the Oct**o**ber **twilight** the **water**." "**Twilight**, for that matter, picks up the sound of **Wild** in the poem's title, just as **Swans** directs us to wat**er**, whose suffix in turn "mirrors" the suffix of **October**..

And now consider the role of the couplet:

Up**ón** the br**ím**ming w**á**ter am**óng** the st**ó**nes
Are n**í**ne-and-f**í**fty **swáns**.

In the earlier drafts, Yeats repeatedly wrote of "numbering" the swans, and he placed them "floating" "among the stones," or "Among the shadow of grey stones" (see Cornell, 11). "Grey," with its connotation of old age was too easy, and the talk of numbering gives way to presenting the swans in action. "Nine-and-fifty" has ballad echoes, as in "four and twenty blackbirds"; it also relates closely to the poet's own age and the "nineteenth autumn," testifying to the precision of his counting ritual. The water, moreover, far from being predictably "low," is now described as "brimming," which relates it to the sky above it and to the stones—stones no longer gray or ominously cast in shadow, but merely stones, earth and water thus forming a union.

But it is the jarring off-rhyme *stones/swans* that is the pièce de résistance. In every other stanza, the irregular couplet (iambic pentameter plus trimeter) rhymes neatly: *rings/wings, head/tread, will/still, day/away*. The harshness of the coupling of **stones** and **swans** is intentional, as if to say that beautiful creatures like these swans have their habitat, not in some idyllic blue water, but, on the contrary, "among the stones." And within that fifth line, almost every syllable mirrors and echoes: look at the repetition, sonic and visual, of the *on* sound in: "Up**on**," "am**ong**," "st**on**es," framed by the nasals, **m**'s and **n**'s. The couplet also carries on the **t** sound from the quatrain. The mirroring motif, so central to the whole poem, is thus neatly laid out, and in language seemingly direct and economical. "Floating," found again and again in the early drafts, is eliminated because it is redundant: of course swans float.

What seems like a fairly ordinary description—"the trees are in

their autumn beauty"—thus has as its subtext the image of mirror-
ing, of union, of brimming water reflecting a still sky, which is the
attribute of the natural world that the poet believes he himself lacks.
"The nineteenth autumn has come upon me / Since I first made my
count." The exposition is fairly dry, but it acts as a bridge to the im-
portant memory that interrupts the counting ritual—the memory
of the swans, "All suddenly mount[ing]":

> And scátter wheéling in greát bróken ríngs
> Upón their clámorous wíngs.

The neat chiming of the rhyme "rings"/"wings" is offset by the
harsh **k** sound heard three times: "**s**catter," "bro**k**en," "**c**lamorous."
The cliché would be to see the swans as gliding along in a grace-
ful flowing motion. But the fact is that when swans "mount," their
wings flapping make an ugly sound and they "scatter," not in per-
fect circles as one might expect but in "broken rings." The swans,
in other words, are seen, not as "immortal birds," as in Keats's ode,
but perhaps more like human beings than one might have thought.
Indeed the less than pleasant sound and movement of the swans is
picked up in the next stanza, which again begins casually:

> I have loóked upón those brílliant creátures
> And nów my heárt is sóre.
> Âll's chánged since Í, heáring at twílîght,
> The fírst tîme ón this shóre,
> The béll-beât of their wíngs abóve my heád,
> Tród with a líghter treád.

The metrical emphasis, after the tum-ti-tum of the second line, is on
"All's changed," with its heavy stressing. For the poet, all may well
have changed, and yet the sound he recalls hearing—"The bell-beat
of their wings above my head"—is quite similar to the "clamorous
sounds" of the present moment. True, the poet recalls in an elegant
sound repetition, those days when he "**Trod** with a ligh**ter tread**."
But if his tread was lighter, the bell-beat of the swans has remained

the same: a sound—"**bell-beat** . . . above"—at curious odds with their visual image.

And so, in the fourth stanza, the familiar man-versus-nature paradigm breaks down as the poet ascribes human qualities to his swans, even as he recognizes their essential *difference* from himself:

> Unweáried stíll, || lóver by lóver,
> They páddle in the cóld
> Cômpánionáble streáms or clímb the aír;
> Théir heârts have nót grôwn óld;
> Pássion or cónquêst, wánder whére they wíll,
> Atténd upón thêm stíll.

The first line here turns the iambic tetrameter line of standard ballad inside out, to give us a nine-syllable line, beginning almost normally (though "Un-" demands a secondary stress), but then with a strong midline pause and switch to falling rhythm: x / x / || / x x / x. It sounds, I think intentionally, almost like prose, the emphasis being on the symbolic properties of the swan. Here, the little word **still** (see "still water" in stanza 1) is used in an oxymoron with "unwearied"—continuously in motion and yet silent—as well as a pun: **still** here, as in the stanza's final line, refers to something that is continuing. The word **still** was a late addition: almost to the end Yeats had "unwearied now," which gave him none of the resonance he derived from "still." And the anthropomorphizing oxymoron "Unwearied still" prepares us for the metaphor of paired swans as lovers: they have a status he sadly lacks. More important: they belong in their habitat, the world of nature; he does not. The key word is "Companionable" in line 3, which has five syllables and thirteen letters and echoes the sounds of "paddle" and "cold," which precede it before the line break. For the swans the "**cold**" streams are not only semantically but phonemically "**Compan**ionable," the latter abstract adjective almost rhyming with "**paddle**" and containing as well the **cl** and **b** of "**climb**." And then the elaborate chiming gives way to a more sober account of what we have just witnessed: "Théir heârts have nót grôwn óld"—an almost perfect iambic trimeter, ex-

cept that the three secondary stresses ensure emphasis: the assertion is presented as incontrovertible. "Passion or conquest, wander where they will"—a ten-syllable recognizably iambic pentameter line with a reversal in the first foot and nursery rhyme–like alliteration ("wander where they will")—is followed by an almost perfect iambic trimeter: "Atténd upón thêm stíll." By the end of the stanza, the familiarity of ballad and rhyming couplet—*will/still*—has all but brought us back to the present moment. The rhythmic counterpoint and tension between abstract and concrete is striking.

The humanizing of the swans is, in any case, brief. The final stanza of "The Wild Swans at Coole" finds them once again "drift[ing] on the still water" like the birds they are:

> But nów they drift on the stíll water,
> Mystérioús, || beaútifúl;
> Amóng what rúshes wíll they buíld
> By whát lâke's édge or poól
> Delíght mên's eýes when Í awáke some dáy
> To fínd they have flówn awáy?

Yeats nailed down the language of this stanza fairly early in the process (see Cornell, 25), although originally he had the swans laying their eggs among the rushes and referred to their nests in the low waters and their having "fled." The poet expunged this unnecessary detail—to think of eggs and nests makes the swans too mundane—and allows them to "drift on the still water, / Mysterious"—with the repetition of "still" once more, embedded in the further short **i**'s and **t**'s of "dri**ft** on the **still** water."

"Mystérioús || beaútifúl": the words defy any attempt to incorporate them into the normative 4/3 stress pattern of the ballad; a four-syllable word is followed by a sharp break and then a three-syllable one, both abstract and connected emotionally in the poet's mind but with distinct sound curves: x / x / || / x /. The rest of the stanza is more regular, though the rhyme *beautiful/pool* is not. The third line, "Among what rushes will they build," is a perfect iambic tetrameter: x / x / x / x /. And the rest follows suit, regu-

larity of rhythm only slightly offset by the vowel repetition in the penultimate line — "De**light** men's **eyes** when **I** awake some d**ay**" and the internal rhyme of *men/when*. The final trimeter has an extra syllable, making it slightly awkward to pronounce — "To find they [have] flown away?" — and giving death an aura more practical than visionary.

The awakening is, of course, that of death. To "awake" when the swans have gone is to be no more; the poet is missing even as the swans (ever reborn and renewed) will still be there, delighting the eyes of others elsewhere. In the words of Eliot's Prufrock, "I do not think that they will sing to me." It is a theme that could be almost trite: man versus animal, the single poet versus the many swans, sometimes paired, poet's speech versus swan's "clamorous" cry, loneliness versus love, past versus present, land versus water, mortality versus immortality, old age versus eternal youth, and so on. What makes "The Wild Swans at Coole" so special — so memorable and satisfying — is not its larger theme, but its brilliant articulation of that theme via rhythm, repetition, and echo structure. The key is surely the four words in line 4, **Mirrors a still sky**, **still** repeated again and again with its double entendre and mirroring occuring in every stanza in one form or another, as in the swans' relationship to the "Cold / companionable streams" in which they "paddle." Or again, the poet's "heart is sore" even as "their hearts have not grown old." Sonic mirroring is everywhere, yielding repetition as well as opposition. The swans, after all, are to be found "among the stones."

In that earlier, much cited poem "Adam's Curse," the poet tries to impress his beloved by telling her and another friend how hard it is to write poetry:

> I said: 'A line will take us hours maybe;
> Yet if it does not seem a moment's thought,
> Our stitching and unstitching has been naught.
> Better go down upon your marrow bones
> And scrub a kitchen pavement, or break stones
> Like an old pauper, in all kinds of weather;

For to articulate sweet sound together
Is to work harder than all these, and yet
Be thought an idler by the noisy set
Of bankers, schoolmasters, and clergymen
The martyrs call the world.'

<div align="right">(PWBY, 204–5)</div>

This was written in 1902, and Yeats was clearly defensive in the face of Maud Gonne's seeming indifference to himself and to his poetry. But he was also telling the truth: the output of lyric poetry he produced in a lifetime was much smaller than, say, John Ashbery's or Adrienne Rich's in more recent years, but its every rift was loaded with ore, to cite Keats. "To articulate sweet sounds together" was a constant challenge," especially to make it all "seem a moment's thought," as in the case of "Where had her sweetness gone?"

"Poetry is the scholar's art," Wallace Stevens declared in one of his *Adagia*. Yeats, as his Rhymers Club companions liked to remind him, was no scholar. All the same, as his sonic inventions and revisions testify, he was perhaps in a deeper sense our great poet-scholar.

Acknowledgments

Chapter 1, "A Rose Is a Rose Is a Rrose Sélavy: Stein, Duchamp, and the Illegible Portrait," was originally delivered at a conference held in conjunction with the exhibition *The Stein Collection*, held at the Grand Palais in Paris in 2011. In earlier versions, it was published in *Moving Modernisms*, ed. David Bradshaw, Laura Marcus, and Rebecca Roach (Oxford: Oxford University Press, 2016), and again in French in *Gertrude Stein et les Arts*, ed. Isabelle Alfandary and Vincent Broqua (Paris: Les Presses du Réel, 2019). The essay has been largely rewritten for *Infrathin*.

Chapter 2, "Eliot's Auditory Imagination: A Rehearsal for Concrete Poetry," was delivered as the "Little Gidding" Lecture for the T. S. Eliot Summer School in August 2018, and published in revised form in *Raritan*, ed. Jackson Lears, vol. 38, no. 3 (Winter 2019): 69–91.

Earlier versions of chapter 4, "Word Frequencies and Zero Zones: Wallace Stevens's *Rock*, Susan Howe's *Quarry*," were delivered first as the annual "Friends of Wallace Stevens" lecture in Hartford, Connecticut, in October 2018, and again at the Huntington Library's Wallace Stevens conference in September 2019. It was published in an earlier version in *The Wallace Stevens Journal* (Fall 2020). A portion of the Susan Howe material in chapter 4 appeared as "Spectral Telepathy: The Late Style of Susan Howe,"

Transatlantica: Revue d'études américaines, special issue: "Revolution of the Word," ed. Clément Oudart (2016), http://transatlantica .revues.org/7983.

Finally, chapter 6, "'The Trembling of the Veil': Poeticity in Beckett's Text Soundings," appeared in earlier form as "The Evolution of Beckett's Poetry" in *The New Samuel Beckett Studies*, vol. 1, ed. Jean-Michel Rabaté, (Cambridge: Cambridge University Press, 2019), 65–84.

For invitations to present these and related materials in various venues, I am grateful to the following: Isabelle Alfandary, Kacper Bartczak, Vincent Broqua, Antoine Cazé, Amit Chauduri, Bart Eckhardt, Lisa Goldfarb, Luo Liangong, Anna Leahy, Jackson I. Lears, Glenn McLeod, Laura Marcus, Jean-Michel Rabaté, Ron Schuchard, and Nie Zhengzhao. At the University of Chicago Press, it has been a pleasure to work once again with Randolph Petilos and my editor of more than thirty years, Alan Thomas. And I want especially to thank my very unusual copy-editor Joel Score, whose encyclopedic knowledge of poetry and prosody greatly improved the manuscript.

As always, I owe a great deal to discussion and debate with friends and colleagues, especially the following: Charles Altieri, Jan Baetens, Mary Jo Bang, Charles Bernstein, Gerald Bruns, Michael Davidson, Al Filreis, Steve Fredman, Rubén Gallo, Nancy Gish, Peter Gizzi, Kenneth Goldsmith, Thomas Harrison, Susan Howe, Efrain Kristal, Susan McCabe, Jerome McGann, Tom Mitchell, Laure Murat, Jann Pasler, Vanessa Place, Jed Rasula, Brian Reed, Vincent Sherry, Richard Sieburth, John Solt, Susan Solt, Cole Swensen, and Robert von Hallberg. The Pound chapter could not have been written without the example of Yunte Huang's writings on Pound. As for Duchamp, I owe more than I can say to the rigorous and transformative criticism—as well as friendship—of Thierry de Duve.

My daughters Nancy Perloff and Carey Perloff have played the role of daily discussants on questions of the *Infrathin*, especially during the long lockdown months of COVID-19. I can't imagine what I would have done without them or without my three incom-

parable grandchildren, Benjamin Lempert, Alexandra Perloff-Giles, and Nicholas Perloff-Giles.

This book is dedicated to a remarkable poet-critic whom I first met when he was a sophomore and I his fortunate professor at Stanford University in the early 1990s. Craig Dworkin's poetry and poetics—and especially his two most recent books, *Dictionary Poetics* and *Radium of the Word*—have provided me with paradigms of a poetics—micro, or otherwise—that give me hope for the future of literary study.

<div style="text-align: right">

Marjorie Perloff
Los Angeles, 2020

</div>

Notes

Introduction

1 M. O'C. Drury, "Conversations with Wittgenstein," in *Ludwig Wittgenstein: Personal Recollections*, ed. Rush Rhees (Totowa, NJ: Rowan and Littlefield, 1981), 112–90, p. 171.

2 Viktor Shklovsky, *Bowstring: On the Dissimilarity of the Similar*, trans. Shushan Avagyan (1970; Champaign, IL: Dalkey Archive, 1994), 57.

3 Duchamp sometimes hyphenates *infra-mince*, but on the whole he uses no hyphen, and so I follow his practice here.

4 Marcel Duchamp, *Notes*, ed. Paul Matisse (1980; Paris: Flammarion, 1999). The forty-six notes on "Inframince" are found on pp. 20–47. As of this writing there is not yet an English edition, but various of the notes crop up in many writings on and museum exhibitions of Duchamp. The best discussion of the concept, which is not, strictly speaking, a concept—one can only exemplify the *inframince*—is that of Thierry de Duve, in *Pictorial Nominalism: On Marcel Duchamp's Passage from Painting to the Readymade*, trans. Dana Polan (1984; Minneapolis: University of Minnesota Press, 1991), 159–63.

5 All these examples come from Duchamp, *Notes*, 21–33. Translations are Thierry de Duve's or my own.

6 Ludwig Wittgenstein, *Philosophical Investigations*, §215.

7 Gertrude Stein, "A Carafe that is a Blind Glass," in *Tender Buttons: The Corrected Centennial Edition*, ed. Seth Perlow (San Francisco: City Lights, 2014), 11.

8 Note for the *White Box* (*A l'Infinitif*) (1914), in *The Essential Writings of Marcel Duchamp (Marchand du Sel/Salt Seller)*, ed. Michel Sanouillet and Elmer Peterson (London: Thames & Hudson, 1973), 78. Subsequently cited as *Salt Seller*.

9 Cleanth Brooks, *The Well-Wrought Urn* (New York: Harcourt Brace, 1947), 11.

10 Cleanth Brooks, *Modern Poetry and the Tradition* (1939; New York: Oxford University Press, 1965), 137, 167.

11 W. K. Wimsatt, *The Verbal Icon* (1954; New York: Noonday Press, 1958).

12 Cited by Roman Jakobson in *New Russian Poetry* (Prague, 1921), 7–8; see Victor Ehrlich, *Russian Formalism: History and Doctrine*, 4th ed. (The Hague: Mouton 1980), 44–45.

13 Roman Jakobson, "Linguistics and Poetics," in *Language in Literature*, ed. Krystyna Pomorska and Stephen Rudy (Cambridge, MA: Harvard University Press, 1987), 62–94, p. 87 and *passim*.

14 *Salt Seller*, 74.

15 Pierre Cabanne, *Dialogues with Marcel Duchamp*, trans. Ron Padgett (New York: Viking Press, 1971), 16. Subsequently cited as *Dialogues*.

16 Jurij Tynjanov, "The Meaning of the Word in Verse," in *Readings in Russian Poetics: Formalist and Structuralist Views*, ed. Ladislav Matejka and Krystyna Pomorska (Cambridge, MA: MIT Press, 1971), 136–45, pp. 136–37.

17 Velimir Khlebnikov, "Z and Its Environs," in *Collected Works*, vol. 1, *Letters and Theoretical Writings*, trans. Paul Schmidt, ed. Charlotte Douglas (Cambridge, MA: Harvard University Press, 1987), 304–6.

18 Jan Mukarovsky, "Two Studies of Poetic Designation," *The Word and Verbal Art: Selected Essays* (New Haven, CT: Yale University Press, 1977), 65–80, p. 66.

19 See Viktor Shklovsky, "Art as Technique," in *Russian Formalist Criticism: Four Essays*, 2d ed., ed. Lee T. Lemon and Marion J. Reis (Lincoln: University of Nebraska Press, 2014); Maria Gouch, "Faktura: The Making of the Russian Avant-Garde," *Journal of Anthropology and Aesthetics* 36 (1999): 32–59.

20 Haroldo de Campos, "Poetic Function and the Ideogram: The Sinological Argument," trans. Kevin Mundy and Mark Benson (1981); reprinted in Haroldo de Campos, *Novas*, in *Selected Writings*, ed. Antonio Sergio Bessa and Odile Cisneros (Evanston, IL: Northwestern University Press, 2007), 287–311, pp. 294–95.

21 Roy Campbell, "The Voyage," in Charles Baudelaire, *The Flowers of Evil*, ed. Marthiel and Jackson Mathews (New York: New Directions, 1958), 133; Charles Baudelaire, "Travellers," in *Les Fleurs du Mal*, trans. Richard Howard (Boston: David R. Godine, 1982), 151–57; Charles Baudelaire, "The Voyage," in *The Flowers of Evil*, trans. Keith Waldrop (Middletown, CT: Wesleyan University Press, 2006): 178–202.

22 *Dialogues*, 37. "I had a mania for change, like Picabia. One does something for six months, a, year, and one goes on to something else."

23 On the significance of Duchamp's Munich year, see esp. de Duve, *Pictorial Nominalism*, 96–118.

24 See Calvin Tomkins, *Duchamp: A Biography* (New York: Henry Holt, 1996), 236–37; Marjorie Perloff, "Dada without Duchamp/Duchamp without Dada: Avant-Garde Tradition and the Individual Talent," *Stanford Humanities Review*, 7, no. 1 (1999): 48–78; Perloff, "The Conceptual Poetics of Marcel Duchamp," in *Twenty-First-Century Modernism* (Oxford: Basil Blackwell, 2002), 77–120.

25 Why, it may be asked, Stein and Pound rather than William Carlos Williams or Marianne Moore? Why Ashbery rather than Sylvia Plath or one of my personal favorites, Lorine Niedecker? And why limit myself to Anglophone poets when my own predilection would have been for the Martinican Aimé Césaire, the Brazilian Augusto de Campos, or any number of German-speaking poets? I could have doubled or tripled my list of poets easily and written a much longer book. But because mine is a highly personal exercise in methodology rather than of movements or chronological, national, or ethnic groupings, I wanted to choose figures where reading, so to speak, against the grain might be most useful. Moore, for example, has not been read in ways I find questionable as has Stein.

26 G. W. F. Hegel, *Aesthetics: Lectures on Fine Art*, trans. T. M. Knox, 2 vols. (Oxford: Clarendon Press, 1975); Jonathan Culler, *Theory of the Lyric* (Cambridge, MA: Harvard University Press, 2015). See also Virginia Jackson, "Lyric," in *Princeton Encyclopedia*

of Poetry and Poetics, 4th ed., ed. Roland Greene et al. (Princeton, NJ: Princeton University Press, 2012), 826–35; Virginia Jackson and Yopie Prins, eds., *The Lyric Theory Reader: A Critical Anthology* (Baltimore: Johns Hopkins University Press, 2014).

27 J. W. von Goethe, *Werke*, 6 vols. (Wiesbaden: Insel Verlag, 1949–52), 1:59; Culler, *Theory*, 194–95. I have emended Culler's translation somewhat.

28 J. W. von Goethe, *Briefe*, Hamburger Ausgabe, ed. Karl Robert Mandelkow, 4 vols. (Hamburg: Christian Wegner, 1962–67), 1:314–15; translation mine. For an earlier version of this discussion of Goethe's poem, see my "Lucent and Inescapable Rhythms: Metrical 'Choice' and Historical Formation," in *Poetry On and Off the Page* (Evanston, IL: Northwestern University Press, 1998), 116–40, pp. 119–23.

Chapter One

1 Gertrude Stein, *Picasso* (Paris: Libraire Floury, 1938; English ed., trans. Stein with Alice B. Toklas, London: B. T. Batsford, 1939), reprinted in *Gertrude Stein on Picasso*, ed. Edward Burns (New York: Liveright, 1970), 3–76. The latter volume also contains Stein's two Picasso portraits, "Picasso" (1909), 79–81; and "If I Told Him: A Completed Portrait of Picasso" (1923), 83–91, as well as Stein's notebook entries on Picasso and extensive illustration.

2 Gertrude Stein, *Everybody's Autobiography* (1937; New York: Vintage, 1973), 37.

3 Pablo Picasso, "21 december xxxv," in Jerome Rothenberg, *Writing Through: Translations and Variations* (Middletown, CT: Wesleyan University Press, 204), 66. For a selection of Picasso's poems in French, see Picasso, *Poèmes*, ed. d'Androula Michaël (Paris: Le cherche midi, 2005). In her introduction, Michaël expresses great enthusiasm for Picasso's poetry: "Ecrire n'est pas pour Picasso une occupation de circonstance, ni un violon d'Ingres mais une activité à laquelle il s'est adonné avec passion" (14).

4 See, for example, my "Poetry as Word-System: The Art of Gertrude Stein," in *The Poetics of Indeterminacy: Rimbaud to Cage* (1981; Evanston, IL: Northwestern University Press, 1999), 67–108; Wendy Steiner, *Exact Resemblance to Exact Resemblance: The Literary Portraiture of Gertrude Stein* (New Haven, CT: Yale University Press, 1978), chap. 4 *passim*.

5 Pierre Cabanne, *Dialogues with Marcel Duchamp*, trans. Ron Padgett (New York: Viking Press, 1971), 42–43.

6 Gertrude Stein, *The Autobiography of Alice B. Toklas* (1933; New York: Vintage, 1990), 133–34.

7 As told by Calvin Tomkins in *Duchamp* (New York: Henry Holt, 1996), 130.

8 On Stein's mathematical interests, see Steven Meyer, *Irresistible Dictation: Gertrude Stein and the Correlations of Writing and Science* (Stanford, CA: Stanford University Press, 2001), esp. chap. 4, "At the Whiteheads': Science and the Modern World," 165–206.

9 *The Letters of Gertrude Stein and Carl Van Vechten, 1913–1914*, ed. Edward Burns (New York: Columbia University Press, 1986), 58–59.

10 See Marjorie Perloff, "Of Objects and Readymades: Gertrude Stein and Marcel Duchamp," *Forum for Modern Language Studies* 32, no. 2 (1996): 137–54; cf. Perloff, *Twenty-First-Century Modernism: The "New" Poetics* (Oxford: Blackwell, 2002), 77–120.

11 "Roche," written in the style of the first Picasso portrait, begins, "Was one who certainly was one really being living, was this one a complete one, did that one complete have it to do very well something that that one certainly would be doing if that one could be

doing something." In Gertrude Stein, *Geography and Plays* (1922; Madison: University of Wisconsin Press, 1993), 141. Subsequently cited in the text as *G & P*. For the 1922 edition, see Project Gutenberg, http://www.gutenberg.org/ebooks/33403.

12 See James Mellow, *Charmed Circle: Gertrude Stein and Company* (New York: Avon, 1974), 311.

13 See Cyrena Pondrom, introduction, in Stein, *Geography and Plays*, i-lv.

14 Stein, "Poetry and Grammar," *Lectures in America*, in Gertrude Stein, *Writings 1932–1946* (New York: Library of America, 1998), 313-36, p. 327.

15 Janet Malcolm, for example, in her widely admired study *Two Lives: Gertrude and Alice* (New Haven, CT: Yale University Press, 2007), makes a sharp distinction between the "experimental writing" (e.g., *Tender Buttons*, the portraits) and the "audience writing" (96) of *The Autobiography of Alice B. Toklas* and such later works as *Wars I Have Seen*, dismissing the former as "unreadable" and hence not worthy of discussion.

16 Tomkins, *Duchamp*, 231.

17 On the absence of facial hair, see Dalia Judovitz, *Unpacking Duchamp: Art in Transit* (Berkeley: University of California Press, 1995), 144-45. In her more recent book *Drawing on Art: Duchamp and Company* (Minneapolis: University of Minnesota Press, 2010), Judovitz writes, "Not only did Duchamp borrow a stylish hat from Germaine Everling (Picabia's mistress), but, more importantly, he also borrowed her arms and delicate hands in order to enhance the illusion of femininity conveyed by the photograph . . . she stood right behind him in a sort of embrace" (32-33).

18 See *Affect-Marcel: The Selected Correspondence of Marcel Duchamp*, French-English ed., ed. Francis M. Naumann and Hector Obalk (London: Thames & Hudson, 2000), 87-160.

19 Francis M. Naumann, *Marcel Duchamp: The Art of Making Art in the Age of Mechanical Reproduction* (New York: Harry N. Abrams, 1999), 98. Portions of the pamphlet are reproduced on pp. 89-91.

20 The "Dossier" includes poems by Pierre de Massot, a selection of letters to Massot from Duchamp, and Paul B. Franklin's important essay "Portrait d'un poète en jeune homme bi: Pierre de Massot, Marcel Duchamp, et l'héritage Dada," 56-85. *The Wonderful Book* is further annotated by extracts from reviews and commentaries by Gerald Pfister, Michel Vanpeene, and others.

21 For a book-length treatment of the topic, see Craig Dworkin, *Reading the Illegible* (Evanston, IL: Northwestern University Press, 2006).

22 Gertrude Stein, *Dix Portraits*, bilingual edition with French translations by Georges Hugnet and Virgil Thomson (Paris: Editions de la Montagne, 1930). The other nine portraits are of Guillaume Apollinaire, Erik Satie, Christian Bérard, Eugene Berman, Bernard Faÿ, Georges Hugnet, Pavel Tchelitchew, Virgil Thomson, and Kristians Tonny.

23 Reproduced in Franklin, "Portrait d'un poète," 13.

24 Gertrude Stein, "Guillaume Apollinaire," in *Writings*, vol. 1, *1903-1932* (New York: Library of America, 1998), 385.For background, see Ulla E. Dydo, *Gertrude Stein: The Language That Rises 1923-1934* (Evanston, IL: Northwestern University Press, 2003), 294-301. Dydo notes that de Massot spoke excellent English and wanted to translate *Tender Buttons* and *Geography and Plays*, but this didn't come to pass. Dydo discusses Hugnet and Thompson's translations of *Dix Portraits* (296-300) and notes that word-for-word translation such as they used fails to reproduce any sense of the original wordplay. But, one might add, Duchamp, able to read Stein in English and now often producing English puns of his own, could appreciate the originals.

25 "Préface," *Expositions de dessins par Francis Picabia*, Galerie Léonce Rosenberg, Paris,

1–24 December 1932. English preface by Gertrude Stein, pp. 1–2; French preface by Marcel Duchamp, pp. 3–4. Reprinted in *Orbes*, no. 4 (Winter 1932–33), 64–67 (where it is found side by side with poems by Hans Arp and Picabia), and again in Olga Mohler, *Francis Picabia* (Torino: Ed. Notizie, 1975), 43. In the French translation, the stanza in question is numbered "Stance 69 des *Stances de meditation*"). I reproduce the French versions from Mohler. For the English text, see Gertrude Stein, *Stanzas in Meditation: The Corrected Edition*, ed. Susannah Hollister and Emily Setina (New Haven: Yale University Press, 2012), 241–42.

26 John Ashbery, "The Impossible: Gertrude Stein" (1957), in Ashbery, *Selected Prose*, ed. Eugene Richie (Ann Arbor: University of Michigan Press, 2004), 11–15; reprinted in *Stanzas in Meditation*, 50–55. The editors explain Stein's misnumbering in successive manuscripts on 264–67.

27 Mohler, *Francis Picabia*, 42.

28 On the use of pronouns in *Stanzas*, see Joan Retallack's introduction, "On Not Not Reading *Stanzas in Meditation*," in *Stanzas in Meditation*, 22–25.

29 On Alice's substitution of the word "can" for every "may" (a reference to May Bookstaver, with whom Stein was once in love) in her transcript of the text, see Dydo, *Gertrude Stein*, 488–502; Retallack, "On Not Not Reading," 8–14. Appendix D to the Hollister-Setina edition tracks all the changes in the manuscript (268–379).

30 Georges Hugnet, "Rose Is a Rose on Stein," *Orbes*, no. 2 (Spring 1929), 59–61, p. 61.

31 *Salt Seller*, 26.

Chapter Two

1 Ian Hamilton Finlay, *Table Talk* (Scotland: Barbarian Press, 1985), 9.

2 The commentary, to be found in *The Poems of T. S. Eliot*, vol. 1, *Collected and Uncollected Poems,* ed. Christopher Ricks and Jim McCue (Baltimore: Johns Hopkins University Press, 2015), is now the fullest source of information about the composition, sources, and allusions of the poem: for the overview of *Four Quartets*, see pp. 881–901; for *Little Gidding*, 989–1044. For the textual history, cross-referenced in volume 1, see vol. 2, 511–45. Since the editors give such a thorough account of the choice of the village of Little Gidding in Huntingdonshire as setting and of the history of the Nicholas Ferrar community, I shall not repeat this information here. For the text itself, see vol. 1, 201–9. The Ricks-McCue edition is subsequently cited as *PTSE*.

3 Hugh Kenner, *The Invisible Poet: T. S. Eliot* (New York: Harcourt Brace, 1959), 307.

4 Grover Smith, *T. S. Eliot's Poetry and Plays: A Study in Sources and Meaning* (Chicago: University of Chicago Press, 1956), 253.

5 Helen Gardner, *The Art of T. S. Eliot* (London: Cresset Press, 1949), 29–38.

6 "the spirit unappeased and peregrine": the phrase has a brilliant orchestration of *p*'s and long *e* vowels. The word **peregrine** originally referred to a kind of falcon; it came to mean foreign, from abroad, wandering, migratory. The spirit cannot cease from its wandering, its exploring. The poet as explorer, moreover, ties in with the fact that Peregrine is also a proper name and, as Susan Howe pointed out to me, Peregrine White (1620–1704) was "the second baby born on the Mayflower's historic voyage, and the first known English child born to the Pilgrims in America." Perhaps the American Eliot, a proud descendant of the great Puritan New England settlers, consciously or not, associates his own "unappeasable and peregrine" spirit with that of the first English "pilgrim."

7 Marcel Duchamp, *Notes*, ed. Paul Matisse (1980; Paris: Flammarion, 1999), 115; my translation.

8 Thierry de Duve, *Pictorial Nominalism: On Duchamp's Passage from Painting to the Readymade*, trans. Dana Polan (1984; Minneapolis: University of Minnesota Press, 1991), 160. Cf. Ludwig Wittgenstein's pressing question in the *Philosophical Investigations* (§ 215), "But isn't the same at least the same?"

9 T. S. Eliot, *The Use of Poetry and the Use of Criticism*, the Charles Eliot Norton Lectures for 1932–33 (Cambridge, MA: Harvard University Press, 1964), 111.

10 T. S. Eliot, "The Music of Poetry" (1942), in *On Poetry and Poets* (New York: Noonday Press, 1961), 25.

11 See *PTSE*, 1:5–9, p. 5, and commentary, 373–99.

12 In marking stresses and pauses, I have followed, as much as possible, Eliot's own reading of his poems, readily available online; see, for example, "T. S. Eliot reading his 'Four Quartets' (1947)," https://www.youtube.com/watch?v=WR-S2Q25nYE.

13 See *PTSE*, 2:512; Helen Gardner, *The Composition of Four Quartets* (New York: Oxford University Press, 1978), 157. The symbol ℘ indicates deletion.

14 For the sake of convenience, I have reproduced this passage in larger type so that the primary and secondary accents will be more prominent and I have given line numbers at the right margin.

15 Gardner, *The Art of T. S. Eliot* (London: Cresset Press, 1949), 30–32.

16 For typescript M1, see Gardner, *Composition*, 158; *PTSE*, 2:511ff. Italics indicated words and phrases that were later changed. For typescript M5, Gardner, *Composition*, 160.

17 On Eliot's admiration for Edward Lear, see the long note on "Five-Finger Exercises," in *PTSE*, 1:838.

18 According to the *OED*, the term *zero sum*, from mathematical game theory, dates from 1944, two years after *Little Gidding* was completed, but perhaps Eliot had already heard it used. In any case, it is hard to read *zero summer* today without thinking of *zero sum*: the situation where one party's gain is precisely another's loss.

19 See Gardner, *Composition*, 171. Eliot's verse form is not, strictly speaking, *terza rima*, since it doesn't use Dante's rhyme scheme *ababcbcdc* . . . and avoids rhyme altogether. But its iambic pentameter tercets approximate the original.

20 Gardner, *Composition*, 194.

21 See the editors' "The Waste Land: An Editorial Composite," in *PTSE*, 1:327.

22 For discussion of Susan Howe's poetic structures, see chapter 3 *passim*, and Marjorie Perloff, "'Spectral Telepathy': The Late Style of Susan Howe," *Transatlantica: Revue d'études américaines*, special issue: "Revolution of the Word," ed. Clement Oudart (2016), http://transatlantica.revues.org/7983.

23 Ian Hamilton Finlay, "Letters to Ernst Jandl," *Chapman*, nos. 78–79, special issue: "Ian Hamilton Finlay," ed. Alec Finlay (1994), 10–16, p. 12; Finlay, *Table Talk*, 4.

24 *Ring of waves* is the July entry in the calendar. The *Blue and Brown Poems* calendar was printed for Jargon Press by Atlantic Richfield Company and Graphic Arts Typographers with the calendar design by Herbert M. Rosenthal (Aspen, 1968). Each of the twelve lithographs measures about 21 × 13 inches. See Marjorie Perloff, "From Suprematism to Language Game: The Blue and Brown Poems of Ian Hamilton Finlay," in the catalogue *The Present Order: Writings on the Work of Ian Hamilton Finlay* (Marfa Book Co., 2010), 85–103.

25 See Jessie Sheeler, *Little Sparta: The Garden of Ian Hamilton Finlay* (London: Frances Lincoln Ltd, 2003), 43.

26 Craig Dworkin, *The Pine-Woods Notebook* (Chicago: Kenning Editions, 2019).

27 Craig Dworkin, email to author, 9 February 2015; my emphasis.

Chapter Three

1 James Joyce, *A Portrait of the Artist as a Young Man*, Norton Critical Edition (New York: Norton, 2007), 13.

2 "The Coming of War: Actaeon" was first published in *Poetry* in March 1915, and then in Pound, *Lustra* (1916). See Ezra Pound, *Poems and Translations*, ed. Richard Sieburth (New York: Library of America, 2003), 285.

3 Timothy Billings's recent critical edition of *Cathay* (New York: Fordham University Press, 2019), with a foreword by Haun Saussy and introduction by Christopher Busch, is central to our understanding of Pound's pre-Canto poetry and the impact of Ernest Fenollosa. Cf. Ernest Fenollosa and Ezra Pound, *The Chinese Written Character as a Medium for Poetry*, Critical Edition, ed. Haun Saussy, Jonathan Stalling, and Lucas Klein (New York: Fordham University Press, 2008).

4 *The Literary Essays of Ezra Pound*, ed. T. S. Eliot (1954; New York: New Directions, 1972), p. 3. Subsequently cited in the text as *LE*.

5 T. S. Eliot, "Ezra Pound," *Poetry*, September 1946; reprinted in *The Poems of T. S. Eliot*, vol. 1, *Collected and Uncollected Poems*, ed. Christopher Ricks and Jim McCue (Baltimore: Johns Hopkins University Press, 2015), 355.

6 *The Cantos of Ezra Pound* (New York: New Directions, 1993), 581. Subsequent references are to this edition.

7 Donald Davie, *Ezra Pound: Poet as Sculptor* (New York: Oxford University Press, 1964), 45.

8 On Pound's use of the Classical meters, specifically the "cleaved hexameter," see Orla Pollen's excellent essay "To Break the Hexameter: Classical Prosody in Ezra Pound's Early Cantos," *Modern Philology* 115, no. 2 (November 2017): 264–88. For the kinds of feet and the notation used in the scansions found in this essay, see the entries under "Classical Prosody," "Meter," and the individual feet in *The Princeton Encyclopedia of Poetry and Poetics*, 4th ed., ed. Roland Greene, Stephen Cushman, et al. (Princeton, NJ: Princeton University Press, 212).

9 On this transition, see Hugh Kenner's delightful short book *The Mechanic Muse* (New York: Oxford University Press, 1987), esp. the chapter "Pound Typing," 39–59.

10 W. B. Yeats, "A General Introduction for My Work" (1937), in *Essays and Introductions* (New York: Macmillan, 1961), 522.

11 See Davie, *Ezra Pound: Poet as Sculptor*, 63–64.

12 Ezra Pound, *ABC of Reading* (1934; New York: New Directions, 1960), 36, 28–29.

13 See Marjorie Perloff, "The Search for 'Prime Words': Pound, Duchamp, and the Nominalist Ethos," in *Differentials: Poetry, Poetics, Pedagogy* (Tuscaloosa: University of Alabama Press, 2004), 39–59.

14 Ezra Pound, "The Approach to Paris," *New Age* 13 (1913): 662; see Pound, *Selected Prose, 1909–1965*, ed. William Cookson (New York: New Directions, 1973), 23.

15 Ezra Pound, "Digest of the Analects," in *Guide to Kulchur* (New York: New Directions, 1952), 16. The reference is to *Analects* 13, 3.

16 See https://plato.stanford.edu/entries/medieval-haecceity.

17 It is interesting to note how far the later Pound moved away from the external print devices (ornamental capitals, two-color printing in red and black) of the first book installments of *The Cantos* (I–XXX), produced by various expensive art presses on the model of William Morris's Kelmscott Press. See Jerome McGann, *Black Riders: The Visible Language of Modernism* (Princeton, NJ: Princeton University Press, 1993), 78–80.

18 See Pound, *ABC of Reading*, 26 and *passim*. In his important foreword to Fenollosa and Pound, *Chinese Written Character*, Haun Saussy defines the ideogrammic method as "a logic of juxtaposed particulars, 'luminous details' that speak for themselves when revealed by the poet" (4).

In *The Pound Era* (Berkeley: University of California Press, 1971), Hugh Kenner refers to the ideogrammic method as "subject rhyme" (423). I discuss the metonymic structure and rhythm of recurrence in the *Cantos* in Marjorie Perloff, "'No Edges, No Convexities': Ezra Pound and the Circle of Fragments," in *The Poetics of Indeterminacy: Rimbaud to Cage* (1981; Evanston, IL: Northwestern University Press, 1999), 155–99.

19 R. P. Blackmur, 'Masks of Ezra Pound" (1934), in *Ezra Pound*, ed. J. P. Sullivan, Penguin Critical Anthologies (Baltimore: Penguin, 1970), 143–73. "The Cantos are not complex, they are complicated; they are not arrayed by logic or driven by pursuing emotion, they are connected because they follow one another" (155). Things have not changed much: cf. David Bromwich in a review of A. David Moody's biography of Pound for the *Times Literary Supplement*, 31 July 2015, 3–5: "Consider a fairly typical example from the *Cantos, a passage of micro-narrative studded with unconnected facts*" (5, my emphasis).

20 Octavio Paz, *The Bow and the Lyre: The Poem. The Poetic Revelation. Poetry and History*, 2d ed., trans. Ruth L. C. Simms (Austin: University of Texas Press, 1973), 67–68.

21 Octavio Paz, "The Word as Foundation," *Times Literary Supplement*, 14 November 1968, 1283–84; my emphasis. For a more extensive discussion of Paz's critique of Pound, see Marjorie Perloff, "Refiguring the Poundian Ideogram: From Octavio Paz's *Blanco/Branco* to Haroldo de Campos's *Galáxias*," *Modernist Cultures* 7, no. 1 (2012): 40–55.

22 See Octavio Paz, letter to Haroldo de Campos, 14 March 1968, in Octavio Paz and Haroldo de Campos, *Transblanco (em torno a Blanco deo Octavio Paz)* (São Paulo: Editora Siciliano, 1986), 101; my translation.

23 Marcel Duchamp, *The Blind Man*, no. 2 (May 1917), unpaginated. The article is printed in large type of various size; on the facing page is a reproduction of Alfred Stieglitz famed photograph of *Fountain*. A 100th anniversary facsimile edition of *The Blind Man* with ancillary materials is available from Ugly Duckling Presse (2017).

24 Haroldo de Campos, "The Informational Temperature of the Text," in *Novas: Selected Writings*, ed. Antonio Sergio Bessa and Odile Cisneros (Evanston, IL: Northwestern University Press, 2007), 223–34. Subsequently cited in text as *Novas*.

25 See Pound's reface to Ernest Fenollosa, *The Chinese Written Character as a Medium for Poetry* (New York: Arrow Editions, 1936), 5. C. K. Ogden, *Basic English*, was first published in 1929; see the revised and expanded version, *The System of Basic English* (New York: Harcourt, Brace & World, 1968). For a detailed study of Pound's response to BASIC, see Yunte Huang, "Basic English, Chinglish, and Translocal Dialect," in *English and Ethnicity*, ed. Janina Brutt-Griffler and Catherine Evans Davis (New York: Palgrave, 2006), 75–103.

26 Ezra Pound to C. K. Ogden, Rapallo, 28 January 1935; see Pound, *Letters 1907–1941*, ed. D. D. Paige (London: Faber and Faber, 1951), 266.

27 This and later examples from Pound's Cantos are given to Richard Sieburth's edition of *The Pisan Cantos* (New York: New Directions, 2003), in which the lines are helpfully numbered and there are excellent notes. For Canto 79, see p. 65. Subsequently cited as *Pisans*.

28 For these references, see *Pisan Cantos*, 143; Carroll F. Terrell, *A Companion to the Cantos of Ezra Pound*, vol. 2 (Berkeley: University of California Press, 1984), 425–26. They can also be found online; indeed, the internet search has revolutionized Pound studies, for names like Guido d'Arezzo are easily identified with a Google search.

29 Ernest Fenollosa, "The Chinese Written Character as a Medium for Poetry," in the Fordham critical edition, 41–74, p. 54. Cf. Haroldo de Campos, "Poetic Function and Ideogram: The Sinological Argument," in *Novas*, 287–311, esp. p. 298.

30 https://media.sas.upenn.edu/pennsound/authors/Filreis/Sieburth-Richard_interview_Penn_05-22-07.mp3.

31 For an interesting treatment of such achronicity as a form of defamiliarization, see Viktor Shklovsky, "The Convention of Time," in *Bowstring: On the Dissimilarity of the Similar*, trans. Shushan Avagyan (1970; Champaign, IL: Dalkey Archive, 1994), 121–44.

32 Hugh Kenner, *Pound Era*, 557–58.

33 Guy Davenport, "Ezra Pound 1885–1972," in *The Geography of the Imagination* (San Francisco: North Point, 1981), 175–76.

34 Kenner's epithet gave me the title of an essay I published some thirty years ago: see Marjorie Perloff, "The Contemporary of Our Grandchildren: Ezra Pound and the Question of Influence," in *Ezra Pound among the Poets*, ed. George Bornstein (Chicago: University of Chicago Press, 1985), 195–229; reprinted in Perloff, *Poetic License: Essays in Modernist and Postmodernist Lyric* (Evanston, IL: Northwestern University Press, 1990), 119–44.

35 Charles Olson, "Projective Verse," in *Selected Writings*, ed. Robert Creeley (1950; New York: New Directions, 1966), 15–26, pp. 17–19.

36 "Pilot Plan for Concrete Poetry," in Haroldo de Campos, *Novas*, 217–19, p. 217. Cf. Haroldo's related essay "Concrete Poetry—Language—Communication," *Suplemento dominical do Journal do Brasil* (Rio de Janeiro, 28 April and 3 May 1957); *Novas*, 235–45.

37 Originally published in the São Paulo journal *Perspectiva* in 1976; *Novas*, 276–86, trans. Craig Dworkin.

38 *Novas*, 282; cf. Marjorie Perloff, "The Invention of 'Concrete Prose': Haroldo de Campos's *Galáxias* and After," in *Differentials: Poetry, Poetics, Pedagogy* (Tuscaloosa: University of Alabama Press, 2004), 175–293; Perloff, "From Avant-Garde to Digital: The Legacy of Brazilian Concrete Poetry," in *Unoriginal Genius: Poetry by Other Means in the New Century* (Chicago: University of Chicago Press, 2014), 50–75.

Chapter Four

1 Letter to Thomas McGreevy, 11 March 1949, *Letters of Wallace Stevens*, ed. Holly Stevens (New York: Alfred A. Knopf, 1966), 632. Subsequently cited as *LWS*.

2 McGreevy, introduced to Stevens by Henry and Barbara Church, was also the chief correspondent of Samuel Beckett, especially during the two Irish poets' youth. Beckett, almost thirty years younger than Stevens, seems to have known nothing of the American poet's work.

3 *The Rock* was never published as a separate volume. When Stevens was preparing the manuscript of his *Collected Poems* in 1954, a year before his death, he included this new "volume" of poems, omitting some that were later included in *Opus Posthumous* (1957) and later in *The Palm at the End of the Mind* (1984) and *Selected Poems*, ed. John N. Serio (2009). The edition, which includes the material in all three, and hence is cited throughout this chapter, is Wallace Stevens, *Collected Poetry and Prose*, ed Frank Kermode and Joan Richardson (New York: Library of America, 1997). Subsequently cited as *CPPS*.

4 Joan Richardson, *Wallace Stevens, A Biography: The Later Years, 1923–1955* (New York: William Morrow, 1988), 291.

5 See Helen Vendler, *Wallace Stevens: Words Chosen Out of Desire* (Knoxville: University of Tennessee Press, 1984), 27–28 and *passim*.

6 "The Thrilling Mind of Wallace Stevens" (review of Paul Mariani's *The Whole Harmonium: The Life of Wallace Stevens*), *New Yorker*, 2 May 2016, https://www.newyorker.com/magazine/2016/05/02/the-thrilling-mind-of-wallace-stevens.

7 Susan Howe, *The Quarry* (New York: New Directions, 2015), 3.

8 W. B. Yeats, *Letters on Poetry from W. B. Yeats to Dorothy Wellesley* (Oxford: Oxford University Press, 1964), 61.

9 See, for example, Richardson, *Wallace Stevens, A Biography: The Later Years*, 390–91.

10 Henry David Thoreau, *Walden*, ed. J. Lyndon Shanley (Princeton, NJ: Princeton University Press, 1971), 324.

11 In a letter to Robert Pack, 14 April 1955, Stevens says the omission of "Course" from *The Collected Poems* was simply a mistake" (*LWS*, 881).

12 Susan Howe, *Spontaneous Particulars: The Telepathy of Archives* (New York: New Directions, 2014).

13 "A teal," writes Howe, "is a small wild fresh-water fowl. Its flesh is food for hunters. But James has seeded the word with the spectral grapheme *h* and the plant, 'wrapped in the dignity of art,' has grown" (*Particulars*, 55).

14 See Helen Vendler, *The Ocean, the Bird and the Scholar: Essays on Poets and Poetry* (Cambridge, MA: Harvard University Press, 2015), 21–22.

15 *Quarry*, 5–6. "Like rubies reddened" is from "Description without Place"; "repetitiousness of men and flies," from "The Plain Sense of Things"; "new knowledge of reality," from "Not Ideas about the Thing but the Thing Itself"; and "Red-in-red repetitions," from "Notes toward a Supreme Fiction."

16 *LWS*, 709–10. Note that in that last sentence, the prose is highly figured, playing on the collocation of *a*'s, *l*'s and *i*'s—

> happy to be alive
> happy again to be alive still
> and I walked half-way . . .

17 Coleridge's "Frost at Midnight" ends with reference to "icicles / Quietly shining to the quiet moon."

Chapter Five

1 John Ashbery, *Selected Prose*, ed. Eugene Richie (Ann Arbor: University of Michigan Press, 2004), 20–21.

2 On *sdvig*, see, for example, David Burliuk, "Cubism" (1912), in *Russian Art of the Avant-Garde: Theory and Criticism 1902–1934*, ed. John E. Bowlt (New York: Viking Press, 1976), 69–76. On Ashbery and collage, see, for example, Olivier Brossard, "Entretien avec John Ashbery," *L'Oeil de boeuf*, no. 22 (September 2001), http://www.doublechange.com/issue3/loeildeboeuf-eng, p. 22: "Je crois qu'en un sens toute mon oeuvre tient du collage même si je ne fais pas de *découpage* à proprement parler. Mon esprit passé d'une chose à une autre chose totalement différente, les juxtapose pour voir ce à quoi tout cela va ressembler." ("I think that in a sense all my work has been collage, even though I have not literally produced *découpage*. My mind moves from one thing to another entirely different one, I juxtapose them to see what can be made of it all.")

In *John Ashbery: The Construction of Fiction*, catalogue for the Pratt Manhattan Gal-

lery (New York, September–November 2018), 2–14, Sergio Bessa refers to the "collagist basis" of Ashbery's poetry, but the collages displayed—made by Ashbery in his spare time out of whatever materials came across his desk—are more casual and spontaneous than his poems, and I want to distinguish between the two.

3 Brossard, "Entretien," 15.

4 For a comprehensive collection of Ashbery readings, talks, and interviews, see the PennSound collection, http://writing.upenn.edu/pennsound.

5 See Silliman's Blog, http://ronsilliman.blogspot.com, 26 January 2003. The blog has since been discontinued. The reference here is to the dichotomy Silliman himself has established between the poets in Donald Allen's famous anthology *The New American Poetry* of 1960—he calls their heirs the "post-avants"—and the traditional confessional or "scenic" lyric Silliman has dubbed and continues to refer to as "School of Quietude." Louise Glück would be a quintessential "School of Quietude" poet, as would Charles Wright. Hollander, Bloom, and Vendler are, in Silliman's view, critics who support this mainstream poetry.

6 See Mark Ford, *The New York Poets: An Anthology* (2004); *Raymond Roussel and the Republic of Dreams* (2001). Ford is the editor of both Library of America volumes.

7 Frank O'Hara was strongly influenced by Hart Crane as well as by William Carlos Williams, but neither the baroque locutions of the former nor the vernacular free-verse rhythms of the latter have had much impact on Ashbery. See Marjorie Perloff, *Frank O'Hara: Poet among Painters*, 2nd ed. (1977; Chicago: University of Chicago Press, 1997), 31–74.

8 In the opening chapter of *The Poetics of Indeterminacy: Rimbaud to Cage* (1981; Evanston, IL: Northwestern University Press, 1999), I contrasted the Ashbery of "These Lacustrine Cities" to the Eliot of *The Waste Land*. I gradually came to see that this was a questionable dichotomy. In "The Conversation" (2002), in *John Ashbery in Conversation with Mark Ford* (London: Between the Lines, 2003), Ashbery says, "It was really only later in life that I suddenly realized how good [Eliot] was" (32). The Eliot echoes in Ashbery's work deserve careful study.

9 John Ashbery, *Other Traditions* (Cambridge, MA: Harvard University Press, 2000), 4.

10 See Allen Ginsberg, "Advice to Youth" (April 1971), in *Allen Verbatim: Lectures on Poetry, Politics, Consciousness*, ed. Gordon Ball (New York: McGraw Hill, 1974), 111: "Ezra Pound has never failed me as a model; I mean he is still my master." And in "The Death of Ezra Pound" (1972), when asked whether Pound deserved the American Academy of Arts and Sciences prize, Ginsberg spluttered, "Certainly, give him *all* the awards. It's a shame he didn't get the Nobel and all the other awards at once—he was the greatest poet of the age! Greatest poet of the age . . ." (*Allen Verbatim*, 180).

11 "Variant," *Houseboat Days* (New York: Viking Press, 1977), 4; reprinted in John Ashbery, *Collected Poems, 1956–1987* (New York: Library of America, 2008), 493. Subsequently cited as *CPA*.

12 See the lines, "MacArthur's Park is melting in the dark / All the sweet, green icing flowing down / Someone left the cake out in the rain." The allusion was pointed out to me by Joel Score.

13 Charles Bernstein, "The Meandering Yangtse (*Rivers and Mountains*, 1966)," *Conjunctions*, no. 49, special section: "John Ashbery Tribute," ed. Peter Gizzi and Bradford Morrow (Fall 2007), http://www.conjunctions.com/print/archive/conjunctions49.

14 Brian Reed, "Hart Crane's Victrola," *Modernism/Modernity* 7, no. 1 (January 2000): 99–125, p. 117.

15 Susan Stewart, "I Was Reading and Rereading John Ashbery's *Self-Portrait* for Many Years: *Self-Portrait in a Convex Mirror* (1975)," *Conjunctions*, no. 49 (Fall 2007), 311–26, p. 326.

16 Helen Vendler, review of Ashbery, *A Wave*, *New York Review of Books* 31, no. 10 (14 June 1984): 32–33.

17 John Shoptaw, *On the Outside Looking Out: John Ashbery's Poetry* (Cambridge, MA: Harvard University Press, 1995), 65–66. Ashbery's irritation about the honey reference was expressed in a conversation with the author in Los Angeles, ca. 1997.

18 The story of Koethe's discipleship to Ashbery, beginning with their first meeting at Princeton when Koethe was an undergraduate, is told in the long autobiographical title poem of Koethe's volume *Ninety-fifth Street* (New York: Harper, 2009). Other members of the original "tribe" were, in alphabetical order, John Ash, Ann Lauterbach, David Lehmann, David Shapiro, Marjorie Welish, and John Yau, to name just the most prominent.

19 John Koethe, "The Absence of a Noble Presence," in Susan M. Schultz, *The Tribe of John: Ashbery and Contemporary Poetry* (Tuscaloosa: University of Alabama Press, 1995), 83–90, pp. 85–86.

20 Koethe, "Absence," 89, on Douglas Crase, *The Revisionist* (Boston: Little Brown, 1981).

21 Cited on the webpage "Douglas Crase," http://www.douglascrase.com.

22 The new edition of *The Revisionist* was published by Nightboat Books (New York) in 2019, together with Crase's slim chapbook *The Astropastorals* (Manchester: Carcanet, 2017), which had not yet been published in the United States. The new book is edited with an introduction by Ford, who was very close to Ashbery, and it has received some glowing reviews—reviews that strike me as motivated by admiration more for Crase, the engaging man of letters, and for the Ashbery legacy than for the poems themselves.

23 John Ashbery, "The New York School of Poets," in *Selected Prose*, 113.

24 Ashbery, "New York School," 113.

25 John Ashbery, *Reported Sightings: Art Chronicles 1957–1987*, ed. David Bergman (New York: Alfred A. Knopf, 1989), 6.

26 James E. B. Breslin, ed., *Something to Say: William Carolos Williams on Younger Poets* (New York: New Directions, 1985), 30; Barry Ahearn, ed., *The Correspondence of William Carlos Williams and Louis Zukofsky* (Middletown, CT: Wesleyan University Press, 2003), xiii–xxiii.

27 Ash died in 2019; Yau is now recognized as a leading Asian-American poet, but in the 1970s and 1980s was part of Ashbery's cenacle.

28 When I first moved to California in 1976 and asked Ashbery what West Coast poets he admired, he immediately cited Armantrout's as a distinctive voice. This was before I had become familiar with Language poetry, only then coming to the fore.

29 Charles Bernstein, *All the Whiskey in Heaven: Selected Poems* (New York: Farrar, Straus & Giroux, 2010). For an early comparison between Ashbery and Bernstein, see John Shoptaw, "The Music of Construction: Measure and Polyphony in Ashbery and Bernstein, in Susan M. Schultz, ed., *The Tribe of John: Ashbery and Contemporary Poetry* (Tuscaloosa: University of Alabama Press, 1995), 211–57.

30 Charles Bernstein, "Dysraphism," *Sulfur* 8 (1983), 39.

31 John Ashbery, *A Worldly Country* (New York: Ecco Press, 2007), 15.

32 Charles Bernstein, *Content's Dream: Essays 1975–1984* (Evanston, IL: Northwestern University Press, 2001).

33 Ron Silliman, foreword to Rae Armantrout, *Veil: New and Selected Poems* (Middletown, CT: Wesleyan University Press, 2001), ix–xvi, p. ix.

34 Rae Armantrout, "Ashbery's Avoidance of the Easy" *New York Times*, 5 September 2017, https://www.nytimes.com/2017/09/05/opinion/john-ashbery-poet.html.

35 Rae Armantrout, "Cheshire Poetics," in *Collected Prose* (San Diego: Singing Horse Press, 2007), 55–62, p. 57.

36 Rae Armantrout, "True," in *Collected Prose*, 134–69, p. 163.

37 Rae Armantrout, "Close," in *Next Life* (Middletown, CT: Wesleyan University Press, 2007), 11–12.

38 William Carlos Williams, "Between Walls," in *The Collected Poems of William Carlos Williams*, vol. 1, *1909–1939*, ed. Christopher MacGowan (New York: New Directions, 1988).

39 Armantrout, "Cheshire Poetics," 55.

40 John Ashbery, *Three Poems* (New York: Viking Press, 1972), 41.

41 Rae Armantrout, "Theory of Everything," *Next Life*, 13.

Chapter Six

1 Samuel Beckett to Mary Manning Howe, 11 July 1937, in *The Letters of Samuel Beckett*, vol.1, *1929–1940*, ed. Martha Dow Fehsenfeld and Lois More Overbeck (Cambridge: Cambridge University Press, 2009), 521n8. This and subsequent volumes (vol. 2, *1941–1956*; vol. 3, *1957–1965*) are cited throughout the chapter as *LSB*.

2 See *The Collected Poems of Samuel Beckett*, ed. Seán Lawlor and John Pilling (New York: Grove Press, 2012), xv, 259–61. This monumental critical edition (subsequently cited as *CPB*) adds many previously uncollected poems, drafts, and translations, and reproduces the 1935 edition of *Echo's Bones*, thus superseding the chronologically arranged Grove Centenary Edition, vol. 4, *Poems, Short Fiction, Criticism*, ed. Paul Auster (New York: Grove Press, 2006), which follows the order and arrangement of the 1977 Grove-Evergreen text of Beckett's *Collected Poems in English and French*—the edition used by Beckett's readers for the prior three decades.

On *Echo's Bones*, the editors tell us, "Sales of the 327 copies . . . were so poor that SB could tell A. J. Leventhal that he still had 'a fat pile' of them in his possession more than twenty years later" (*CPB*, 260). Reviews, almost nonexistent, were tepid at best.

3 *CPB* references the translation by David Luke in *Selected Poems of Goethe* (Penguin, 1964): "Like a hawk poised, with scarce-quivering wings on lowering morning clouds, watching for prey, let my song hover" (261). My own is more literal.

4 An *enueg* is a Provençal genre; its title, from the Latin *inodium*, literally meaning "vexation," is a variant on the *planh* (complaint), taking up the trifles and serious insults of life, usually without continuity of thought. *Sanie* refers to noxious discharges of bodily fluids; *serena* is an evening-song, longing for reunion with one's lover. See Lawrence E. Harvey, *Samuel Beckett: Poet and Critic* (Princeton, NJ: Princeton University Press, 1970), 80–81, 85, 109. Harvey's book remains the definitive exposition of Beckett's poems. Cf. Marjorie Perloff, "Beckett the Poet," *A Companion to Samuel Beckett*, ed. S. E. Gontarski (Oxford: Wiley-Blackwell, 2010), 211–27.

5 SB to Thomas McGreevy [summer 1929], *LSB*, 1:10–11.

6 For a very informative recent set of essays on *Echo's Bones* and some of the later poems, see *Fulcrum*, no. 6, special section: "Samuel Beckett as Poet," ed. Philip Nikolayev (2007), 442–624. Cf. Perloff, "Beckett the Poet," 211–15; Perloff, "The Space of a Door: Beckett and the Poetry of Absence," in *The Poetics of Indeterminacy: Rimbaud to Cage* (1981; Evanston, IL: Northwestern University Press, 1999), 200–247; Perloff, "Between Verse and Prose: Beckett and the New Poetry," in *On Beckett: Essays and Criticism*, ed.

S. E. Gontarski (New York: Grove Press, 1986), 191–206; Perloff, "Lucent and Inescapable Rhythms: Metrical 'Choice' and Historical Formation," in *Poetry On and Off the Page: Essays for Emergent Occasions* (Evanston, IL: Northwestern University Press, 1998), 132–40.

7 For Beckett's translation of Rimbaud's "Le Bateau ivre," see *CPB*, 64–67, 358–61. In "Beckett, McGreevy and the Stink of Joyce," *Fulcrum*, no. 6 (2007), 484–99, Sean Lawlor suggests that Beckett's rather conservative poetics, at this stage, had also been influenced by McGreevy's way of writing poetry.

8 Beckett's "eyelid" example is very similar to Duchamp's "Infra thin separation between / the *detonation* noise of a gun / (very close) *and* the *apparition* of the bullet / hole in the target" (see Duchamp, *Notes*, 115).

9 Jonathan Culler, *Theory of the Lyric* (Cambridge, MA: Harvard University Press, 2015); Virginia Jackson, "Lyric," in *Princeton Encyclopedia of Poetry and Poetics*, 4th ed., ed. Roland Greene et al. (Princeton, NJ: Princeton University Press, 2012), 826–35.

10 See SB to Thomas McGreevy, 12 January 1938, *LSB*, 1:584–85n1; James Knowlson, *Damned to Fame: The Life of Samuel Beckett* (New York: Simon & Schuster, 1996), 259–62. The stranger was identified—and forgiven—by Beckett himself as a professional pimp named Prudent.

11 See SB to Arland Ussher, 12 January 1938, *LSB*, 1:597n11; *CPB*, 375. According to the note in *Collected Poems*, when Peggy Guggenheim first published the poem, she changed the last line to read, "With each the absence of life is the same."

12 See Marjorie Perloff, "John Cage as Conceptualist Poet," *South Atlantic Quarterly* 77, nos. 1–2 (2014): 14–33.

13 Mary Reynolds, a good friend of Beckett's via Peggy Guggenheim, had a long liaison with Marcel Duchamp. In the late 1930s, Beckett sometimes played chess with the artist, but they were not close.

14 On the relation to Wittgenstein, see Marjorie Perloff, *Wittgenstein's Ladder: Poetic Language and the Strangeness of the Ordinary* (Chicago: University of Chicago Press, 1996), 115–24.

15 On "je suis ce cours de sable qui glisse," see Perloff, *Poetics of Indeterminacy*, 244–47.

16 *LSB*, 2:300. As to the disposition of the poems sent to *84: Nouvelle Revue Littéraire*, see SB to Marcel Bisiaux, 22 March 1951, *LSB*, 2:230n1.

17 SB to Richard Seaver, 5 March 1958, *LSB*, 3:113. I discuss the three short stories in "In Love with Hiding: Samuel Beckett's War," *Iowa Review* 35, no. 2 (2005): 76–103.

18 Oddly, this letter is not included in the Cambridge edition. I owe the information to Ruby Cohn, "Twice Translated Texts: Beckett into English and Chaikin," *Modern Drama* 41, no. 1 (Spring 1998): 7–18, p.10. It would be useful to follow up on Cohn's lead and compare the micropoetics of *Texts for Nothing* to the French original, but since such comparison would lead to a discussion of translation as such and since Beckett himself translated the *Textes* with so much difficulty, taking a decade to do so and producing what we can construe as original poems, I here confine myself to the English. See *Stories* and *Texts for Nothing* (New York: Grove Press, 1967); reprinted in *Samuel Beckett*, Grove Centenary Edition, vol. 4. All further references are to this edition.

19 H. Porter Abbott, *Beckett Writing Beckett: The Author in the Autograph* (Ithaca, NY: Cornell University Press, 1996), 89.

20 Alain Badiou, *On Beckett: Dissymetries*, ed. Nina Power and Alberto Toscano (Manchester: Clinamen Press, 2003), 15. For interesting readings of subjectivity and trauma in the *Texts*, see Jonathan Boulter, "Does Mourning Require a Subject: Samuel Beckett's *Texts for Nothing*," *Modern Fiction Studies* 50, no. 3 (Fall 2004): 332–50; Christopher Langlois,

"The Terror of Literature in Beckett's *Texts for Nothing*," *Twentieth-Century Literature* 61, no. 1 (March 2015): 92–117; Daniel Katz, *Saying I No More: Subjectivity and Consciousness in the Prose of Samuel Beckett* (Evanston, IL: Northwestern University Press, 1999), 125–56.

21 Badiou, *On Beckett*, 41; Katz, *Saying I No More*, 145.

22 Edward Young, "Night First: On Life, Death, and Immortality," lines 19–23, in *Night Songs* (1744), Project Gutenberg, http://www.gutenberg.org/files/33156/33156-h/33156-h.htm.

23 See Perloff, "Witt-Watt: The Language of Resistance/The Resistance of Language," in *Wittgenstein's Ladder*, 115–44 and *passim*.

24 For a reading of the Fizzle "Still," see Marjorie Perloff, "Light Silence, Dark Speech: Reading Johns's Images, Seeing Beckett's Language in *Foirades/Fizzles*," *Fulcrum*, no. 1 (2002), 83–105. Here, I argue, visual prosody, important to the late Beckett, is also at play, "Still" being almost a Concrete poem.

25 Anne Atik, *How It Was: A Memoir of Samuel Beckett* (Emeryville, CA: Shoemaker & Hoard, 2005), 60–61.

26 On the Yeats citations in *Words and Music* and . . . *but the clouds* . . . , see Marjorie Perloff, "'An Image from a Past Life': Beckett's Yeatsian Turn," *Fulcrum*, no. 6 (2007), 604–15. The passage in question, from "The Tower," begins with the poet's assertion, "Now shall I make my soul," and vows to defy death, letting its very threat "Seem but the clouds of the sky / When the horizon fades, / Or a bird's sleepy cry / Among the deepening shades."

27 See, for example, Mark O'Connell, "The Stunning Success of 'Fail Better': How Samuel Beckett Became Silicon Valley's Life Coach," *Slate*, 29 January 2014: "The entrepreneurial class has adopted the phrase with particular enthusiasm, as a battle cry for a startup culture in which failure has come to be fetishized, even valorized." https://slate.com/culture/2014/01/samuel-becketts-quote-fail-better-becomes-the-mantra-of-silicon-valley.html.

28 "Worstward Ho," in *Samuel Beckett*, Grove Centenary Edition, 471–85, p. 471.

Chapter Seven

1 Samuel Beckett to Barbara Bray, 22 September 1964, in *The Letters of Samuel Beckett*, vol. 3, *1957–1965* (Cambridge: Cambridge University Press, 2014), 628.

2 W. B. Yeats to Ellen O'Leary, 1899, in *The Letters of W. B. Yeats*, ed. Allen Wade (New York: Macmillan, 1955), 109.

3 *The Variorum Edition of the Poems of W. B. Yeats*, ed. Russell Alspach and Peter Allt (New York: Macmillan, 1957), 320. All further references are to this edition, subsequently cited as *PWBY*.

4 Samuel Beckett, "Recent Irish Poetry" (August 1934, under the pseudonym Andrew Belis), in *Disjecta: Miscellaneous Writings and a Dramatic Fragment*, ed. Ruby Cohn (New York: Grove Press, 1984), 70–76.

5 Beckett, *Letters*, 3:391, 534.

6 See W. B. Yeats, "Reveries over Childhood and Youth" (1914), in *Autobiographies* (London: Macmillan, 1966), 102.

7 W. B. Yeats, "A General Introduction for My Work" (1937), in *Essays and Introductions* (New York: Macmillan, 1961), 521–22.

8 See Marjorie Perloff, *Rhyme and Meaning in the Poetry of Yeats* (The Hague: Mouton, 1970). And see, for example, Gayatri Spivak, *Myself Must I Remake: The Life and Poetry of W. B. Yeats* (New York: Crowell, 1974).

9 Anne Atik, *How It Was: A Memoir of Samuel Beckett* (Emeryville, CA: Shoemaker & Hoard, 2005), 60.

10 In her synoptic study *Our Secret Discipline: Yeats and Lyric Form* (Cambridge, MA: Harvard University Press, 2007), Helen Vendler gives a very full account of Yeats's formal devices—his chosen stanzas and verse forms, the arrangement of rhymes, and the larger architecture of individual poems. But she has little to say about sound itself: the deviations from the standard meter, the repetitions, the "infrathin" distinctions between A and B, that interest me and that I think are key to an understanding of Yeats's poetry. Brian Devine's *Yeats, the Master of Sound* (New York: Oxford University Press, 2006) has a suggestive title, but the book is primarily a study of Anglo-Irish rhythms in general and Yeats's adaptation of them in his earlier work. Again, there are no close analyses of specific poems.

The best studies to date of Yeats's sound and syntax remain Richard Ellmann, *The Identity of Yeats* (New York: Macmillan, 1954), and the essays by Donald Davie and Graham Martin in *An Honoured Guest: New Essays on W. B. Yeats*, ed. Denis Donoghue and J. R. Mulryne (London: Routledge, 1965). The manuscript studies of Jon Stallworthy—*Between the Lines: Yeats's Poetry in the Making* (Oxford: Clarendon Press, 1963) and *Vision and Revision in Yeats's Last Poems* (Oxford: Clarendon Press, 1969)—as well as Curtis Bradford, *Yeats at Work* (Carbondale: Southern Illinois University Press, 1963), are also very useful.

11 Yeats was never especially concerned with syllable count: his iambic tetrameter line might well have seven or nine syllables rather than eight. It is hence more accurate to refer to a four-stress line, rather than to call that line iambic tetrameter, but for the sake of clarity, I stick to the latter.

12 Yeats's source here was Pierre de Ronsard's Petrarchan sonnet "Quand vous serez bien vieille," but Yeats reduced the requisite fourteen lines to twelve and made it a three-stanza ballad. Helen Vendler argues that he nevertheless retains the *volta* of the Petrarchan sonnet which here comes after line 6, "But one man loved the pilgrim soul in you," a line which marks the shift from the second person to the first (*Our Secret Discipline*, 153). This may well be the case but tells us little about the actual linguistics and rhythms of the poem. Such adaptation of foreign source material was, in any case, quite unusual for Yeats, who preferred creating his own forms.

13 Available online at http://www.openculture.com/2012/06/rare_1930s_audio_wb _yeats_reads_four_of_his_poems.html.

14 *PWBY*, 357. See also Marjorie Perloff, "Introduction," in *The Sound of Poetry/The Poetry of Sound*, ed. Marjorie Perloff and Craig Dworkin (Chicago: University of Chicago Press, 2009), 4.

15 See *Words and Music*, in *Samuel Beckett*, Grove Centenary Edition, vol. 3, *Dramatic Works* (New York: Grove Press, 2006), 332–40, p. 337; *Krapp's Last Tape*, vol. 3, 226. Beckett's most overtly Yeatsian play, both formally and thematically, is the television play . . . *but the clouds* . . . (1971); for an analysis of this play, which can be considered a riff on Part III of Yeats's "The Tower," see Marjorie Perloff, "An Image from a Past Life": Beckett's Yeatsian Turn," *Fulcrum*, no. 6 (2007): 604–15.

16 See Yeats, "General Introduction," 521; *Letters on Poetry from Yeats to Dorothy Wellesley* (Oxford: Oxford University Press, 1964), 18, 56.

17 "The Wild Swans at Coole," written in 1916, first appeared in a slightly different form in *The Little Review*, June 1917. It next appeared in the Cuala Press limited edition of the volume (1917) and then in the Macmillan volume (1919).

18 *The Wild Swans at Coole: Manuscript Materials by W. B. Yeats*, ed. Stephen Parrish (Ithaca, NY: Cornell University Press, 1994), 3. Subsequently cited in text as "Cornell." The many bracketed passages with question marks occur because Yeats's handwriting is notoriously difficult to read.

19 On Beckett's allusions, in the plays *Words and Music* and *. . . but the clouds . . .* , to Yeatsian motifs in "The Tower," see Perloff, "Image from a Past Life," 611–13.

Index